THE BEAST DEMYSTIFIED

Aleister Crowley

THE BEAST DEMYSTIFIED

Roger Hutchinson

MAINSTREAM
PUBLISHING

EDINBURGH AND LONDON

First published in Great Britain in 1998 by
MAINSTREAM PUBLISHING COMPANY (EDINBURGH) LTD
7 Albany Street
Edinburgh EH1 3UG

ISBN 1 84018 229 6

This edition 1999

A catalogue record for this book is available from the British Library

Typeset in Stone Print Roman
Printed and bound in Finland by WSOY

The truly awful thing about Crowley is that one suspects he didn't really believe in anything. Even his wickedness. Perhaps the only thing that wasn't fake was his addiction to heroin and cocaine.

– Christopher Isherwood

Contents

1

Afterlife

Those gifted young men, the Beatles, have added him to their escutcheon.

– John Symonds

For perhaps twenty years after his death in 1947, the reputation of Aleister Crowley slumbered. It was revived by the four most famous young men in the world.

Early in 1967, Paul McCartney was toying with ideas for the sleeve of a long-playing Beatles record which the group was presently recording at Abbey Road studios in London. The album was to be called *Sergeant Pepper's Lonely Hearts Club Band*. McCartney – an art school graduate – firstly conceived it as a kind of tribute cover, with the Beatles standing in front of a wall hung with framed photographs of their heroes.

He sketched pen-and-ink drawings of The Beatles in military band jackets in an Edwardian sitting-room with the wall of photographs behind them. Then he prepared a series of compositions of John, Paul, George and Ringo being presented to a Lord Mayor in front of a floral clock. McCartney showed these sketches to a friend, the art gallery owner Robert Fraser, who

suggested commissioning a 'real artist' to execute them, and he proposed the pop artist Peter Blake.

Blake, who had already completed a repertoire of portraits of rock stars such as Elvis Presley and Bo Diddley, rendered in a nostalgic fairground tone of Edwardian England's popular culture. McCartney recalled:

> I took the little drawings of the floral clock and the Lord Mayor and all our heroes, which was like the end design, and we went to see Peter. He lived in a little suburban house in an ordinary row; a very cosy house with lots of things everywhere like an antique shop. All the walls were loaded with pictures, the corridor to the next room and up to the bedroom was filled with tattooed-lady pictures – he had a lot of those.

It was a perfect marriage of concept and artist. With the approving Robert Fraser overseeing the project as voluntary 'unofficial art director', Blake picked up the idea and ran with it. It changed – 'in good ways', considered McCartney. The clock became a flower-bed with The Beatles' title on it; the Lord Mayor disappeared; and the heroes in photograph frames became a crowd of dignitaries. It was decided to make life-sized cut-out figures of these people (most of whom were dead) for a photo session.

McCartney asked his fellow Beatles each to contribute a list of heroes for the cover. George Harrison handed in a roll-call of Indian gurus. Paul himself offered, among others, the disreputable novelist William S. Burroughs, H.G. Wells, Carl Jung, the cowboy-film star Tom Mix, Karl Marx, the author of the *William* books Richmal Crompton and Fred Astaire. Ringo Starr said that he had nobody to suggest: he would go along with the others.

John Lennon nominated Adolf Hitler (whose cut-out figure was duly made, but was removed from the set just before the photo shoot began), the Marquis de Sade, the German philosopher Friedrich Nietzsche, the American 'black-comedian' Lenny Bruce (who had been banned from Britain earlier in the 1960s), the

outlandish American cabaret performer Lord Buckley, the poet Dylan Thomas, the novelist James Joyce, Oscar Wilde . . . and a dimly remembered self-styled magician and seminal proponent of sexual and narcotic freedom called Aleister Crowley. A photograph of Crowley in hairless middle-age was uncovered, and he duly appeared on the cover of *Sergeant Pepper's Lonely Hearts Club Band* glaring out from between one of Harrison's gurus and Mae West (who had crept into the gathering, along with several others, during the creative process). Crowley's presence there was noticed with puzzlement and some dismay by the *Daily Express* newspaper, whose sister Sunday paper had, four decades earlier, done so much to establish the man's diabolical reputation during his lifetime. (One can only conjecture about the response of the *Express* group if Hitler had made it onto the sleeve.)

The effect was dramatic. Upon its release in the spring of 1967, *Sergeant Pepper* immediately became the most influential record of the 1960s. Anybody related to the LP became, of necessity, a source of interest to The Beatles' huge young constituency. That constituency was doubly delighted to learn that the bald and baleful man in the crowd had taken lots of drugs, had advocated the legalisation of narcotics and had used as his mantra the term: 'Do what thou wilt shall be the whole of the law.' An exhortation custom-made to the late 1960s, many of whose population had already determined to establish a new civilisation upon the more prosaic proposition 'do your own thing'.

A period of fringe fascination followed. In 1969 the hip film-maker Kenneth Anger, who had directed the black cult movie *Scorpio Rising*, rented Crowley's old Highland retreat, Boleskine House on the south-east shore of Loch Ness. A year later Jimmy Page of the rock band Led Zeppelin heard from Anger that Boleskine House was for sale and bought the place. When it became known that Page was a Crowleyite, the popular press of the 1970s wondered aloud whether Led Zeppelin's otherwise inexplicable success was owed to a Faustian pact with the devil – a pact which had provoked the Antichrist to carry off the band's drummer, and then lead singer Robert Plant's boy child and, as an

encore, almost to kill the rest of Plant's family on a Greek island at exactly the same time as Jimmy Page, hundreds of miles away, was exploring Crowley's deserted temple on the north coast of Sicily.

(In point of mundane medical fact: an overdose of vodka killed drummer John Bonham; a virus destroyed little Karac Plant; and while Page was in Sicily Karac's mother was badly injured in a car crash on a tortuous track on the island of Rhodes. These things happen, even to rock stars and the families of rock stars who work with Crowleyites. Jimmy Page never spent too much time in the lonely drizzle at Boleskine House, and when he did he was as likely to be found opening village halls, or putting in benign appearances at local school dances, as raising demons.)

Something of a Crowley renaissance was under way. In 1969 Jonathan Cape in London, and a year later Hill & Wang in New York, decided to publish – for the first time in hardback – the full one thousand pages of Crowley's Confessions, which had been commissioned by William Collins of London in 1922. Despite making payable to the author an advance royalty cheque of £120 (£3,000 in today's money), Collins had taken fright from the vicious attack on Crowley in the Sunday Express and, in common with all other mainstream British publishers of the time, refused to touch a further word of the Beast's prolific output. The Mandrake Press published two of the six volumes in 1930, but not until 1971 when Bantam Books issued a mass-circulation paperback edition of the entire Confessions did they receive a proper audience.

The belated popularity of this massive work ('amorphous, clumsy, without design or sense of proportion; a mere chaos of facts,' judged Crowley himself in 1923, considering that the manuscript should be passed on to the great biographer Lytton Strachey for a complete rewrite) was partly attributed by its latter-day editor John Symonds to the fact that 'those gifted young men, the Beatles, have added him to their escutcheon'.

By the 1990s whole wide shelves in occult and alternative bookshops were groaning under Crowley reprints, Crowley

interpretations, Crowley appreciations, and the memoirs of long-lost illegitimate Crowley offspring.

In 1973 the present writer was asked by a publisher of hippie guidebooks to divert from an Italian holiday to visit Cefalù and file a couple of paragraphs on Crowley's former Sicilian dwelling. Even to me, a standard product of the time, it seemed like a weird commission. But, by 1989, Crowley sites had become, to a new generation of travel writers, standard stages on the European itinerary.

'I'd also like to find the Abbey of Thelema at Cefalù which Aleister Crowley set up,' explains Duncan Fallowell early in his brilliant, barnstorming travelogue *To Noto*, or London to Sicily in a Ford. 'I believe his wall-paintings are still there,' responds Harold Acton. 'Lots of cocks!' In the company of a woman friend, Fallowell found the place on a hillside now cluttered with modern villas.

> The cottage is one storey with closed green shutters along the garden side, whitewashed walls, terrace with no porch, three steps down from a double front door, pink and red geraniums running wild. In a copse there is a tilted plinth of maroon, blue and white diamond tiles. Nothing stands on it. A battered suitcase and broken-down gas oven are sunk in grass. By the back entrance is an old door painted with a ghoulish grimace, perhaps one of the survivors of Crowley's invocatory decorations.

'The place has a good feeling,' declares Fallowell's friend, before jumping to her feet and shouting the most famous lines from the only one of Crowley's poems to become half-way famous: 'Io, io Pan! Io, io Pan!', and then laughing lengthily 'in a high trailing ribbon of heartfelt gold'.

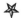

Perhaps the most startling and complete revision of the value of the man's life and work occurred in 1993. That comprehensive compendium of the good, the great and the merely noteworthy in British life, the *Dictionary of National Biography*, had been published every ten years since Victorian times. It routinely appeared after the close of each decade, containing full and idiosyncratic biographies of every Briton of note who had passed over in the previous ten-year cycle.

By rights, Aleister Crowley should have been included in the *DNB* which was published in 1950. But he was not there. It was a curious omission, considering the obscure parsons and academics who were traditionally among those so honoured. Aside from his self-proclaimed magical powers, Crowley had been a mountaineer and published writer of some note – not top of the range, but of some note. He had not exactly conquered K2 or Kangchenjunga, but he had climbed higher up those peaks than any other man of his time, and higher than anybody else was to manage for another two decades. He had not dominated the best-seller lists, but his books had a certain brash integrity. His most successful creation, his own character, should itself have guaranteed him a B-list entry in the *DNB*. By the time of his death the thinly disguised figure of Aleister Crowley had enjoyed a leading role – and occasionally a title role – in at least eight published works of fiction by authors as celebrated as W. Somerset Maugham and Arnold Bennett, and as obscure as H.R. Wakefield and Manly Wade Wellman.

Luckily, by the early 1990s the editors of the *DNB* had become painfully aware that their predecessors had succeeded in ignoring a number of deserving Britons whose reputations had elsewhere been embarrassingly advanced since their deaths. As well as Aleister Crowley, the *DNB* had failed to eulogise the poets Sylvia Plath, Gerard Manley Hopkins and Wilfred Owen, the magisterial muse Maud Gonne, the suffragette Sylvia Pankhurst, the pioneering

cookery writer Mrs Beeton, the actor Charles Laughton and the unique Lillie Langtry.

A disproportionately large number of those omitted had been women, which fact advances its own reason for their absence. In 1993 the *Dictionary of National Biography* published a special 'Missing Persons Supplement'. In an explanatory foreword the editors suggested that it was not possible to revise the previous decennial volumes. But, they admitted, a number of people had not appeared in those earlier volumes who, on sober reflection, should have been there. Now was the time to correct that, in a special, one-off, catch-up, 'Missing Persons Supplement'.

There were a number of reasons, continued the editors, why such figures as Aleister Crowley and Lillie Langtry had earlier been rendered *personae non gratae*. It is instructive to quote those reasons and parenthetically assess their merit with regard to Crowley (and, for that matter, Langtry).

Those who had been airbrushed out of the historical record were men and women 'who acquired posthumous fame' (not true); 'whose careers have come to light only through recent historical research' (certainly not); 'whose achievements were unrecognised by the editors of the time' (close, in one interpretation, but not truly applicable to 'the wickedest man in the world'); or 'who had failed to come to the editors' attention for whatever reason' (surely not).

The real reason for Aleister Crowley's (and Lillie Langtry's) omission from their contemporary *DNB* had been that the editors disapproved of them. They were infamous enough in their time, but the years had not yet put sufficient distance between the date of their interment and the compilation of their final decade's *DNB* to lessen that infamy. Unlike Brummell and Gwyn, they were not centuries dead. The editors may have hoped, as they tipped Crowley and Langtry into the reject bin, that the years would not be kind, but would rather erase these scurrilous disreputables from the public mind.

That was truly wishful thinking. By 1993 Crowley and Langtry had been firmly established as lovable eccentric rascals of the recent past. *Sergeant Pepper's Lonely Hearts Club Band* had done its job.

And so, on page 162 of the *Dictionary of National Biography*, 'Missing Persons Supplement, 1993', Aleister Crowley appears at last, engraved upon the official tablet of British history. It was a kind of posthumous knighthood. Sandwiched between a life of the seventeenth-century ironmonger and Tory MP Sir Ambrose Crowley (how did they miss him out, first time round?), and one of the scientific instrument-maker Edmund Culpeper (*c.* 1670–1738), is an uncommonly kind thousand-word appraisal by Gerald Suster of the achievements of Edward Alexander ('Aleister') Crowley (1875–1947). The *DNB*, after all those years and doubtless following much editorial debate, chose to classify him simply as a 'writer'.

There was more to him than that, of course, much more. His 'doubted' claims to have been the greatest mountaineer of his generation, were ruled by the *DNB* ninety years later to actually 'have foundation in fact'. His arrogation of the majority of available world mountaineering records in 1900 has 'not been convincingly refuted'.

Crowley's verse (superior to that of Percy Bysshe Shelley or of his acquaintance W.B. Yeats, in his own estimation), was a thornier plant for the *DNB* to handle. It had 'aroused extremes of praise and blame', and 'appreciation was marred by the poet's increasingly vilified personal reputation'.

From his sadly besmirched rhymes, the *DNB* moved seamlessly on to its prodigal subject's work in 'mapping hitherto unexplored regions of the brain'. The fact that Crowley's selfless application to this cartographical task involved the enthusiastic use of sacks of classified drugs and a Kama Sutra of sexual technique was merely hinted at by the *DNB* in 1993 (in Suster's words, the new subject was 'always a keen adventurer and womaniser'). His pro-German propagandising in America during the First World War – the kind of work for which other British subjects had been executed by firing-squad – was 'ludicrous' and 'counter-productive', and did not, somehow, prevent his cheerful return to Great Britain in 1919.

In short, Aleister Crowley, writer, was 'colourful, eccentric, flamboyant, and deliberately shocking'. He died 'excoriated and ignored' (ignored not least by the *Dictionary of National*

Biography). But, in this tender reappraisal permitted by the passing years, Crowley's abiding message to humanity had been 'not vulgar hedonism but the honest and honourable fulfilment of a person's deepest potential'.

Aleister Crowley would have laughed aloud. Like the outdated Messiah whom he had decided to replace, he had died to rise again: proof positive that no reputation is beyond redemption. This person had been, according to a riotous assembly of popular newspapers, not only 'the wickedest man in the world'. He was also 'a human beast'. He was 'the man we would like to hang'. His student Jimmy Page might, many years later, have complained about scurrilous treatment at the hands of the British press. How would Page have enjoyed the following headlines in the *Sunday Express*: COMPLETE EXPOSURE OF DRUG FIEND AUTHOR. BLACK RECORD OF ALEISTER CROWLEY. PREYING ON THE DEBASED. HIS ABBEY. PROFLIGACY AND VICE IN SICILY . . .?

He would have laughed aloud because he is not there in the *Dictionary of National Biography*'s belated profile, any more than he was to be found in the black caricatures of *John Bull* magazine or the *Sunday Express*. The mythology which he understood so well confused his hunters in death as in life, baffled those who followed him in good humour as in foul. Duncan Fallowell might have discovered him – 'he's a genuine charlatan, and a remarkable character. His ostentations are irresistible, indeed courageous' – but Duncan had a mythological lake of black water to find, and had neither the time nor the inclination to dwell for more than a few paragraphs on the erstwhile tenant of Cefalù.

The wildly coloured smokescreens which Aleister Crowley laid down around his person from maturity unto death had not yet, by 1993, been blown away. It may be that they never will. But we are adults now; the third millenium approaches. Pick up the bellows

and have a sustained blast at the aura around this balding Puck. Io Pan! Indeed! He is beyond annoyance. He would only laugh, and laugh aloud again, the self-canonised saint, the god in human form, at well-intentioned acolytes who failed to spot the difference between a pious existence selflessly devoted to exploring the deepest potential of humankind, and an honest-to-goodness life of vulgar hedonism.

2

Early Life

*Do not expect the honour, admiration, and love of the men of
this age, but, on the contrary, scorn, reproach, and hatred.*

– Edward Crowley

Ten years before the birth of his son, Edward Crowley foresaw the
death of established Christianity and the temporary accession of the
Antichrist.

'There can be no doubt,' wrote this good, pious brewery heir in
1865,

> but that they [the religious systems] will continue
> their course, that they will grow worse and worse,
> waxing bolder and bolder against God until the
> Antichrist himself shall be revealed, who shall oppose
> and exalt himself above all that is called God, or that
> is worshipped; who shall sit in the temple of God,
> showing himself that he is God; whom the Lord shall
> destroy with the brightness of His coming, and
> consume with the Spirit of His mouth.

To the young Edward Alexander Crowley, who was known to his family as Alick, and who would later style himself Aleister, writing of his own childhood in the third person many years later, 'his father was his hero and his friend, though, for some reason or other, there was no real conscious intimacy or understanding.' He adored the older Edward, seeing him as 'naturally a leader of men . . . He knew no superior but his father.'

Edward Crowley the elder can hardly have imagined, however, that the son who worshipped him and followed him in all things, the son whom he never saw mature, would pursue his father's word so far and so obediently as to aspire personally to usurp the throne of God.

Edward Alexander Crowley was born in Leamington, Warwickshire, on Tuesday, 12 October 1875. He arrived, the first child and only son (a daughter, his sister Mary Grace Elizabeth, would die in February 1880 after just five hours of life), into the centre of a family of Plymouth Brethren.

His mother Emily Bertha Bishop came from a Devonshire and Somerset background. Edward Crowley, his father, was the affluent son of a small brewing dynasty. Crowley's Ales were, however, perhaps less well known than were Crowley's Alehouses. These were an enterprising chain of small shops that had been established by the family in order to give their beer the monopolised outlet which was denied to them by most taverns. They were effectively lunch-bars. Crowley's Alehouses offered young professional men who disdained the spit-and-sawdust ambience of nineteenth-century public houses, the opportunity to buy and eat ham or cheese sandwiches in relative calm and hygiene, and to wash it all down with ale – Crowley's ale.

Little is known of the origins of the Crowley family. In adulthood, Aleister Crowley claimed Celtic blood from his father's side of the family. It is possible that they came from Ireland: Crowley is a more

common surname there than in Britain, and two of the most prominent Crowleys of the nineteenth century (the Dublin-born painter Nicolas Joseph Crowley and the Cork insurrectionist Peter O'Neill Crowley) were Irish. Both were opposed to the British ascendancy; Peter Crowley died after being shot by the constabulary in a skirmish. On the other hand, the most famous English Crowley before young Edward Alexander, the sixteenth-century printer, writer and divine Robert Crowley, had his roots firmly in Gloucestershire; and he seems in his life to anticipate the family's religious bent: he devoted himself to spreading the doctrines of the Reformation and refused to minister in the 'conjuring garments of Popery'.

Like Robert Crowley, Edward and Emily Bertha Crowley must have adopted their religion. They can hardly have inherited the faith: the schismatics who would become known as the Plymouth Brethren were not formed until 1827, when a protestant minister of the Church of Ireland John Nelson Darby and a lapsed Roman Catholic Edward Cronin agreed – also like Robert Crowley, three centuries before them – that their own and other churches were ministered to by men of straw, and were consequently lacking in pure spirituality.

It was a common complaint in the first half of the nineteenth century. Similar dissatisfactions north of the Tweed would lead, in 1843, to the massive Disruption which rent the established Church of Scotland and brought about the creation of the fundamentalist Free Church.

Many of the Plymouth Brethren's credos – such as the refusal to celebrate Christmas – had much in common with the Free Church of Scotland, but Darby and Cronin had less impact than their Caledonian cousins. After several years of missionary wandering Darby settled in Plymouth where he attracted the congregation, the only substantial congregation in England, which led to his sect's name. And soon, just as the Scottish Free Church splintered into numerous proud and unbending orthodoxies, so did the Plymouth Brethren subdivide into the Open and the Exclusives, and later into the Darbyites, the Kellyites, the Newtonites and Bethesda.

In his celebrated *Father and Son* Sir Edmund Gosse left a vivid account of being brought up in the middle of the nineteenth century by a father, the eminent zoologist Philip Gosse, whose adherence to the Plymouth Brethren led him to throw out his family's secretly bought Christmas turkey and gifts, refuse his son access to secular writing, and even deny the Darwinist conclusions which his own professional work supported.

Edward Crowley knew Philip Gosse. Edward was a member of the Exclusive Brethren, and Philip a leader of the Open Brethren. Edward Crowley considered Philip Gosse to be a liberal backslider who was facing eternal damnation because of the Open Brethren's willingness to share a communion table with other, unaffiliated Christians.

On the more basic question of Christmas Day, however, the Crowley and Gosse families were in accord. It was a pagan festival which should not be recognised: there were no decorations; no presents were exchanged; no cards were sent and any received were destroyed. (But as young Alick enjoyed turkey, the Crowley family ate the flesh of that bird on the twenty-fourth and twenty-sixth of the month.)

Edward Crowley faced some contradictions himself. An active evangelist, he would occasionally be taxed at public meetings with the charge that his wealth derived from alcohol. Edward was no abstainer. He disliked the self-righteousness of the Salvation Army and he saw nothing in the gospels which counselled the rejection of alcohol. He had relinquished drink, he told his hecklers, during the nineteen adult years in which he had held shares in Crowley's Ales. Since then he had ceased to abstain – he regularly drank wine – but his money was now all invested in a Dutch waterworks. One Sunday, his son remembered, Edward Crowley told a town hall meeting that he 'would rather preach to a thousand drunkards than a thousand teetotallers', as abstainers were more likely to be misguidedly

complacent about their own heavenly prospects. Those were ironical, thrawn, pernickety Crowleyan attitudes – father and son.

Drink may have been allowed, in moderation, in the Crowley household, but it was otherwise a strict and stifling Victorian premises. The evasion of sin was all. Non-members of the Brethren (including, of course, those other Christians who were shamefully permitted to break bread with the Open schismatics) were routinely labelled Sinners. Members of the Brethren, the exclusive, the saved, were – as the young Edward Alexander Crowley most certainly noted – known to each other as Saints. To be a saint was, in the childhood of Edward Alexander 'Alick' Crowley, a common experience.

We know exactly what Edward Crowley believed in, and the precise parameters of behaviour which he prescribed for his wife and young son. In 1865, ten years before Alick's birth, Edward Crowley published a pamphlet advertising his faith. It was titled *The Plymouth Brethren (so called), Who They Are – Their Creed – Mode of Worship – etc.* It was printed in Paternoster Row, East Central London, and it cost one penny. It had originally been written, Edward explained, for private circulation among a chosen few, but demand had proved so great that he felt obliged to offer the tract to a wider audience. This explanation was certainly sophistical. In his son's words, 'Edward Crowley used to give away tracts to strangers, besides distributing them by thousands through the post.' By writing and publishing his own pamphlet he was simply cutting out the middlemen. He wrote:

> The Brethren believe all that is written in the word of
> God . . . The Bible is their one standard, and to that
> they constantly appeal. They know nothing about acts
> of Parliament, articles of religion, catechisms, or rules

drawn up. The Bible, and nothing but the Bible, is
their guide.

Edward Crowley and his fellows worshipped, he said, in a
straightforward fashion. They followed 'the custom of the early
Christians' in gathering together on the first day – Sunday – of each
week: 'Their [the early Christians'] simple object was to break bread
and to worship, not to hear sermons; and therefore Brethren follow
the same course.' The praise and worship of the 'Saints' so gathered
would thereby 'flow forth freely to Him'. The Brethren would not
permit vicars, ministers, priests or parsons to obstruct this direct
line to the Almighty:

> They do not, therefore, allow one man, however good
> he may be, or however much he may have been owned
> of the Lord as a servant of His, to take a place of
> authority in the assembly for worship, because by so
> doing they would hinder the free operations of the
> Spirit of God.

This basic religious egalitarianism extended into secular life:
Edward would not allow himself to be addressed as 'Mister' or
'Esquire'.

The Exclusive Brethren were not, however, strictly Sabbatarian.
Every day of the week was considered by Edward Crowley to be the
Lord's Day and, although the Brethren chose to take communion on
Sunday, the particular elevation of the Sabbath was thought to be a
Judaic heresy. He did not believe 'that the cut and colour of Sunday
clothes could be a matter of importance to the Deity'. Young Alick
Crowley was therefore permitted to dress casually and even to read
secular literature after communion on Sundays.

Only the Plymouth Brethren and the Quakers, Edward Crowley
asserted, had a Godly attitude towards ministers – which was to say,
that ministers were really no different from any other servant of the
Lord, and should not be falsely elevated. This realisation had led the
Brethren (if not the Quakers) towards 'purging themselves from

those who do dishonour to the Holy Ghost' (a gentle dig there at Philip Gosse and his easy-going Open Brethren).

This had naturally inspired vexation in 'they who are left behind', which led those stragglers 'to persecute and say all sorts of evil things of those who have done what the word of God tells them to do.' The path of the righteous, the path chosen by Edward Crowley for himself, for his wife and for young Alick Crowley, was a lonely track which trailed through ambush and hardship to its goal: 'the place Brethren have been led to take by the Spirit of God is a place of trial and reproach. They have gone outside the camp . . .'

And so, as Edward Crowley informed all who bought his penny pamphlet in 1865, and as he certainly instructed his attentive, devoted son, expect and prepare 'to be despised and be nobodies, so far as the world is concerned . . . do not expect the honour, admiration, and love of the men of this age, but, on the contrary, scorn, reproach, and hatred.'

Edward then asserted – and we have no reason to suppose that Alick Crowley was shielded from this revelation – that the Antichrist would shortly appear, 'and shall sit in the temple of God, showing himself that he is God'.

The Plymouth Brethren were a sect. Edward Crowley used the word himself, without embarrassment. There was nothing wrong with living in a small sect: Edward and his fellow devotees were not 'very anxious to swell their numbers for the sake of numbers . . . they have no earthly or political end in view, and therefore mere numbers are no object to them.'

Alick Crowley spent his formative years in a small congregation which was domestically so sealed from the outside world as to be almost monastic, and which was so utterly, arrogantly confident in the singular correctness of its own beliefs and activities that the opinions and criticisms of others counted for nothing. It was a small step, a very small step, a slight shift sideways, from being outright antisocial.

The boy found this life to be 'entirely pleasant'. He had never known any other, and the certainty, the security of it appealed to him. 'The Bible was his only book', and although a deep fascination

with certain passages in the Book of Revelations led to 'an instinctive love of terrors' – natural enough in a growing lad – he enjoyed a happy childhood. Only after the death of his hero, the natural leader of men, his father, would Alick become disillusioned with the regime. As a boy he revolted only against eating jam (because it looked messy) or salad (because the word 'salad' sounded unpleasant – 'I dislike the combination of consonants'. He was middle-aged before he overcame this distaste and first ate salad.)

While Edward Crowley was alive the two of them, stern father and plump little boy, would tread tirelessly from village to village spreading the good news – an exercise which gave Edward an impressive ear for different English dialect and accents. Young Alick could be entertaining company. He was clearly of an empirical frame of mind, and on one occasion while walking in a field Edward advised his son to avoid a clump of nettles. Alick was unconvinced. 'Will you take my word for it, or would you rather learn by experience?' offered Edward. 'Learn by experience,' replied Alick, diving headfirst into the nettles. At some other time, having been told by his mother that 'ladies have no legs', he disappeared under the dinner table to examine the bottom halves of two visiting venerable maiden sisters, and emerged to announce that: 'Sister Susan and Sister Emma are not ladies.'

Edward was a diligent evangelist. He would arrive in some unsuspecting hamlet, hand out his tracts, and then locate a man engaged in some everyday task – digging his garden, perhaps, or repairing a drain. 'Why are you doing that?' Edward would ask in a sympathetic, friendly manner. The man would invariably explain, and say that he hoped for such-and-such a result.

He was then trapped. Edward Crowley would patiently, gently hear him out, and trump him with: 'And then?'

'By repeating this question,' Aleister Crowley later recalled, 'he would ferret out the ambition of his prey to become mayor of his town or whatnot.'

'And then?'

'What . . .?'

'And then?'

26

'Er . . .'

'And then?'

Until the interrogated citizen was brought face to face with his own inevitable end . . .

'And then?'

By which time he had ideally been led to realise 'the entire vanity of human effort' – even such superficially valuable effort as digging a garden – and his previously sunny afternoon had been transformed into a bleak, nose-to-nose confrontation with his prospects in Eternity. Edward Crowley was fascinated by death.

Alick did not go to school until he was eight years old. Before then he was educated at home, both by his father – in such verities as the creation of the universe in 4004 BC, and the divine infallibility of the version of the Holy Bible which had been authorised by King James in 1611 – and by visiting tutors. His father's biblical tuition ensured that the boy could read by the age of four, even if the subject matter was somewhat narrow. Edward Crowley's favourite text was Genesis, Chapter Five: the story of the descendants of Adam, all of whom lived for several hundred biblical years, and yet all of whom – which was crucial to Edward Crowley's interpretative sermons – finally, satisfactorily, died. One of Edward Crowley's more idiosyncratic sermons was predicated on the use in the Bible of that multifunctional adverb, preposition, relative pronoun and conjunctive, the word 'but'. In preparation of this lesson he had his only son scour every page of the King James edition, highlighting in ink each use of 'but'.

However it was attained, Alick's early literacy served him well: he was able before his teens to read such boys' novels as R.M. Ballantyne's *Martin Rattler*, and such Victorian parlour verse as *Casabianca* ('The boy stood on the burning deck . . .' etc.) and Longfellow's *Excelsior* ('A youth, who bore, 'mid snow and ice / A

banner with the strange device . . .'). The visiting tutors gave him a thorough grounding in geography, history, Latin and arithmetic.

The death of the tiny Mary Grace Elizabeth Crowley in 1880 was, we may assume, a traumatic occasion for the family. It was certainly disturbing to the five-year-old Alick, who deeply resented being taken to see his sister's corpse, and during the rest of his sixty-seven years on earth attended only one other funeral before his own. Shortly afterwards the Crowleys moved from Leamington to a big suburban house in its own grounds at Redhill in Surrey. This was not unfamiliar territory to Edward Crowley, who had lived before his marriage in nearby Clapham, which was then another village south of the River Thames. But it was new to Alick, although the move did nothing to disturb the endless sunniness of his pre-school childhood, and he would remember all of those days as a time of 'perpetual happiness'.

He had not yet been properly introduced to the rest of the human race. His schooling was entirely domestic, and he was allowed to play only with the children of other Plymouth Brethren. It was not entirely a protected existence: he would recall laying ambush with other young Brethren to parties of children on their way to the local National School; showering the unfortunate infants with arrows and peas from shooters until they were obliged to take another route. He also developed a passion for a cousin twice his age, the twelve-year-old Gregor Grant, whose Scottish Presbyterian upbringing presumably qualified him narrowly as a suitable companion for the growing Alick. The two would enact boyish dramas of Gregor's devising, in which cousin Gregor was Rob Roy Macgregor and Alick was the outlaw's faithful henchman Greumoch. It would not be the last time that Alick played apprentice to a fantastic Macgregor.

But he was being raised in a sect. By any usual standards he was a lonely single child, as likely to be found mooning around in the big garden at Redhill, imagining that the Lord had taken all of his family and he alone was left on earth, as to be playing with other youngsters. He was not surrounded by anything remotely resembling a consensus of his peers until 1883, when he was sent

away to a private preparatory school run by a family of strict Evangelicals – but not Plymouth Brethren – at St Leonards, fifty miles distant on the East Sussex coast. Edward Crowley prepared his eight-year-old son for this introduction to the sins and temptations of the world outside the sect by carefully reading him Genesis, Chapter Nine. In those verses Noah, having survived the flood, plants a vineyard and proceeds to get drunk on the produce. In his intoxication Noah then loses his clothes. Luckily his three sons, Ham, Shem and Japheth, spot their father's difficulties, and Shem and Japheth edge backwards into his tent carrying between them a cloak, with which they manage to cover Noah without once having to look at his naked body. 'Never,' concluded Edward Crowley to his son, 'let anyone touch you there.'

So began an intermittently miserable twelve years of institutional schooling. Alick Crowley was quite unprepared for such a life. He was a plump child, running to fat, with chubby cheeks and a young girl's breasts. He had a sunny, unsuspicious disposition. He knew few boys' games and fewer tricks. He had previously inhabited a world of lonely fantasy ruled over by a God-like father. He was versed in the social requirements of a religious sect, and little else. He was entirely vulnerable, and he was consequently, inevitably, bullied.

The bullying rarely stopped; it followed him from one establishment to the next, and he was never able to forget. Forty years after he first entered the Habershons' Preparatory School at St Leonards, Aleister Crowley wrote (or rather, dictated): 'I had been the butt of every bully at school, I had suffered the agonies of feeling myself a coward and a weakling. My whole life seemed at times to be one vast and slimy subterfuge to cozen death.'

There were only brief periods of respite; a few short interludes of comparative happiness. After two years at St Leonards, when he was ten years old, Alick was moved from St Leonards to the Plymouth Brethren's Preparatory School at Cambridge (possibly because the elder Mr Habershon had died, shortly after the desolated Alick had prayed for his demise: early proof, which he was happy to accept, of the power of the will; possibly because of his obvious

discontentment; and possibly because it was time for his education to progress beyond a three-teacher private prep school staffed entirely by one old man and his two sons).

This new establishment was run in a converted Cambridge town house by a retired clergyman named H. d'Arcy Champney, who turned out to be not much of an improvement on the deceased Mr Habershon. Alick had decided that the best way to order his life in the wider world was to mimic his father in every way: to become 'big, strong, hearty', eloquent and deeply religious. Size, strength, heartiness and eloquence could not be learned, however, whereas religious conviction could. So he devoted himself to the scriptures, and was quickly rewarded by coming top of the class in Religious Knowledge, for which achievement he received (but never read) a copy of the eighteenth-century curate Gilbert White's celebrated study of *The Natural History and Antiquities of Selborne*.

There was some such prestige to be found here, among other scions of other Brethren, and all might have been well but for the fact that the Rev H. d'Arcy Champney MA was an unutterably dreadful teacher. Number 51 Bateman Street, Cambridge, rapidly became, for the ten-year-old Alick Crowley, 'hell on earth'.

In 1910, at the age of thirty-five, he wrote and had privately published an early autobiography, which he titled *The World's Tragedy*. A large section of the preface is devoted to his two years spent under the governance of H. d'Arcy Champney. It is the recollection in early middle-age of the distressed childhood of a pre-teenaged boy, and not all of it can therefore be considered as fact. It is impossible to substantiate now, for instance, whether or not Champney crossed out the names of the candidates on his General Election ballot paper and wrote instead: 'I vote for King Jesus'; although such a deed is entirely credible in a devoted Plymouth Brother of the 1880s.

But, fundamentally, even if all or most of his memoirs are discounted as unreliable, *The World's Tragedy* did confirm that Alick Crowley was deeply disturbed by the school in Bateman Street. Some of his grievances seem slight; some of Champney's educational theory would even excite sympathy in educationalists of

a century later. The boys were, for instance, allowed to play cricket but not to score runs, for fear of exciting 'the vice of emulation'. Crowley also objected to 'the scourings of Barnswell', or Cambridge slum children, being let into the school on Monday evenings to be fed and preached at, on the grounds that this deed of Christian charity spread proletarian parasites and infection among the paying pupils.

In other matters Champney must be deemed suspect. Twenty years on Crowley claimed that the headmaster had told his young self that he, Champney, had never made love to his wife – but used a 'coarser' term. Champney informed his charges that God had a special eye for what was done in darkness, and the teacher himself seems to have been particularly susceptible to the prattle of schoolboy informers, happily beating boys or banishing them to Coventry on ludicrous and unsubstantiated charges, following quasi-legal hearings which resembled – in their frequent appeals to the Lord's guidance – the jurisdiction of the Spanish Inquisition. Crowley himself claimed to have been given sixty lashes on the legs, and to have known a boy to get one hundred and twenty on the shoulders. The beatings came in fifteen-stroke sessions, interspersed with prayer. To eliminate the possibility of sexual excitement, they were never inflicted on the buttocks.

The Plymouth Brethren appear to have successfully imitated any other private college of their time. The life so lamented by Aleister Crowley two decades later was not unusual to an English preparatory school pupil in the 1880s. Indeed, it was arguably liberal: not all boys of that period got prayer breaks every fifteen strokes. But to the sensitive, imaginative Alick it was agonising. And his pain was amplified when he could least easily deal with it, by the most cruel of losses.

In May 1886, when Alick was not yet eleven years old and had been at Champney's School for less than a year, he was called back to Redhill in the middle of the summer term. He arrived at the big Surrey country house to find a prayer-meeting of Brethren taking place. The Saints were attempting to discover the will of the Lord in the vexing matter of Alick's father. Edward Crowley had been

diagnosed with cancer of the tongue. He had hastened to the best specialist in the land, Sir James Paget, who was in 1886 the vice-chancellor of London University and Queen Victoria's own 'surgeon-extraordinary'. Paget recommended an immediate operation. After some prayer the Brethren decided to reject Sir James Paget's advice and offers of assistance, and to choose instead for Edward Crowley a bizarre and short-lived treatment known as 'electro-homeopathy'.

There being no electro-homeopathist in north Surrey, the house at Redhill was sold and the Crowley family moved to Southampton. There, following a few short months of electro-homeopathy, Edward Crowley died in March 1887. On the night of his demise his eleven-year-old son, who was at school in Cambridge and still fully expected his father to recover, dreamed that Edward was dead. After his dream was confirmed in fact, Alick Crowley was never the same again.

In his own words, 'the change was radical'. Within the tight constraints of Alick Crowley's first eleven years of life, his father had been his cynosure. Alick had looked in all ways up at Edward. Nobody else in his short existence had compared with the large, witty, eloquent evangelist. Edward may not have been a leader to most other men, but he had been the only leader to Alick. His loss was irreparable.

It was compounded by the fact that his fatal illness had led Edward's family to desert the big house in Redhill with which Alick associated so much pre-school childhood bliss, and by the unfortunate truth that Alick disliked his mother as much as he had adored his father. It is difficult not to diagnose here a deliberate slanting of the scales, an almost purposeful need on the part of the snobbish boy and the disaffected young man to make the low-born Emily Bertha Crowley as unworthy as the affluent Edward Crowley had been saintly. In describing their relationship his language was bitter and intemperate: he not only disliked but 'despised' his mother: 'There was a physical repulsion, and an intellectual and social scorn. He treated her almost as a servant . . . She always antagonised him.'

Emily Bertha could have done no right by Alick Crowley, and the child's interpretation of what she did do must be seen in that light. But what she did do brought teenaged curses raining on her head.

The widow found herself alienated both from Edward's family, who had never reconciled themselves to his beliefs, and from Edward's friends in the Brethren, who saw no point in continuing to visit Emily Bertha. So she moved once more, from Southampton up to Streatham in London, in order to be close to her brother, an evangelical civil servant named Tom Bond Bishop who lived in South Kensington.

In the meantime, Alick was creating havoc back at Bateman Street. He almost instantly got into hot water with Champney. His punishment was sympathetically reduced due to his bereavement; but he then offended again . . . and again. He had progressed from being a troubled boy to being a troublesome one. His childish fears and dismay had given way to obstinate rebellion, which finally found a suitably horrifying subject in the eleven-year-old Alick's determined pursuit of masturbation. He vaguely knew what this was; he crucially understood that the deed was guaranteed to outrage H. d'Arcy Champney; and so he sought advice from another boy. This youth told him of the necessary action to take, but failed to identify the appropriate organ. Despite 'mysterious hints' from his school chum, Alick omitted to link, as it were, appendage with act; and consequently failed to achieve his diabolical goal. But whatever he was stroking, the thought was there.

When, in this newly independent frame of mind, he discovered that he was expected to spend his holidays in the company of Tom Bond Bishop – perhaps even expected to regard his mother's brother as his surrogate father – Alick's disaffection was complete.

It is difficult to judge whether or not he decided to hate Tom Bond Bishop even more than he hated his mother: it was a close-run thing. One of Alick's complaints about Emily Bertha had been that she was more dogmatic than her husband. She objected, for instance, to the boy reading novels on the Sabbath, whereas Edward Crowley had allowed it. Now Alick was to discover that Tom Bond Bishop shared all of his sister's anathemas, and had a few of his own besides. In

place of the humane and commonsensical Edward, there was suddenly a man whom Alick considered to be 'mentally and morally lower than the cattle of the fields'.

Tom Bond Bishop was – like the Habershons of St Leonards – a member of the Evangelical branch of the Church of England, which is to say that he was extremely low church and noncomformist, sharing very many attitudes with the Plymouth Brethren, but that he had decided to stay within the established Church of England in the hope of swaying it to his point of view. When Alick's mother moved to London he had already founded the church's Children's Scripture Union and Children's Special Service Mission, from which it may be inferred that Tom Bond Bishop considered himself an authority on the development of young souls.

He failed, however, to convince Alick Crowley. Alick hinted at this in his memoirs, where he described Tom Bishop as having 'the meanness and cruelty of a eunuch . . . perfidious and hypocritical . . . unctuous . . . odious . . . in feature resembling a shaven ape, in figure a dislocated dachshund . . . no more cruel fanatic, no meaner villain, ever walked this earth . . . a ruthless, petty tyrant.'

It is possible that Uncle Tom was not that bad. He had certainly a repetitive, predictable line in jokes – whenever Alick addressed him as uncle, Tom would snigger out the same quotation from *Hamlet*: 'Oh my prophetic soul, my uncle!' A conversational tick which would have driven to violence a more tolerant youth than Alick Crowley. And it does seem likely that he would have destroyed his mother's – Alick's 'extremely lovable' maternal grandmother's – one vice, the game of bezique, by his evangelical refusal to allow playing cards in the house, had another of Grandmother Bishop's daughters not ingeniously circumnavigated the problem by creating a permissable pack of cards decorated with roses, violets and other flowers instead of hearts, diamonds, clubs and spades. But, as with the school at Cambridge, the picture which emerges a century later of Tom Bishop's back-street terrace off Old Brompton Road is of a fairly commonplace establishment: a nonconformist Victorian household, headed by a diligent, virtuous and rather silly professional gentleman, and staffed by a seemly gaggle of his

womenfolk. No more than Champney's school was it hell on earth. Like Champney's school, it merely seemed that way to a delicately raised and broken-hearted boy.

It would take a while for Alick Crowley to shake off Uncle Tom, but he was free of H. d'Arcy Champney within a year of his father's death. He attributed his removal from Bateman Street to a combination of his Uncles Tom and Jonathan, and the school's Monday evening gathering of the grateful poor.

His father's elder brother Jonathan Crowley was fortunately a rich patrician who, while having little other interest in the raising of Edward's son, was fittingly shocked to hear from the boy during a visit to Cambridge that each week dozens of indigent children carried lice and disease into the midst of the young fee-payers. Uncle Jonathan confronted Champney, told him that the practice must end, and then promised Alick that he could leave for a proper public school the instant he had passed the appropriate examination.

Shortly after his twelfth birthday Alick proceeded to fall ill during the holidays, and told his mother that it was due to his having been sent to Coventry by Champney. For a term and a half, he claimed, he had been permitted to talk to no other boy at the Plymouth Brethren's School, no other boy had spoken to him, and the masters had addressed him only 'with sanctimonious horror'. This was the headmaster's punishment for some offence which Alick could not remember committing.

H. d'Arcy Champney was summoned to Tom Bishop's house in Kensington for an inquisition which was compromised by Tom's fastidious refusal to hear the grimy details of the charges against Alick. Uncle Tom then followed young Alick back to Cambridge, where he finally swallowed his distaste and heard Champney's accusations. These were that when he was eleven years old (and, we may recall, unable to link his penis with the masturbatory function) Alick had 'corrupted' another boy. He had also 'held a mock prayer meeting', and called another child a 'pharisee'. There was some truth in the second two charges, but Uncle Tom – that 'odious, cruel fanatic' – decided that H. d'Arcy Champney was insane, and carried his nephew once and for all away from the doomed school at

Bateman Street and back to the bosom of his mother and family in south London.

Predictably, Alick did not instantly regain complete good health. He claimed to have been diagnosed with the kidney condition albuminuria by a doctor who suggested (to whom?) that he would never see the age of twenty-one, and therefore never come into his comfortable inheritance. A series of private tutors were engaged, a regime of fresh air and exercise was prescribed, and Alick Crowley spent his early teens touring the mountains, fishing streams and golf courses of rural Great Britain.

He had revolted against school and family since his father's death: he was duty-bound to complete the set by spurning his religion. It was not difficult for a sceptical, intelligent boy to reject the doctrines of the Plymouth Brethren, particularly as he now saw them embodied in the persons of an unpopular mother and uncle, and especially because such a youth grew increasingly to perceive the Brethren as having directed his sick father away from the attentions of the best surgeon in the land, and towards a form of quackery which had led Edward Crowley to a speedy death. When the apostasy came it was guaranteed to be as immoderate as the original faith. The scales had a violent swing to make.

Alick was enrolled at a day school in Streatham, which he attended only intermittently, but where he finally discovered the secrets of masturbation and 'applied myself with characteristic vigour to its practice'. When Tom Bishop wrote an article for the *Boy's Magazine* titled 'The Two Wicked Kings', which warned young readers to avoid the tyrannies of 'Smo-King' and 'Drin-King', Alick dutifully informed his uncle that he had omitted the third and most dangerous autocrat of them all: His Royal Highness Wan.

Ridicule of his uncle in South Kensington was accompanied by detestation of his mother's household in Streatham. There he was

still not allowed to mix with any children other than the offspring of Plymouth Brethren. This was made even more restrictive and complicated by the increasing number of schisms and splits in the brotherhood. Emily Bertha Crowley was still devoted to the Exclusive Brethren and, in the late 1880s, that sect was made more exclusive still by a massive disruption within the movement.

(The tremors which caused the division originated in the Highland seaport of Oban, where the Plymouth Brethren communion was taken by three members of the same family. This family, the Camerons, argued over an almost imperceptible difference of interpretation between two versions of the same Biblical text. As a quorum of Plymouth Brethren was two or more – 'Wheresoever two or three are gathered together in my name . . .' – the difference left one of them inquorate, and consequently without communion. The failure of London HQ to resolve the matter convincingly led to the opening of a seismic fault throughout the entire length of the brotherhood, from Oban to Plymouth.)

Emily Crowley's – and therefore Alick's – already restricted social circle was reduced even further by this division. As well as limiting Alick's friendships, Emily diminished that traditional refuge of the lonely single child: his reading material. Less liberal than her dead husband, and virtually unread herself, she wielded a shaky censor's hand. The hearty adventure novels of R.M. Ballantyne continued to be permitted; G.A. Henty's more blood-stained imperial efforts were given an uneasy nod. Some of Walter Scott's and Charles Dickens' produce was approved, some not – such as *David Copperfield*, apparently because it featured a naughty girl called Emily. A reading of *The Ancient Mariner* was cautiously received, until the lines about water-snakes ('Blue, glossy-green, and velvet black, / They coiled and swam;') threw her – 'a rather sensual type of woman' – into Freudian hysterics. Emile Zola's reputation had spread so far that, although he remained unread in the Crowley home, the very mention of his name caused maternal fury. Occasionally it was the subject rather than the telling of the story which caused offence. Alick had to read an obscure thriller called *The Mystery of a Hansom Cab* in the toilet because Emily

considered hansom cabs to be, literally, diabolical inventions.

There was a collected Shakespeare in the house at Streatham, but for the very reason that it was one of his mother's possessions, Alick refused to read it. Not until he discovered some old folio editions in a farmhouse on one of his lonely holidays in the Scottish Highlands did Crowley open the pages of Shakespeare.

Exactly when Alick Crowley lost his virginity is unclear, but for a late-Victorian public schoolboy, let alone a young Saint, it was unusually early in his teens. It may have been with a parlourmaid in Streatham who then tried to blackmail his family. It might have been with 'a village girl named Belle McKay' at Forsinard in the empty wilds of Sutherlandshire. Or it could have been, at the latest, when he was fifteen in the spring of 1891, when he was seduced by a young actress in Torquay.

Whether that girl took his virginity or simply showed him for the first time that sex could be a thing of 'joy and beauty' rather than a hurried, shameful scramble with parlourmaids, is not obvious from Crowley's own writings, and no other sources are available. Set beside the overall importance of that dalliance on the south coast, the detail is immaterial.

The visit to Torquay in 1891 was an altogether seminal trip. Alick had gone there with a new tutor, a former Bible Society missionary who had been approved by Uncle Tom. Luckily, the new man turned out to be from the liberal wing of the evangelical movement. His name was Archibald Douglas and, in short order, he introduced his new charge to racing, billiards, betting, cards and – remembered the adult Aleister – women. This teen-dream of a tutor also warned against excessive physical exercise and taught that alcohol and tobacco were natural products. Exactly how such a man came to be entrusted by Uncle Tom Bishop with the care of his nephew is unclear. Aleister would later suppose that Douglas had got the job

under false pretences: he was an Oxford graduate, with gentlemanly manners and an impressive accent, who had travelled in Persia for the Bible Society. Perhaps both jobs had been taken in financial desperation. Travelling across Persia, whosoever the sponsor, might have been a temptation to any adventurous young man of the Empire; but becoming the tutor of a troubled fifteen year old, with a wage packet paid by his austere and inflexible guardians, was hardly a plum ticket. Like many another Oxford graduate, Archibald Douglas probably needed the cash.

Whatever his motives, young Alick Crowley certainly appreciated his new instructor. The boy swung as ever from one extreme to the other. Black night became brightly shining day. Depression and despair turned into 'a period of boundless happiness'. With Douglas's kindly touch 'the nightmare world of Chistianity vanished at the dawn'.

Alick suffered from a bout of whooping cough in the spring of 1891. When he recovered, Archibald Douglas recommended that the two of them bicycle down from Streatham to Torquay for a holiday. It was an over-ambitious enterprise – they covered just thirty miles on two wheels before Alick could go no further – and they caught a train at Guildford for the remaining two hundred miles. This aborted exploit had one large compensation: it gave them a lot of time in Torquay. Within ten days at the seaside, Alick, under the indulgent gaze of his tutor, had fallen in with 'a girl of the theatre' who proceeded to demonstrate that sex was joyful rather than a 'detestable' and mysterious sin.

Alick never looked back. From that spring holiday on the Devon coast in 1891 can be dated Aleister Crowley's pre-Reichian conviction that sexual repression was responsible for many of the world's ills. He would write:

> As long as sexual relations are complicated by religious, social and financial considerations so long will they cause all kinds of cowardly, dishonourable and disgusting behaviour . . . Men and women will never behave worthily as long as current morality

> interferes with the legitimate satisfaction of
> physiological needs. Nature always avenges herself on
> those who insult her.

His commonplace equation of sexual hunger with the daily desire for food would fail to take into account the complicating psychological factors involved in the former.

Sexual inhibitions flew out of the window, closely followed by the last tattered remnants of young Alick Crowley's Christianity. Once more he, perfectly understandably, careered from pole to pole. John Milton's *Paradise Lost* had sat beside that untouched collection of the works of Shakespeare on his mother's shelf. Alick had always relished *Paradise Lost* for its vivid anti-hero, Satan. Now Milton's Satan joined the Beast and the Whore of Bablyon from his favoured Book of Revelations as iconic boyhood figures. ('You *are* the Beast,' he would later claim that a horrified Emily Bertha spat at her teenaged son, her drawled west country consonants curdled with bitterness, when the mother discovered her demon seed's genuine fascination with the Antichrist.) Such figures pleased him aesthetically. They had artistic balance. They had depth. They were *interesting*. Satan was, after all, detached from bourgeois Victorian society. Satan was *separate*. Satan was an outsider.

These preoccupations coupled with Alick's clearly improving health and an unfortunate accident on 5 November 1891 when he blew up the playground at his Streatham day school by burying two pounds of gunpowder, sugar and chlorate of potash in the earth, fixing a rocket on top of the mixture, and applying a match. The result was that windows were smashed all around, and his health consequently received a setback: the bandages were not removed from his face for fifty days and it led Uncle Jonathan Crowley to suggest that the time was right for Alick to resume his public-school education.

Malvern College was elected as the fortunate institution. Before the start of the autumn term, 1892, Emily Bertha Crowley took her son on what would prove to be, after the jaunt to Torquay, the most seminal holiday of his young life.

———

The two of them ventured to the far north-west of Scotland, to stay at the Sligachan Hotel on the island of Skye. This was, even in the Highlands, an isolated spot. Situated halfway up the island, between the population centres of north and south, Sligachan stood alone at the head of a long and gloomy sea loch, beneath the ragged black peaks of the Cuillin mountain range.

Emily Bertha probably chose Sligachan because of its very isolation (less temptation to a growing boy) and the invigorating properties of its mountain air. Others had already adopted the hotel, however, for different reasons. Sligachan was already the most celebrated climbers' hotel in the most famous sub-Alpine mountaineering region of Britain.

When he arrived, Alick knew nothing of climbing. Before he left, he was a devotee. He could hardly have stumbled upon a better place and into more auspicious company. The summer of 1892 was a busy one at the Sligachan Hotel. During the previous six years the celebrated Professor Norman Collie had 'discovered' and pioneered many of the Cuillin routes and climbs. A succession of articles had appeared in the climbing press which praised the Cuillins as an irresistible combination of *terra virga*, Celtic twilight and comfortable accessibility from the south by virtue of the new railway to Kyle of Lochalsh. The professional classes, wedded to their new sport, flocked to the gaunt Victorian pile at the head of Loch Sligachan.

The Crowleys arrived to find the surgeon, and celebrated creator of antiseptic operations, Sir Joseph Lister in residence. Alick prattled away to the great man about hill walking. Baron Lister pointed out a group of climbers, and suggested that they take the sixteen-year-old with them up Sgurr nan Gillean [the Young Man's Peak], by way of the Pinnacle Ridge, on the following day.

In an edition of the *Scottish Mountaineering Club Journal* which appeared a year later, there is an account of a group ascent of Sgurr nan Gillean in April 1892. It is unlikely to be the self-same ascent which introduced Alick Crowley to mountaineering (although the coincidence is not impossible), but it will do. It took place on the same slopes, at the same time, and in similar – if not identical –

conditions and circumstances. In the absence of a personal testimony, it will serve perfectly well as an account of the first climb of Aleister Crowley, who was to become the most unorthodox, possibly the most unpopular, certainly the most controversial, and arguably the most successful British mountaineer of the Edwardian era.

Like the Crowleys, the author of that climb to the summit of Sgurr nan Gillean, J.H. Gibson, checked into the Sligachan Hotel in April 1892. Gibson arrived with two friends, and was later joined by a third.

It was noon on the day after their arrival on Skye before the party set off: a late start 'that may be attributed to the air of the West Highlands, or to our own natural slothfulness', and which says much about the casual, happy-go-lucky amateurism of Victorian climbing. They walked up the track behind the hotel to mount the jagged ridge which loomed – 'like the Ride of the Valkyries frozen in stone', as another Victorian put it – directly over the building.

'The route we were following up the mountain is known as "the pinnacle route",' recorded Gibson, 'from the five pinnacles of which this north ridge consists, the last pinnacle being the top of Sgurr nan Gillean itself.'

It was effectively a dragon's-tooth ridge which climbed erratically for about a mile from north to south, to the 3,167-foot summit of Sgurr nan Gillean. Much of it was nothing more than a stiff walk, but:

> there is a steep drop between the third and the fourth
> or Knight's pinnacle, and another between the fourth
> and fifth, and for these drops it is advisable to put on
> the rope, but the rocks are everywhere firm and good,
> and the climb is one of the most interesting in Skye.
> Eventually the summit of our peak was reached about
> half past three.

Alick Crowley returned to his mother at the Sligachan Hotel following, we may presume, his three- to four-hour ascent and two-

hour descent, a converted young man. It had not been a dangerous introduction to the sport, but the Pinnacle Ridge was clearly a step up from hillwalking. 'I found myself up against it,' he recalled, 'and realised at once that there was something more to be done than scrambling.'

Whatever release from the everyday was offered by climbing to this confused young man, it would be a further year before he could fully experience it again – and by then its catharsis was needed. For in the autumn term of 1892 Alick Crowley was sent to resume his full-time public-school education at Malvern College.

He hated it and, given that he had in the intervening years enjoyed some sort of freedom, he was made even more unhappy by Malvern than he had been by H. d'Arcy Champney's establishment in Cambridge. There is a photograph of Alick Crowley taken at about this time. It is an appealing shot of a teenager in a tight-fitting worsted suit and a school cap clamped to the back of his head. The fully buttoned waistcoat strains to contain an incipient belly. His chubby, rounded face makes him look younger than his years, as do the arms awkwardly gangling at his side, and his nervous, scared-to-be-friendly expression. His face and his attitude would instantly be recognisable to his peers at late-Victorian public schools as those of a bullied child. Even before the camera, he has a frightened smile.

This was the 'shy, solitary' boy who went up to Huntingdon's House at Malvern College in 1892, to find a place where 'bullying went on unchecked, the prefects being foremost offenders'.

Uncle Jonathan had chosen Malvern as much for its athletic record as anything else, but Alick Crowley neither enjoyed nor was good at any sport other than the one discovered in the Cuillins that summer – and mountaineering was not a term-time public-school recreation. So he paid the penalty for being unsporty in a sporty school. At Malvern that penalty included – as well as the normal routine of physical brutality and dedicated persecution – being 'greased': an especially unwholesome boyish prank which involved spitting copiously upon someone's face.

His misery was intensified by friendlessness, and remained unalleviated by academic achievement. He had the ability to excel at

lessons, but, unsurprisingly, lacked the will. Alick was quickly removed from Malvern after he spun his mother a series of lurid tales about sexual activity there (he was never slow to exploit for his own ends her despised puritanism, but he did have some kind of a case: his study-mate had added to his pocket money by serving as 'the tart of the house') and he was sent to Tonbridge.

Sexual behaviour at Tonbridge was not much different to Malvern, but it was a change. This merry-go-round of minor educational establishments was perfectly common among the late-Victorian and Edwardian bourgeoisie. The prosperity and prevailing ethos of the time insisted that their male children both could and should be classically educated by private tutors or at public schools. Too often, of course, those schools and tutors proved to be sources of indescribable distress, in which case they were quickly and – usually – uncomplainingly switched. Alick Crowley's pre-university orbit through five schools and at least four tutors was by no means a record.

Naturally, he did not last long at Tonbridge either. His constitution's practised response to periods of deep unhappiness soon asserted itself, and he fell ill once more. It was only then decided, in his nineteenth year, that Alick Crowley was 'unsuited' to life at boarding-school. His mother could plainly not bear the notion of having her troublesome son permanently at home, and so he was shipped out to live with another tutor, a Plymouth Brother named Lambert. In the day Alick studied at Eastbourne College, and at night he went home to Lambert.

The day school at Eastbourne did not change him. He was still a singular boy, without friends, spurning games and all physical recreation other than the mountain climbing which he pursued ardently in the Lake District and Wales during the school holidays, and at nearby Beachy Head in term-time. His academic work improved only marginally.

There was one seminal moment at Eastbourne. In a classically thrawn piece of early Crowley behaviour, when his brilliance at chess resulted in young Alick being offered a chess column in the *Eastbourne Gazette,* he celebrated by criticising in print the town's

chess team, of which he was a member, for inadequate study of the game and lack of practice. This was followed by the weekly printed scourge of a colleague whom Crowley accused of nervously avoiding fixtures with the *Gazette*'s chess columnist. When his team-mates objected he refused to retract or apologise. He had acted, he insisted, from the best of motives: to urge the team to improve itself and become the best in England; and to get local chess matches played. He could not understand the other members' irrational fury at being publicly pilloried. In the course of a long and eventful life, Aleister Crowley would affect never to understand those who were offended by his logical, consistent, straightforward behaviour.

He found his escape from all of this misunderstanding and unpleasantness a couple of miles south of Eastbourne, on the towering chalk cliffs of Beachy Head. Those rock faces, soft and sticky in rain and suffocatingly dusty in the heat, had largely been spurned by accomplished climbers. Alick Crowley, often in the company of his cousin and childhood friend Gregor Grant, scaled them one after the other, carefully logging each new conquest of a pinnacle, a crack, or a chimney, and announcing his achievements in the *Scottish Mountaineering Club Journal* and in letters to such climbing luminaries as Albert Frederick Mummery.

If Beachy Head was his climbing nursery, the rock faces around Pen y Gwryd and Pen y Pass in Snowdonia, and Wastdale Head in Cumbria – both districts being, along with the Skye Cuillins, growth areas for the new late-Victorian sport of mountaineering – developed Alick Crowley into a climbing prodigy. The years 1882 to 1903 have been described by a historian of the sport as 'English rock-climbing's golden age'. To mountaineers the world was still young and full of unexplored land. There were peaks to be conquered and new routes to be blazed on every mountain range on earth. Alick Crowley found them irresistible. Between 1892 and the end of the century he claimed, while still in his teens and early twenties, three new routes up Beachy Head, one in Wales, and one in the Lake District. He claimed them arrogantly and occasionally with insult to his fellow climbers, of course, and so they were dogged by controversy. But his claims were not refuted.

———

In 1894, when he was eighteen, Alick was permitted his first visit to the legendary Alpine peaks. With his tutor as chaperon, he travelled to the Austrian Tyrol, engaged a guide, and swaggered about the rocks. Shortly after returning to Eastbourne he outraged the Lambert family by offering – at breakfast – a full and frank criticism of all of their shortcomings. Uncle Tom arrived once more to remove his nephew. Alick went off to spend the summer of 1895 in the Bernese Oberland. He was called back home to take the Cambridge University Entrance Examination, which he passed. At the start of the autumn term of 1895 he entered Trinity College, Cambridge. His subject was to be Moral Science. For all his protestations, Alick Crowley had, at the age of nineteen, not yet escaped entirely from the Plymouth Brethren.

3

Salad Days

*Till the Great Gate of Trinity opened me the way to freedom I
had always been obsessed more or less either by physical
weakness or the incubus of adolescence.*

– Aleister Crowley

One of his earliest deeds at Cambridge University was to change his
name. Throughout the rest of his life, in a psychologically curious
effort to escape from his family identity, Crowley would adopt a
variety of *noms de guerre*. Most of these – such as the Laird of
Boleskine and Abertarff and Count Vladimir Svareff – were just too
exotic and implausible for everyday use. He required a home base, a
name to which he could safely revert, a name into which Count
Svareff could retreat after his adventures, a name which the
university authorities, publishers, new-found friends and,
eventually, the courts of law, would recognise.

 Edward Alexander Crowley clearly would not do. Edward, his
father's name, had never been his, and he disliked the diminutives
of Ted and Ned. Since boyhood he had been known by the
shortened version of Alexander: Alick. This he detested for the
obvious reason that his mother used it. Alexander was too clumsy,

and the other common derivative, Sandy, smacked of a Scottish ploughman. He had read that the most memorable type of name was cinquesyllabic – three syllables followed by two, in poetic rhythm. His family surname already suited the second half of that requirement. In search of a three-syllabled forename, he was informed – wrongly – by cousin Gregor that Alaister was the correct spelling of the Scottish Gaelic form of Alexander. (The proper Gaelic version, which should employ a soft 'd' in place of the 't', and a drawn-out final syllable, was actually considered and rejected as a bad dactyl.) He disliked the 'ai' sound, and replaced it with 'ei'. Aleister Crowley he became, and remained.

He did, he would extravagantly claim, precisely one day of academic work during his entire three years at Cambridge University. It was little surprise that he left without a degree. Free at last to indulge himself as he desired, Aleister Crowley was not the first or the last student from a constrained background to wallow undisciplined in the comparative liberty of student life. He read thoroughly and avidly, relishing his escape from the censored bookshelves of Streatham, but his university days were unmarred by scholastic attainment. They were marked by other consummations.

Crowley never forgot, and remained wholly grateful for, the forbearance of Cambridge University. He would write:

> It seems to me no mere accident that Cambridge was able to tolerate Milton, Byron, Tennyson and myself without turning a hair, while Oxford inevitably excreted Shelley and Swinburne . . . I remember only too well the wave of sympathy which swept through Cambridge at the news that the Oxford authorities, panic-stricken at some projected demonstration, had actually imported mounted police from London. Our own dons would have cut their throats rather than do anything so disgraceful . . .

Much of the latitude allowed was sexual. Aleister Crowley had never looked back since his teenaged deflowering. Women liked and were

frequently attracted to Crowley, a blessing which he was to exploit for the whole of his life and, at Cambridge, for the first time free from chaperones, an adult with his own St John's Street lodgings, he made hay. 'Cambridge is, of course, an ideal place for a boy in my situation. Prostitution' – with which Aleister had already acquainted himself, at the expense of at least one mild bout of venereal disease – 'is to all intents and purposes non-existent, but nearly all the younger women of the district are eager to co-operate in the proper spirit.'

Crowley's university career was – initially, at least – an understandable marriage of the orthodox and the bizarre. On the one hand, he was not yet so far free of his mother and Uncle Tom Bishop that he could relinquish all intentions of a respectable vocation. Early in his academic life he planned a career in the diplomatic service. The possibility of Aleister Crowley becoming ambassador to Washington, Berlin or St Petersburg was not, entirely, a ridiculous one. A sinecure in the diplomatic corps was famously available to those products of Oxford and Cambridge whose university careers had fallen short of the higher reaches of academic achievement. Young Aleister liked the idea of travel ('home was my idea of hell'); was thoroughly entranced by the exotic prospect of sexual intrigue in distant capital cities; and positively doted on the notion of espionage, and adored the idea of false titles and officially sanctioned double-dealing. Had things gone otherwise, he might have made a perfectly passable representative to Lima or Bangkok. Many a less suitable candidate has decomposed beneath a banyan tree. In preparation, he took himself to Russia during one long vacation. In St Petersburg he planned to study Russian for the civil service entrance examination. He failed dismally. The acquisition of foreign languages was, after all, another academic discipline, and Aleister Crowley was on the run from discipline. He proved to be as poor a student of the tongue of Tolstoy as he was of the intricacies of the course which supposedly led to success in the Moral Science tripos.

So he reverted to poetry, chess and climbing. His poetry was dreadful, and would always be dreadful. He had dabbled in verse

since he was able to hold a pen. As a seventeen-year-old, Alick had chosen the venerable Liberal prime minister William Gladstone as the unwitting subject of a typically embarrassing public schoolboy diatribe ('Thy deeds are seamier, my friend, Thy record blacker now. Your age and sex forbid, old man, I need not tell you how, Or else I'd knock you down, old man . . .). The most notable and unusual thing about *Lines On Being Invited To Meet The Premier In Wales, September 1892* is that Crowley's verse rarely, throughout the remaining fifty-five years of his life, got any better. Poetry played a huge part in his ambitions and pretensions thoughout his career 'of which fact the reader must be forewarned, and against which prospect steeled'. But that did not and does not mean that he was ever any good at it. And, incidentally, he never did meet William Gladstone at Hawarden in September 1892. Although the Grand Old Man had a narrow escape: he actually was in Wales during that month, the Crowley family did receive a vague invitation through a shared family friend, but the Prime Minister was cheerfully bedridden after colliding with a cow.

The proprietor of a local pub took the same view of Gladstone's policies as did seventeen-year-old Alick Crowley. He stuck the cow's head above his bar and apostrophised it as the beast which tried to save Ireland from Home Rule.

(Perhaps the second most interesting point about *Lines* . . . is that Alick's knee-jerk political reaction to Gladstone's Irish Home Rule policy [the 'black record' of the verse: a tediously commonplace attitude of the late-Victorian bourgeoisie] was so dramatically to correct itself in his adulthood. By which time William Gladstone, even had his ears reddened slightly in the September of 1892, was past caring; but his successors in the Foreign Office took note.)

Luckily Aleister's chess was much better than his poetry, and his climbing skills were superior to either of them. He twice played in the university chess team, and won a half-blue. Every holiday trip to the Lake District or the Alps honed his mountaineering flair, and there were many such expeditions. In the summer of 1896, his first at Trinity College, he went to the Bernese Oberland with Morris Travers, a celebrated chemist of University College, London, and a

climbing associate as well as a chemical protégé of the great Norman Collie. The twenty-four-year-old Travers (a man of considerable attraction to his female students, which certainly helped in his gaining Aleister's respect) and the twenty-year-old Crowley claimed the first guideless traverse of the Monch and the Vuibez Seracs, and the first traverse in any form of all the pinnacles on the Aiguilles Rouges. This was heady stuff from a couple of tiros. Crowley admired his companion's immense strength and courage – on one occasion Travers used his own body to form a human bridge across a crevasse, and allowed Aleister to stand with crampons on his shoulders for fully forty minutes, while cutting out fresh handholds. Travers and Crowley might have gone on to even greater things (and might perhaps have spared Aleister from the bitter harvest of another, later, association) had not the partnership been broken by the claims of Morris Travers' brilliant professional career – in the 1890s he discovered the substances of krypton, neon and xenon – and by his eventual posting to the Indian Institute of Science at Bangalore.

Back at Cambridge, a precedent was being set. Throughout his life, and after it, Aleister Crowley was an irresistible attraction to writers of fiction. A rough count has him starring – renamed, of course, and thinly disguised – in the work of at least ten novelists and authors of short stories. One of the most peculiar of these fictionalisations has a mysterious connection to his student days.

When Aleister arrived at Cambridge University in 1895, in King's College there was a thirty-three-year-old Dean named Montague Rhodes James. James had already begun experimenting with a literary form which would make him famous: the ghost story.

There is no evidence that M.R. James and Aleister Crowley ever met. Indeed, the likelihood is that they did not. Two men could hardly have been more different. James was a virginal academic

recluse who spent his entire life at Eton (as a schoolboy), Cambridge (as student, Fellow, Dean, Tutor and then Provost of King's), and then back at Eton again, also to the Provost's Lodge, where he died at the age of seventy-four. James was a devoted scholar who gained his King's College Fellowship with a scintillating dissertation on the Apocalypse of Peter, and who spent almost forty years at Cambridge cataloguing the university's entire manuscript collection.

On the other hand, the Dean of King's could well have had this recalcitrant student from a neighbouring college drawn to his attention. We may never know. What is certain is that in 1895, the year that Crowley arrived at Cambridge University, Montague Rhodes James published in a magazine two of the ghost stories which he had made a habit of inventing and then reading aloud to students and gatherings of his gentlemen friends.

Nine years later his first collection – *Ghost Stories of an Antiquary* – appeared in book form. Its successor, *More Ghost Stories of an Antiquary*, was published in 1911, and included a tale which was to become one of M.R. James's most famous works. The story 'Casting The Runes' features an unpleasant leading man named Karswell. This Karswell bears an uncanny likeness to the adult reputation of the student whose time at Cambridge had coincided with Dean James. Karswell – fiendishly enough, he has no christian name – had bought and lived in a disused Warwickshire abbey, leading him to be known locally as 'the Abbot of Lufford'. But Karswell was no ordinary holy man . . .

> Nobody knew what he did with himself: his servants were a horrible set of people; he had invented a new religion for himself, and practised no one could tell what appalling rites; he was very easily offended, and never forgave anybody: he had a dreadful face . . . he never did a kind action, and whatever influence he did exert was mischievous.

Karswell was best known in his locality of Lufford for an unkind trick on a group of village schoolchildren. He had written to the

local clergyman offering to show the youngsters magic-lantern slides. Once they were all sitting comfortably he started with a display of *Little Red Riding Hood*, in which his description of the wolf was so vivid that one or two of the younger infants began to bawl and had to be taken out. This was followed by depictions of a small boy being slowly dismembered in a park by 'a horrible hopping creature in white'; and the whole terrifying exhibition was brought to a close by a vivid slide of:

> snakes, centipedes and disgusting creatures with wings and somehow or other he made it seem as if they were climbing out of the picture and getting in among the audience; and this was accompanied by a sort of dry rustling noise which sent the children nearly mad. That would teach the brats to trespass on Karswell's estate.

It *sounds* like the Beast. There is no mention of Crowley in James's notes, although an unpublished manuscript passage refers to Karswell as an apostate Roman Catholic, 'thirsting I believe for recognition by the literary and scientific world'. M.R. James's anthologiser Michael Cox did not believe that James could have based Karswell on Crowley, because Aleister 'did not come to wide public prominence as "the wickedest man in the world" until the 1920s' (and 'Casting The Runes' was published in 1911). But, as we shall see, Aleister Crowley was infamous enough in 1909, 1910 and 1911. The seeds of his glorious reputation had, by then, begun to flower. There is no reason why an observant man such as M.R. James should not, in 1911, have heard of this weird and wonderful and distinctly menacing alumnus of his beloved Cambridge University. And every reason why, having heard of this ghastly figure, James should then take the trouble to include him – and give him a suitably sticky end – in an Edwardian ghost story.

Karswell probably is Aleister Crowley. The very name is similar, and the lines about new religions and 'appalling rites' are too close for coincidence. And James, in offering Crowley a fictional life, was

equally probably aware of their shared university background. Karswell is almost certainly drawn, however, not from M.R. James's recollections of a student in the mid-1890s, but from his reading about Crowley's activities fifteen years later, and from common-room gossip about the deeds of the former scholar of Moral Science at Trinity.

In one aspect, 'Casting The Runes' is truly, spookily inexplicable. James's depiction of Karswell/Crowley as the head of a new religion who had moved into a deserted abbey and blasphemously adopted the title of Abbot rang a carillon of bells with a number of later readers who were familiar enough with the broad outline of Crowley's career, but unfamiliar with its precise details and dates. In fact, while by 1911 Aleister Crowley was unashamedly announcing himself as the head of a new millennial religion, he did not become the Abbot of Thelema until 1920 – *nine whole years after the publication of M.R. James's short story*. Montague Rhodes James always said that he was agnostic about the supernatural – 'I am prepared to consider evidence and accept it if it satisfies me'. In his own prescient portrait of Karswell/Crowley as the head of a ruined priory, James had either furnished for himself the proof that he demanded, or had simply, after subconsciously pondering on his leading character, unwittingly offered a remarkable example of a common artistic phenomenon – literary clairvoyance. While Aleister Crowley would certainly have claimed the former, there is no good reason to deny the latter explanation.

In 1898, his last year at university, Aleister Crowley made two significant friendships, and took two long steps towards his vocation. He published his first written works, and he met magic. The first friendship first: at Easter he took himself climbing once more to the mountaineers' rendezvous at Wastdale Head in Cumberland. There he encountered a driven, argumentative thirty-nine-year-old mathematician who took one look at Crowley and recognised the protégé of his dreams.

There was, and there still is in climbing circles, some dispute about the true qualities of Oscar Eckenstein. Perpetually and doggedly at war with the chaps of the Alpine Club, the log-rolling

rulers of the game, Eckenstein was not a clubbable fellow. He had a thick black beard, deep-set eyes, the appearance of a penny-sheet anarchist and the glare of a prophet. He thought, and he said aloud, that the Alpine Club was a retreat for self-advertising quacks who could barely climb a ladder without a guide. This may have contained some truth, but it did not endear Eckenstein to mountaineering's legislators, and as a result his accomplishments – such as the invention of a new and considerably improved type of crampon – went largely unrecognised by many of his peers.

But Aleister Crowley was never in any doubt about the genius of Oscar Eckenstein. 'Provided he could get three fingers,' wrote Aleister to a friend many years later, 'on something that could be described by a man [Eckenstein] far advanced in hashish as a ledge, would be smoking his pipe on that ledge a few seconds later, and none of us could tell how he had done it.'

Aleister threw himself at this master's feet. Together they ascended a couple of lakeland hills that Easter, and parted with the promise to meet again, and even to plan a Himalayan expedition. In his 1922 novel *Diary of a Drug Fiend* Crowley has his own fictional *alter ego* declare:

> The greatest mountaineer of his generation, as you know, was the late Oscar Eckenstein . . .
>
> I had the great good fortune to be adopted by this man; he taught me how to climb; in particular, how to glissade. He made me start down the slope from all kinds of complicated positions; head first and so on; and I had to let myself slide without attempting to save myself until he gave the word, and then I had to recover myself and finish, either sitting or standing, as he chose, to swerve or to stop; while he counted five. And he gave me progressively dangerous exercises. Of course, this sounds all rather obvious, but as a matter of fact, he was the only man who had learnt and who taught to glissade in this thorough way.

In teaching Crowley to glissade, Eckenstein was, probably intentionally, doing his young disciple a greater favour than Aleister realised. Crowley was acquiring renown in climbing circles not only for his pioneering minor ascents, but also for his recklessness. Naturally, he made a virtue of this, insisting that it was not himself who was headstrong but his olders and betters who were over-cautious. But he got himself into awkward situations. 'He was a fine climber, if an unconventional one,' was the judgement of one of the indisputably great mountaineers of his day, his exact contemporary Tom George Longstaff, after Longstaff had watched Crowley ascend an Alpine ice fall 'just for a promenade – probably the first and perhaps the only time this mad, dangerous and difficult route had been taken.' Mad, dangerous and difficult: Longstaff understood his acquaintance's ambitions better than he knew. On the mountains therefore, as Aleister would testify, Eckenstein's lessons proved useful . . .

> The acquired power, however, stood me in very good stead on many occasions. To save an hour may sometimes mean to save one's life, and we could plunge down dangerous slopes where (for example) one might find oneself on a patch of ice when going at high speed if one were not certain of being able to stop in an instant when the peril were perceived. We could descend perhaps three thousand feet in ten minutes where people without that training would have had to go down step by step on a rope, and perhaps found themselves benighted in a hurricane in consequence.

Oscar Eckenstein would join that tiny pantheon of acquaintances whom Aleister Crowley could never bring himself to insult or even to criticise. On the high hills, he insisted, the two were uncannily complementary, despite the fact that:

> it is impossible to imagine two methods more opposed. His climbing was invariably clean, orderly

and intelligible; mine can hardly be described as human . . . Owing doubtless to my early ill-health, I never developed physical strength; but I was very light, and possessed elasticity and balance to an extraordinary degree.

If Eckenstein would be forever beyond reproach, the same could not be said of his second important new friend.

In the autumn of 1897 an eighteen-year-old product of Eton College named Gerald Festus Kelly had entered Trinity Hall. Kelly, a sickly youth of under five and a half feet in height, had spent the previous winter convalescing in South Africa. The spoiled son of a Camberwell vicar and a Kentish mother, both of Irish descent, Kelly carried two parentally encouraged hobbies to Cambridge, where he studied politics. One was the watching of cricket, and the other – inspired by a visit to Dulwich College Picture Gallery – was painting watercolours.

Kelly was a charming, petulant, talented, witty and tactless young man, and when he and Aleister Crowley met in the early summer of 1898, they got along wonderfully. The subsequent career of Gerald Festus Kelly illustrates beautifully the life which was available to Aleister Crowley, and which he rejected. Kelly and Crowley would share many things, including a riotously misspent youth, the occasional bed, and a relationship through marriage, but in middle-age their lives dramatically diverged. While Aleister Crowley sacrificed all to his beliefs and his art, his college chum became a pillar of the establishment. In 1922 Gerald Kelly the portrait artist became an associate of the Royal Academy. In 1938 this draughtsman – who had dallied, womanised, drunk, seen the sun rise over Paris, dabbled in magic, and been 'very intimate' with 'the wickedest man in the world' – was commissioned to paint the state

portraits of King George VI and Queen Elizabeth. With World War Two raging, Kelly worked up these likenesses at Windsor Castle, and in 1945, with both the war and the portraits finished, they were exhibited at the Royal Academy and Aleister Crowley's erstwhile friend and brother-in-law became Sir Gerald Festus Kelly. After Crowley's death the honours rained down on Kelly (including, which would have irked Aleister thoroughly, an Honorary Doctorate of Laws at Cambridge University in 1950), and he died in his bed in Gloucester Place at the age of ninety-five in 1972 as one of the most respected and respectable figures of his age. God and Aleister Crowley alone know what secrets he took with him to his grave. Crowley had, in fact, long given up on young Gerald. 'It saddens me more than I can say,' he wrote upon seeing his friend take his first deliberate steps up the social ladder, 'to think of that young life which opened with such brilliant promise, gradually sinking into the slough of respectability. Of course it is not as if he had been able to paint . . .'

But all of that was, in 1898, the unimaginable future. They met in Cambridge at Kelly's request. Gerald had seen, and been amused by, a copy of Aleister's first publication.

It was inevitable that the son of Edward Crowley should become a pamphleteer. As a boy Alick Crowley had been made more familiar with that form of publication than had any other ten-year-old in Britain. As a twenty-two-year-old in 1898 he published, through a Cambridge bookseller and printer who was happily familiar with the literary aspirations of undergraduates, *Aceldama, A Place to Bury Strangers In*, by a gentleman of the University of Cambridge.

The title was also a legacy of his childhood. It was taken from The Acts of the Apostles, Chapter 1, verse 19:

> Now this man purchased a field with the reward of iniquity; and falling headlong, he burst asunder in the midst, and all his bowels gushed out.
>
> And it was known unto all the dwellers at Jerusalem; insomuch as that field is called in their proper tongue, Aceldama, that is to say, The field of blood.

'In a sense,' wrote Crowley in the 1920s, 'I have never written anything better.' That is probably true. *Aceldama* is no worse than any of his other verse. It may have entertained Gerald Festus Kelly, but it is, of course, pretty poor . . .

> All degradation, all sheer infamy,
> Thou shalt endure. Thy head beneath the mire
> And dung of worthless women shall desire
> As in some hateful dream, at last to lie;
> Woman must trample thee till thou respire
> That deadliest fume;
> The vilest worms must crawl, the loathliest vampires gloom.

Aceldama's byline, 'by a gentleman of the University of Cambridge', was a brutal hint to the authorities that Aleister Crowley desired to mimic the career of Percy Bysshe Shelley, whose 1811 pamphlet The Necessity of Atheism, by a gentleman of the University of Oxford had famously resulted in the young poet being sent down from Oxford.

In 1898 the authorities at Cambridge were, as Crowley himself had already noted, more sanguine. Even with the will, they had no need to expel a twenty-two-year-old who was in his final term, and whose academic record suggested that he was about to disappear without trace, with no help from Cambridge University. They ignored *Aceldama*.

So he quickly published *White Stains*. This brilliantly titled collection of pornographic verse was more likely to stir up the Provost. Its various stanzas – which Crowley's Cambridge printer refused to handle, with the result that the delighted author was obliged to publish in Paris – lovingly chronicle the decline of a hitherto ordinary poet into necrophilia, bestiality, despair and death. It is, as Crowley himself would later note, something of a morality play, if morality plays were to be written by overexcited teenaged boys, and it is none the better for that. The authorities of Cambridge University refused to be stirred. Aleister Crowley's days in academe were drawing quickly to their natural end.

Aleister was able to indulge himself in this orgy of vanity publishing because on Monday, 12 October 1896, he had attained the age of twenty-one, and had inherited his father's legacy. It was a considerable sum of money, although we do not know exactly how much. Aleister's own version of his inheritance varied between £60,000 and £100,000, with the occasional tantalising mention of £50,000. A friend would claim that it was as little as a third of £50,000 – about £16,600. That was, then as now, far from being the biggest legacy in Britain. But £100,000 in 1896 was the equivalent of £5.5 million a century later; £60,000 would have been £3.3 million, £50,000 would have been £2.75 million, and even the negligible £16,600 would have had the value in 1996 of over £900,000. It could have been enough to last him a lifetime. It would have lasted most ordinary people a lifetime. But Aleister Crowley was not ordinary.

The inheritance enabled him at once to put the finishing touches to his restored self-portrait. It is possible even now to draw a convincing miniature of Aleister Crowley, the twenty-two-year-old undergraduate. Above all, and unsurprisingly, we see a figure strongly influenced by Oscar Wilde.

In 1895, the year that Crowley went up to Cambridge University, Wilde launched his unsuccessful action for criminal libel against the Marquis of Queensberry, and was himself subsequently successfully prosecuted under the Criminal Law Amendment Act. The two trials of Oscar Wilde obscured all other news, all other issues, in Aleister Crowley's twentieth year. And the first two years of his university life coincided exactly with the two years that Wilde spent imprisoned with hard labour in Reading Jail.

Count the ways in which Aleister Crowley would have been Oscar Wilde. Crowley already considered himself to be stifled by the oppressive miasma of late-Victorian public morality. He thought of himself as an indolent poet and aphorist, into whose apparently effortless life genius tripped like a faery king. He considered sexual adventure to be his birthright, and although his early experiments had all been heterosexual, he was determined to be inclusive, and enjoyed his first homosexual experience at university. It was with a long-haired thirty-two-year-old aesthete called Herbert Charles

Jerome Pollitt. Herbert – a friend of no less than Aubrey Beardsley – arrived back at his alma mater in 1898 in order to reprise his undergraduate success of a decade earlier as a female impersonator and dancer with the Footlights Dramatic Club. He spotted and seduced the fresh-faced undergraduate of Trinity Hall, and the two men enjoyed a dalliance of several months which was refreshing for Aleister in that Herbert Pollitt – unlike, say, Gerald Kelly – was clearly uninterested in his young friend's mind, being besotted by his body. If Crowley gained anything from this 'noble and pure' comradeship, it was the knowledge – passed on selflessly by a friend of a friend of Oscar Wilde – that he got most pleasure from buggery as the active partner.

Most of all, perhaps, the undergraduate Aleister Crowley arrived quickly at the conclusion that his vocation was *épater les bourgeois*, and in 1895 – and for a good many years after – nobody in Britain shocked the local bourgeois more than Oscar Wilde.

It was a notable (and wearying) feature of Crowley's adult life that he refused to pay homage, or even give credit, to almost any other artist. He was generous to the fault of hero-worshipping to his climbing guru Oscar Eckenstein, but rarely was he less than abusive of his fellow writers. All of them – Yeats, Shelley, George Bernard Shaw, the list is endless – were inferior to Aleister Crowley. Even Algernon Charles Swinburne, whose work Crowley, like most other undergraduates of the 1890s, once adored, fell into disfavour.

Wilde did not entirely escape this gnat's bite, but he achieved some kind of tribute. In sniping affectionately at Oscar, Crowley employed faux-Wildean analysis. So . . .

> He was a pefectly normal man; but, like so many Irish, suffered from being a snob . . . Wilde's only perversity was that he was not true to himself. Without knowing it, he had adopted the standards of the English middle class, and thought to become distinguished by the simple process of outraging them . . . He naïvely accepted the cockney view that Paris is a very wicked place.

Whenever he was lucky enough to meet friends of the late Oscar (Wilde died in 1900), Crowley treated them with untypical respect, and quizzed them ardently. One of his earlier pranks, as we shall see, involved the monument to Wilde in Paris.

Fortunately, the young Crowley even looked a little like the younger Wilde. They shared a chubbiness of feature – although Crowley's climbing kept him from running to fat – a sensual mouth, and large, attractive, vulnerable and friendly eyes. Photographs of Aleister in his twenties show him adopting the posture of a serious Oscar. Flamboyantly bow-tied, a brown lock falling untameably over his forehead, his chin cupped artistically in his hand, he gazes at the camera – at once calmly and as if sharing a joke. This is a description of Aleister Crowley, the wealthy undergraduate, by his friend John Symonds:

> He had taken to wearing pure silk shirts and great floppy bow-knotted ties; on his fingers were rings of semi-precious·stones. An atmosphere of luxury, studiousness and harsh effort pervaded his rooms at Cambridge. Books covered the walls to the ceiling and filled four revolving walnut bookcases. They were largely on science and philosophy, with a modest collection of Greek and Latin classics, and a sprinkling of French and Russian novels. On one shelf shone the black and gold of *The Arabian Nights* of Richard Burton; below was the flat canvas and square label of the Kelmscott *Chaucer*. Valuable first editions of the British poets stood beside extravagantly bound volumes issued by Isidor Liseux. Over the door hung an ice axe with worn-down spike and ragged shaft, and in the corner was a canvas bag containing a salmon rod. Leaded Staunton chessmen were in their mahogany box upon a card-table scattered with poker chips.

That, then, was the Aleister Crowley who, in the summer of 1898,

left Cambridge University – 'like Byron, Shelley, Swinburne and Tennyson' – without even bothering to sit for his degree. 'It has been better so; I have accepted no honour from her; she has had much from me.'

Luckily, he had already discovered a cheaper hobby than Alpine climbing. Two years earlier, while holidaying in Stockholm, Aleister had experienced a minor epiphany. He had woken in the middle of the night to a conviction of 'magical' powers. For a couple of years the illumination remained inchoate. It was always there, nagging at the back of his mind, and he would occasionally mention the experience to such as Eckenstein and Kelly.

That got him nowhere. Kelly attempted to evoke spirits, but 'nothing happened'. Eckenstein 'openly jeered at me for wasting my time on such rubbish'. So he conducted his researches in private. The volumes of Burton and Chaucer upon his shelves soon found themselves in odd company. Aleister collected and devoured Arthur Edward Waite's *The Book of Black Magic and of Pacts*, which led him to *The Kabbalah Unveiled* by S.L. Mathers, and *The Cloud upon the Sanctuary* by Councillor von Eckhartshausen.

Then, just in time, the right man came along.

4

I Can Call Spirits from the Vasty Deep

*London, Paris, New York, Berlin – are full of all sorts and
conditions of organisations experimenting and researching and
playing about generally with the Unseen. Mostly they are just
mutual admiration societies, and the only credentials required
are credulity and a vivid imagination.*

– Dion Fortune

Julian L. Baker was yet another chemist and mountaineer. Aleister
met him at a hotel in Zermatt, and inquired about the feasibility of
alchemy. Baker informed him that such an equation was not only
possible but had been accomplished – he himself had achieved
'fixed mercury'.

Emboldened, Aleister told Baker of his reading matter. Where was
the 'secret sanctuary' containing all the mysteries of God and nature
which was hinted at in Waite's work and described in
Eckhartshausen? Who were the initiates? Where could they be found?

Baker promised an introduction. The chemist returned first to
London, and when Aleister himself repatriated he dashed round to

his new friend's house. Julian Baker then introduced him to a further chemist, one George Cecil Jones; and Jones in his turn took Aleister Crowley along to a meeting of the Hermetic Order of the Golden Dawn, featuring Brother God as leader and sword as companion: Samuel Liddell 'MacGregor' Mathers, author of *The Kabbalah Unveiled*, a work of which Crowley, despite diligent study, had hitherto failed 'to understand a word'.

What was the Golden Dawn? A simple club, a meeting-place of friends, as the dismissive apostate George Cecil Jones would claim many years later? The 'mutual admiration society' that another member, Dion Fortune, apparently implied? An 'embarrassing' collection of 'all those absurd books . . . mediums, spells, the Mysterious Orient', as W.H. Auden – annoyed by the Order's seduction of another great poet – would suggest? A fraternity of half-hearted fakes; the magical equivalent of the Alpine Club, as Aleister Crowley would come to believe? Or a valid theosophical attempt to come to terms with the spiritual?

It had, in the last decade of the old century, a remarkable appeal. As well as Mathers, the aforementioned A.E. Waite and the minor writer named Dion Fortune, the Order claimed among its one hundred and thirty-odd initiates some substantial figures. The author Arthur Machen was briefly a member, with the given motto 'Avallaunius'; as was the actress Florence Farr Emery. Julian Baker himself – 'Causa Scientiae' ['For the Sake of Science'] – was a semi-detached affiliate. But the two names which leap to the startled eye of any unprepared twentieth-century reader scanning the register of members of the Hermetic Order of the Golden Dawn are those of the motto/titles *Per Ignem Ad Lucem* ['Through the Fire to the Light'] and her friend *Demon Est Deus Inversus* ['The Evil Sprit is God Inverted'], better known then as now as Miss Maud Gonne and Mr William Butler Yeats.

They came to it like the others, into the drapes and embroideries of late-Victorian spiritualism which was asserted most loudly by Madame Helena Petrovna Blavatsky, and which was thirty years later blasted out of the intellectual waterways by the Roman Catholic T.S. Eliot:

Madame Sosostris, famous clairvoyante,
Had a bad cold, nevertheless
Is known to be the wisest woman in Europe,
With a wicked pack of cards . . .
Thank you. If you see dear Mrs Equitone,
Tell her I bring the horoscope myself:
One must be so careful these days.

The Golden Dawn was established in the wake of Madame Blavatsky's disgrace (she was accused of fraud by the Society for Physical Research) and death in 1891. Many, such as Yeats who had been attracted to Blavatsky's Theosophical Society, carried over her broad theme into the new Order. This theme essentially insisted that an illustrious but intensely private body of men, known variously as Secret Chiefs, Mahatmas and (Blavatsky's favourite) Hidden Masters, observed and directed humankind from caves in the uppermost reaches of the Tibetan Himalaya.

The agnostic may scoff. These Hidden Masters did not remain entirely hidden. Two of them, Koot-Hoomi and Morya, revealed themselves to Madame Blavatsky. And after Samuel Liddell Mathers had picked up Blavatsky's baton on behalf of the Hermetic Order of the Golden Dawn early in the 1890s, three Secret Chiefs bumped into him in the Bois de Boulogne (he would become known in Paris as the Chevalier Macgregor), causing his nose and ears to bleed.

Mathers shared with many of his contemporaries – Aleister Crowley not excepted – a fascination with the Celtic Twilight. As Crowley had adopted a 'Gaelic' forename, so Mathers gave himself the extra middle name of Macgregor, and added to his hermetic Latin catchword of *Deo Duce Comite Ferro* ['God as Leader, and Sword as Companion'] the designation 'S Rioghail Mo Dhream' which is perfectly good Scottish Gaelic for the extravagant claim: Royal Are My People. W.B. Yeats shared this interest. Some of his verse of the 1890s – 'Fergus and the Druid', for instance, or 'Cuchulain's Fight with the Sea' – differs from James MacPherson's Ossianic travesties of a century earlier only because Yeats was a far superior poet to MacPherson. Only occasionally did Yeats let slip

into verse his hermetic involvement. 'Swear by the parents of the gods,' demands Anashuya in 'Anashuya and Vijaya . . .'

> Dread oath, who dwell on sacred Himalay,
> On the far Golden Peak; enormous shapes,
> Who were still old when the great sea was young;
> On their vast faces mystery and dreams . . .

Yeats was sensitive to criticism of his membership of the Golden Dawn. Long before Auden's bitter lines, his mentor and father's friend, the Irish nationalist John O'Leary, in a worried postcard reproved Yeats for 'weakness' in heeding such quackery. The poet was unapologetic. He replied:

> The mystical life is the centre of all that I do and all that I think and all that I write. It holds to my work the same relation that the philosophy of Godwin held to the work of Shelley and I have always considered myself a voice of what I believe to be a greater renaissance – the revolt of the soul against the intellect – now beginning in the world . . . I sometimes forget that the word 'magic' which sounds so familiar to my ears has a very outlandish sound to other ears.

Aleister Crowley was delighted to discover within his new circle a published poet of some reputation. In 1898 he had written a play called *Jephthah*, and when he published this work along with some spare verse in 1899 he hurried to show Yeats the proofs. Yeats glanced at the stuff and, in Aleister's words, 'forced himself to utter a few polite conventionalities'. The Irishman had recognised, jibed Crowley later, the work of a superior artist, and 'what hurt him was the knowledge of his own incomparable inferiority'.

The two would clash more fiercely in the near future. But in late 1898 and 1899 Crowley devoted himself to scaling the foothills of the Golden Dawn hierarchy, from initiate to the halfway stage (where he was mysteriously baulked, just short of the grand ascent

into the select Second Order), rather as a practitioner of judo collects dans. Along with Yeats he attended Golden Dawn meetings in Hammersmith and Euston, quaint, picturesque affairs, where a newcomer such as Aleister – who was officially inducted in November 1898 – would be clothed in a robe and a hood and led, held by a triple cord, towards a gloomy altar and the priestly figure of Samuel Liddell Mathers, the 'half-lunatic, half-knave' of Yeats's recollection.

Voices off would query his initiation: 'Child of Earth! Unpurified and unconsecrated! Thou canst not enter our sacred hall!' (This was probably Mark Mason's Hall, just north of Southwark Bridge.)

Mathers would then demand the neophyte's reasons for entry, and another ghostly voice from the wings would answer for him: 'My soul is wandering in the darkness . . . in this Order Knowledge of the Light may be obtained', etc., etc. He was made to kneel and was sworn to secrecy about the Order's activities (the inevitable penalty for breaking this masonic oath was falling slain or paralysed 'as if blasted by a lightning flash', which indicates that Mathers was a charlatan in at least one regard, considering the number of Golden Dawn initiates who broke their vows and yet lived to a ripe and hearty old age), and before he knew it he was standing up with a foot on the bottom rung of the Golden Dawn's hierarchy, and forking out his first year's ten shillings subscription. In their innocence they dubbed the twenty-three-year-old *Perdurabo* ['He Who Will Endure']. Gerald Festus Kelly, who followed his college chum to Mark Mason's Hall, became *Eritis Similis Deo* ['You will be like a God'].

There was schism within the Hermetic Order of the Golden Dawn before the initiation of the neophyte Brother Perdurabo. By 1896 S.L. Mathers was mainly resident in Paris, and he attempted in his absence to govern with a rod of iron. Only he and (to a lesser extent) *Vestigia Nulla Restrorsum* ['No Traces Backwards'], or Mrs Moina Mathers, were the chosen instruments of the Secret Chiefs. The remainder of the tribe in England must consequently obey him absolutely – 'by abstaining,' he informed them, 'to the utmost of your power from putting any extra hindrance in my way'.

His plea was not entirely heeded. There were quibbles about money and about doctrine; there were expulsions and resignations. A year after Aleister Crowley's introduction ceremony matters came to a head. In January 1900 Mathers fell out with Florence Farr Emery, whom he had nominated as his chief representative in London. Accusing the actress of slandering his personal life and 'attempting to make a schism', he sacked her. This move was sufficient to convince most of the London brethren, including W.B. Yeats, that Samuel Liddell Mathers had lost his grip and must be replaced. Most, but not all . . . On 15 January the promising young adept Aleister Crowley, who had been experiencing difficulty in rising through the ranks and attributed his slow promotion to the envy and hostility of his colleagues, took the boat to France and visited Mathers in Paris. There he was quickly admitted into the higher Second Order, and he returned to England effectively as the representative on earth of Samuel Liddell Mathers and the Hidden Masters of Tibet. Upon his reappearance on the streets of London bearing these new powers, Crowley asserted, horses bolted at the sight of him and his rubber macintosh caught fire.

Aleister knew that he was in for a battle, and he relished the fact. He would prove himself before the guns. On 20 January he was told that the rest of the London branch wanted their temple and meeting-rooms at 36 Blythe Road in Hammersmith closed because of an 'astral jar'. 'This is a lie,' Crowley informed his diary. 'Politics the real base.'

It was indeed: a timeless political struggle for the property of a disintegrating soviet; a tussle for the astral radio station. On Tuesday, 17 April, Crowley and a woman initiate named Elaine Simpson or *Donorum Dei Dispensatio Fidelis* ['Faithful Superintendant of the Gifts of God'], went to 36 Blythe Road, broke in, and began – on the orders of Mathers – to remove the contents. They were frustrated by the arrival of Florence Farr Emery and a police constable, but not before Aleister had achieved a *fait accompli* by signing himself in as a member of the Second Order and back-dating his promotion to January.

Crowley instantly circulated all of the members cancelling a

planned meeting for Saturday, 21 April, and demanding a convention on the previous Friday. On the day before *that*, Thursday, 19 April, W.B. Yeats and Edward Hunter, on behalf of Florence Farr Emery and the rest of the breakaway London chapter, travelled to Blythe Road, changed the locks, told the landlord not to worry, and prepared to defend their station.

'At about 11.30,' Hunter recorded, 'Crowley arrived in Highland dress, a black mask over his face, and a plaid thrown over his head and shoulders, an enormous gold or gilt cross on his breast, and a dagger at his side.'

This considerable apparition was confirmed by Yeats in one of the most remarkable evocations of literary life in the late-Victorian age. Writing six days later to his friend, the playwright and poet Lady Isabella Augusta Gregory, William Butler confided:

> I have had a bad time of it lately. I told you that I was putting Macgregor out of the Kaballa. Well last week he sent a mad person – whom we had refused to initiate – to take possession of the rooms and papers of the society. This person seized the rooms & on being ejected, attempted to retake possession wearing a black mask & in full Highland costume & with a gilt dagger by his side.

The dagger which so startled Hunter and Yeats was apparently the result of Mathers informing Crowley that Hunter – an amateur boxer – 'would shrink from cold steel'. It proved bad advice. There are two versions of what happened next. One, favoured by the editor of Yeats's correspondence, has a 'bully-boy' employed by Crowley to assist him in the raid failing to show up, Crowley nonetheless pushing his way single-handedly past the anxious landlord and climbing the stairs to the rooms – where he was met, repulsed, and kicked back down the stairs by Hunter and Yeats.

The other, more likely, edition of the tale says that when he was forbidden entrance Aleister called for a policeman. The constable assessed the situation and – doubtless quite uninfluenced by

Aleister's apparel – told him to go away. This he did, to place the matter in the hands of a lawyer.

Yeats continued to Lady Gregory:

> Having failed in this [the storming of Blythe Road], he has taken out a summons on the ground that he is Mathers' 'envoy', & that there is nothing in the constitution of the society to enable us to depose Mathers. Charles Russell, the son of the Lord Chief Justice is acting for us, & is trying to keep my name out of the business. The case comes up next Saturday & for a week I have been worried to death with meetings law & watching to prevent a sudden attack on the rooms. The trouble is that my Kabalists are hopelessly unbusinesslike & thus minnuts [sic] & the like are in complete confusion. I had to take the whole responsibility for everything & decide on every step. I am hopeful of the result. Fortunately this wretched envoy has any number of false names & has signed the summons in one of them. He is also wanted for debt & a trade union representative is to attend court on Saturday. The envoy is really on Crowley a quite unspeakable person. He is I beleive [sic] seeking vengeance for our refusal to initiate him. We did not admit him because we did not think that a mystical society was intended to be a reformatory.

A few of W.B. Yeats's points require clarification. Aleister Crowley did truly employ 'any number of false names' (although it is unclear why a man who called himself *Demon Est Deus Inversus* should be concerned at this). Upon leaving Cambridge he had taken rooms in Chancery Lane as Count Vladimir Svareff, which title he occasionally reduced to Count Swanoff. In 1899 he had, as we shall see, bought a property in Scotland which entitled him, he considered, to the Lairdship of Boleskine and Abertarff (and to the wearing of 'full Highland costume'). He would occasionally simplify

matters by employing a straightforward 'Aleister Macgregor', although the court papers in the case of 36 Blythe Road were signed 'Edward Aleister'.

The 'trade union representative' who would – according to Yeats – be testifying to Crowley's indebtedness was, in fact, a representative of a trades' protection society. He would have spoken on behalf, not of the employed proletariat, but of small businessmen and shopkeepers laid low by bad debts. Aleister Crowley still had money, but he recklessly ignored invoices and stacked up credit lines.

At least, the trades' protection society's man would have so spoken, had he been given a chance. On Saturday, 28 April 1900, W.B. Yeats sat in his Euston Road apartment composing another letter to Lady Gregory. The poet agonised:

> I am expecting every moment, a telegram to say how the case goes at the court house.
>
> I have had to go through this worry for the sake of old friends . . . If I had not the whole system of teaching would have gone to wrack & this would have been a great grief to . . . others, whose whole religious life depends on it. I do not think I shall have any more bother for we have got things into shape & got a proper executive now & even if we lose the case it will not cause any confusion though it will give one Crowley, a person of unspeakable life, the means to carry on a mystical society, which will give him control of the consciences of many.

When Augusta Gregory received that letter she discovered, written hastily upon the back of the envelope, the message: 'Just got telegram about law case. We have won. Other side fined £5.'

That was not strictly true. Crowley had been persuaded to withdraw his suit because of the weight of evidence against him, and because the Police Court decided that the value of the property of the Order was too high to be within its jurisdiction. He was also

intimidated by the work which had been done on Yeats's behalf by the solicitor Charles Russell:

> On the hearing of the summons we were amazed to find Mr Gill KC, one of the most famous men at the bar, briefed to appear in a police court to squabble over a few pounds worth of paraphernalia . . . I knew enough of campaigning to decline joining battle against such heavy artillery as Mr Gill. Luckily the value of the property had been sworn at a sum beyond the limit at which a police magistrate can deal. The summons was therefore withdrawn and Mr Gill kept his eloquence and his fee to himself.

The £5 'fine' was an order for costs, against 'Edward Aleister'.

So concluded Crowley's ambitions for the Hermetic Order of the Golden Dawn. The London branch duly arraigned and expelled S.L. Mathers. 'We have barbed our arrows with compliments and regrets,' wrote Yeats, '& to do him justice he has done little less. The "envoy" [Aleister Crowley] alone has been bitter & violent & absurd. Mathers like all despots must have a favourite & this is the lad.'

Mathers – that 'scholar and Magician of considerable eminence' in Crowley's words – responded by announcing that several of the documents upon which the Golden Dawn was predicated were in fact fakes, thereby sacrificing his own credibility to the greater cause of irritating his enemies.

And into the early summer the unpleasant business ticked along.

Soon after the fiasco of the Blythe Road case, Aleister found himself once more in court. A fellow adept of the Golden Dawn – and another favourite of S.L. Mathers – a twenty-nine-year-old named Allan Bennett, was in 1900 in considerable difficulty. Suffering

acutely from asthma, according to Crowley he treated the illness with month-long treatments of opium, morphine, cocaine and chloroform, not all at once but in steady succession.

Bennett was as a consequence severely debilitated. No sooner would he recover from the chloroform than the asthma would strike again, and he would feel obliged to repeat the cycle of treatment. He was clearly in need of a change of life. Crowley and George Cecil Jones decided that unless Bennett moved to live in a warmer climate he would surely die. They determined to send him to Ceylon. The difficulty was that Bennett had no money, and Crowley refused to lend him the necessary sum because it would cheapen their occult relationship – 'The amateur status above all!'

Luckily, Aleister was engaged in an affair with a married woman, whose name was probably Laura (she is indirectly hinted at only in his diaries; the autobiographical writings for publication refer to her anonymously), and whose husband was certainly safely tucked away with the army in India. This 'seductive siren' was persuaded to hand over £100 (£5,000 a century later) to send Allan Bennett, whom she never met, to rebuild his life in Ceylon.

That might ordinarily have been that. But two things occurred to complicate this pure transaction. Firstly, Crowley tired of his siren, with the result that Laura began to wonder aloud about getting her £100 back. And, secondly, the remnants of the Hermetic Order of the Golden Dawn took an astral interest in her affairs.

'Our recent quarrell [*sic*] with Macgregor,' wrote W.B. Yeats – whose spelling had not in the meantime improved – to a friend in May 1900, 'has been a small triumph for our clairvoyants & thaumaturgists . . .' The clairvoyants had apparently advised against taking early drastic action against S.L. Mathers, on the grounds that if the London chapter bided their time Mathers would do 'something so outrageous' that he would effectively hang himself.

So they had waited, and sure enough: Mathers did do something phenomenally, self-destructively outrageous. As we have seen, he 'sent over a certain unspeakable mad person to represent him'.

Next it was the turn of the thaumaturgists, the Order's miracle-workers, of Laura and of Aleister Crowley. Yeats wrote:

> We found out that his [Mathers's] unspeakable mad
> person had a victim, a lady who was his mistress &
> from whom he extorted large sums of money. Two or
> three of our thaumaturgists after, I think, consulting
> their master, called her up astrally, & told her to leave
> him.

The results of these ethereal anonymous telephone calls were spectacular and gratifying. The poet continued:

> Two days ago (about two days after the evocation) she
> came to one of our members (she did not know he was
> a member) & told a tale of perfectly medeaval [*sic*]
> iniquity – of positive torture & agreed to go to
> Scotland Yard & there have her evidence taken down.
> Our thaumaturgists had never seen her, nor had she
> any link with us of any kind. It & much else that has
> happened lately is a clear proof of the value of
> systematic training even in these subtle things.

Indeed. As a consequence of the systematically trained thaumaturgists of W.B. Yeats's chapter of the Golden Dawn, Aleister Crowley's name went down in the police record. 'Laura' did apparently visit the constabulary, where her accounts of life with Aleister attracted some interest. But hair-raising though her details of their sex life together may have been, she neither could nor would testify to those in public without at best embarrassing her absent husband, and at worst inviting legal action against herself. The same may also have been true of her 'gift' of £100 to Crowley and Allan Bennett. Whatever the reasons, no action was taken against Crowley in the early summer of 1900. But when, almost twenty years later, Scotland Yard was requested by the Foreign Office confidentially to file a report on Aleister, it began with the words:

> Aleister Crowley, who has passed under the names of
> Aleister Crowley, A.E. Crawley, Count V. Zoneret,

Alastair McGregor and Earl of Middlesex, first came
under the notice of Police in 1900, when he became
acquainted with a widow with whom he cohabited.
Eventually left her stealing property worth £200. She,
however, refused to prosecute the man and no action
was taken.

(This report does not excite confidence in the police force. They
have entirely mistaken some of their subject's pseudonyms, and
missed many others. On the subject of 'Laura's widowhood': there is
on this occasion no reason to doubt Crowley's assertion that she was
married to an absent soldier; while there was every reason for
'Laura' herself to conceal that fact from the police and others.
Similarly, if Crowley had 'stolen' £200 – and as the assertion of theft
was never proved or challenged in a court of law, it was surely rash
for Scotland Yard to state it as fact many years later – rather than
£100 from his lover, he would almost certainly have admitted to it
just as easily as he confessed to persuading 'Laura' to part with the
smaller sum – he saw no disgrace in the transaction. Nor did the
police restrict their information to confidential reports. When
Aleister Crowley did appear in the London courts in the 1920s, an
excited Fleet Street press made free reference to the affair of the
'widow's stolen £200'.)

William Butler Yeats and his friends were doubtless disappointed
that the 'unspeakable mad person' had got away scot-free with
Laura's £100 (to say nothing of the 'medeaval [sic] iniquity' of his
private life); but were thoroughly relieved to have seen the last of
Aleister Crowley. It was quite reciprocal. 'The whole crew of . . .
scabs and skunks and bitches,' announced Aleister, 'have been
swept into oblivion.'

Not quite. Remnants of the Golden Dawn persisted down
through the years, and continued to attract the pleasing loyalty of
W.B. Yeats. It was better, considered its vestigial membership,
without Mathers, and far, far better without Crowley. But Yeats
could not easily get Crowley out of his mind. 'The unspeakable mad
person,' he would write, 'is a much worse Captain Roberts & has

gone into this dispute with us in part, because of our refusal to teach him & in part to earn knowledge from Macgregor [Mathers].'

Captain Roberts was the English leader of a group of Dublin black magicians, who had once urged Yeats to share his own delight in animal sacrifice. Yeats did so, and was shortly afterwards observed by a friend:

> hurrying along Pembroke Road, his olive complexion turned to a bilious green. He had just been present in a nearby house where an Englishman, adept in the Black Art, had sacrificed a cock. The sensitive poet rushed out into the street, horror-stricken by the bloody rite, and never again had anything to do with this ancient cult.

Yeats had therefore reason to be nervous of a 'much worse Captain Roberts'. His sometime comrade in the Golden Dawn, Arthur Machen, recalled being told by Yeats shortly after the Crowley affair:

> a queer tale of the manner in which his life was in daily jeopardy . . . [from a] monster . . . [who] had, for some reason I do not recollect, taken a dislike to my dark young friend. In consequence, so I was assured, he had hired a gang in Lambeth, who were grievously to maim or preferably to slaughter the dark young man; each member of the gang receiving a retaining fee of eight shillings and sixpence a day.

And early in the June of 1900 when, had he but known it, Aleister Crowley was safely on his way to Mexico, Yeats found himself raising the dread name once more in a letter. After wishing to a friend in Ireland that he could be at Coole rather than in 'noisy' London (which was celebrating the Boer War fall of Pretoria), the poet reflexively added: 'Even the fact that Macgregor's masked man Crowley has been making wax images of us all, & putting pins in

them has not made life interesting.' Then W.B. Yeats relaxed, let Aleister Crowley slip out of his life, wrote 'The Wild Swans at Coole', and was to prosper in the knowledge that while he may have been an inferior poet to this 'unspeakable mad person', nobody would ever know.

There were two literary postscripts to this, one of the strangest feuds in the history of the British illuminati, each of which sheds some light on its leading characters. Some thirty years later, that fourth-rate novelist who had in 1900 been in Yeats's corner of the Blythe Road battlefield, Deo Non Fortuna, or Dion Fortune, published a dreadful novella titled The Winged Bull. It featured an unpleasant character named Hugo Astley, 'a heavily built, pock-marked mulatto', who was responsible for magically enchaining a pretty young girl. The hero of the story, one Ted Murchison, first encounters Astley when the latter forces an unauthorised entry to a London flat . . .

> 'And do you know who I am?' The mulatto struck an attitude reminiscent of the late Henry Irving . . .
>
> [He] looked as if he had been an athlete before time and debauchery had taken toll of him.
>
> 'Do you imagine you could throw us out?' he inquired, with an unpleasant smile.

Luckily Ted Murchison was a rugby-playing pugilist, and threw Astley down the stairs, where a police constable discovered him:

> 'I'd better have the names and addresses,' said the policeman, getting out his notebook, to Murchison's great satisfaction, who learnt that . . . the mulatto was Hugo Astley; whereupon Murchison pricked up his ears, for the name was not unknown to him in connection with a series of lurid revelations in one of the less reputable Sabbath journals . . .
>
> Astley looked up . . . and there came into his face an expression so fiendish that Murchison's laugh was

arrested in mid career, leaving him open-mouthed. If
ever the Prince of Darkness appeared in human form,
he was sitting on the door-mat now. Astley was
prepared to believe anything of this man, even what
the Sunday papers said of him.

Before the villain is manoeuvred into his inevitable sticky end,
Murchison is apprised by a good white magician of Hugo Astley's
true nature:

'London, Paris, New York, Berlin – are full of all sorts
and conditions of organisations experimenting and
researching and playing about generally with the
Unseen. Mostly they are just mutual admiration
societies, and the only credentials required are
credulity and a vivid imagination. But some are like
the one run by Hugo Astley, and that is an altogether
different pair of boots.'

'What do they go in for? Blackmail? Drugs? A spot
of loose living?'

'All those, and more, with a dash of subversive
politics thrown in sometimes . . . the thing that
entitles organisations like Astley's to our
consideration, if not our respect, is their knowledge of
certain of the rarer powers of the human mind. And
that knowledge is genuine, Murchison. There is no
fake about it. I'll tell you what it is, and I'll show you
how it's done if you work with me.'

'Are you planning an exposé?'

'What's the use? Astley's been exposed over and
over again. Exposure is what he thrives on. So much
free advertisement . . .'

Dion Fortune was, of course, writing in the 1930s with the benefit
of recent information. When the real Aleister Crowley gatecrashed
the apartments of the Golden Dawn in 1900, he was still an athlete,

uncorrupted by 'time and debauchery'. Nor had he yet been 'exposed' in the Sunday papers; nor had he launched his own sect; and we are by no means certain that he actually had been knocked down the stairs of 36 Blythe Road by Edward (Ted?) Hunter. Fortune's description of her villain as a 'mulatto' was probably nothing more or less than an intentional – and therefore implicitly racist – insult to the living man. The Winged Bull mythologises the fully rounded fictional character and exploits of Aleister Crowley, complete with his 'genuine' – if appallingly misapplied – knowledge.

Crowley himself had entered these particular literary stakes long before Dion Fortune. In 1909 his magazine *The Equinox* featured in its first issue a tale which purported to tell of his struggle with W.B. Yeats. '"At the Fork of the Roads" is,' asserted Aleister, 'in every detail a true account.'

It is a remarkable short story. The best that could ever be said of Crowley's fictional prose style was that it was an improvement upon his verse (his non-fictional writing was better than either of them, without ever threatening excellence). But his imagination – the well-spring of his being – was boundless, and his malice unequalled.

'At the Fork of the Roads' contains four characters. 'Count Swanoff', as we have seen, was Aleister himself. 'Will Bute' was W.B. Yeats. 'Hypatia Gay' was Althea Gyles, a young artist friend and sometime lover of Yeats, who had shocked bohemian society in 1899 by her affair with the older married publisher Leonard Smithers, who features in 'At the Fork of the Roads' as 'The Publisher'. This ménage was complicated in reality by two further details. Smithers had, a year or two earlier, managed to lose one of Crowley's manuscripts rather than publish it (he said it had been destroyed in a printer's fire). And Yeats priggishly refused to smile upon Gyles's affair with the adulterous publisher – 'she is throwing off every remnant of respectability with an almost religeous [*sic*] enthusiasm,' he said, before writing to poor Althea to tell her that Leonard Smithers would not be welcome in his rooms.

In other words, almost nobody here likes anybody else. It was immensely fertile ground for Aleister Crowley, and he ploughed it

manfully. Bute/Yeats became – in the second sentence – a 'long lank melancholy unwashed poet . . . not only a poetaster but a dabbler in magic, and black jealousy of a younger man [Yeats was ten years older than Crowley] and a far finer poet gnawed at his petty heart'.

In short, Gay/Gyles visits Swanoff/Crowley, and on behalf of Bute/Yeats she scratches his hand with a brooch and carries a pin-prick of blood back to the 'unwashed poet'. Bute/Yeats uses this globule to invade Swanoff/Crowley's sleep. For a couple of nights the two poets slog it out in dreamworld (such a contest is known as a 'magical duel'). While they do so Gay/Gyles takes some drawings to a Bond Street publisher. Smithers (for it is he) was 'bloated with disease and drink; his loose lips hung in an eternal leer; his fat eyes shed venom; his cheeks seemed ever on the point of bursting into nameless sores and ulcers'. Although he bought the maiden's art, she was at first inexplicably unattracted to him.

For ten successive nights Swanoff/Crowley struggles in his sleep with visions of Gay/Gyles. On the eleventh day she revisits him in search of more blood. Forewarned, the handsome younger poet visits her boarding-house and sprinkles some potion about the place. The result is devastating. Hypatia Gay/Althea Gyles actually succeeds in making love to a slimy bloodstained skeleton. After that not even Bute/Yeats wants anything more to do with her – 'You fool! You have ruined me – curse you!' – and she is obliged literally to fall back upon Smithers the publisher, who is pleased to receive the girl. 'He saw the leprous light of utter degradation in her eyes; a dull flush came to his face; he licked his lips.'

Students of infatuation, jealousy and the occult should note that, while Aleister Crowley was having sleepless nights over Althea Gyles and Leonard Smithers ('in every detail a true account'), so was W.B. Yeats. 'I was ill, with indigestion and sleeplessness,' he told his diary in November 1899, ' . . . & met certain very sensual persons, & [heard] observed certain disagreeable things of this kind in connection with a friend.' But he never admitted to instigating a 'magical duel' with Aleister Crowley, and he certainly never confessed to despatching Althea

Gyles to steal a drop of Crowley's blood. The joust took place, it seems, in one bed alone.

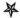

It is significantly easier to achieve a likeness of W.B. Yeats from these troubled events at the end of the nineteenth century, than a detailed picture of Aleister Crowley. Nervous, earnest, troubled Yeats was facing a rival whose image of himself was already blurred. The shy, plump, bullied Home Counties schoolboy had become an apparently bold and vigorous twenty-five-year-old; given material independence by a substantial inheritance and physical confidence by a successful sex life and an impressive career on the mountains of Europe. But for all of these plain, encouraging attributes, the single most striking thing about Aleister Crowley at the turn of the century is his powerful fantasy. He lived in a world of rich imagination, a land of black villains and white heroes, pure virgins and fallen women, ogres, witches and Merlins. He named himself accordingly, as the caprice took him, and he dressed by whim. His deeds and his opinions, his conversation and his writing were the products of a restless, flippant intelligence – a small bird, in comparison with the eagle of Yeats's genius, and one which found it difficult to rest upon any branch for very long. If there was a brilliance there, it was theatrical, it lay in colour and attitude and song – the terrifically dressed young man who invades Blythe Road wearing plaid and sgian dubh, who strikes the stance of Henry Irving when confronted and talks like the hero of *Martin Rattler*. If there is an attraction, it is to a young man who has decided that money and youth empower him to live the life of his dreams, and nobody shall restrain that wonderful ambition. 'I feel,' he would write, 'that the world owes me a handsome income', and that phrase alone was of course a conscious refutation of an old but sturdy Victorian saw, the chant of the work ethic, the scolding admonition that the 'world doesn't owe you a living'. For most of the twentieth century, indeed,

let alone the nineteenth century, such an alternative philosophy –
deliberately post-Wildean – would have shocked the bourgeoisie.

But despite these markers, because he wishes it to be so, he is
difficult to grasp. At the age of twenty-five, the Aleister Crowley that
Yeats, Fortune and the others saw, was the Aleister Crowley that
they got. Beneath the stage clothes beat a simple, selfish heart;
behind the black mask was a mind concentrated chiefly upon its
next impressive operatic scene.

Early in his hermetic career Samuel Liddell Mathers had decided
that his Mage was to be Abra-Melin. This master delivered his
teachings to a medieval Jew named Abraham, who in turn passed
them on in 1458 to his son Lamech, who in his turn wrote them in
Hebrew into a single volume.

The Book of the Sacred Magic of Abra-Melin the Mage had
subsequently been translated into Old French, and a copy of it lay in
the Bibliothèque de l'Arsenal in Paris, where it had attracted
sporadic bursts of attention before Mathers dug it out and
translated it into English. Quickly, Mathers decided that this
exponent of 'white magic' ('angelic forces are superior to satanic
forces') was the one. And so did Aleister Crowley.

One of the difficulties faced by disciples of Abra-Melin was that
the master insisted upon idiosyncratic architecture and
environment to house his 'Operation of the Sacred Magick'. Aleister
Crowley had done his level best to make his Chancery Lane rooms
suitable. There is a useful description of them in *At the Fork of the
Roads*. A visitor went from 'the cold stone dusk' of the stairway to:

> a palace of rose and gold. The poet's rooms were
> austere in their elegance. A plain gold-black paper of
> Japan covered the walls; in the midst hung an ancient
> silver lamp within which glowed the deep ruby of an

electric lamp. The floor was covered with black and
gold of leopards' skins; on the walls hung a great
crucifix in ivory and ebony.

A cupboard had been converted into a 'temple'. The altar was 'a round table supported by an ebony figure of a negro standing upon his hands'. Above the altar sat the very human skeleton with which Hypatia Gay/Althea Gyles had achieved orgasm. It must in reality have been a disgusting sight, for Crowley claimed that he occasionally fed the skeleton blood and small birds in an attempt to give it life, 'but I never got further than causing the bones to be covered with a viscous slime'.

However suitable these apartments may appear to the layman, they were not enough for Abra-Melin. The Mage demanded a house in a secluded spot, with a north-opening oratory door and a terrace which could be covered with fine river sand.

A chap with £40,000 capital, who was prepared to spend every penny of it on such a dwelling, should in 1899 have had little difficulty in finding one. But Crowley scoured Britain before coming across the perfect location.

It was in the Scottish Highlands, with which he had been familiar since his teens. It stood on the steep south-eastern bank of Loch Ness, halfway between the tiny parishes of Foyers and Inverfarigaig (and, which must have delighted him, not very far away from the Benedictine monastery and Catholic public school at Fort Augustus). It was a single-storey Georgian villa; a kind of bow-windowed longhouse looking out over the loch – and looking, therefore, approximately north. Behind it lay naked hillside; below it the ancient gravestones and imperial memorials of Boleskine Burial Ground lay shrouded in stunted trees and wind-blown grass. All about the building burns poured through gullies down from the hills and released themselves by sandy coves into the unfathomed loch.

He bought it in August 1899, for 'twice as much as it was worth', which means that he probably got it for a couple of thousand pounds (£100,000 a century later, which would be more or less its

market value). He wasted no time after acquiring Boleskine House and its two surrounding acres in titling himself 'Laird of Boleskine and Abertarff', and having a coronet with a gilded 'B' embossed on his writing-paper. The honorific was later elevated to the simpler 'Lord Boleskine' – 'I am entitled to this address and I intend to assert it.'

He did all of the things that were expected of the late-Victorian gentility in the Highlands. He hooked a forty-four-pound salmon in the loch (and for once there is no particular reason to suspect Crowley of fisherman's tales: Loch Ness was and is celebrated for the size of its fish); his southern dog worried sheep; he planned to build a flying bicycle and launch it over the water. He protested against the British Aluminium Company's plans to exploit the sensational Falls of Foyers in a hydro-power scheme. One morning he awoke to find a large stone jar full of illicitly distilled whisky at his front door. He assumed it to have been left there as a propitiation by bootleggers disturbed by his long walks in the surrounding hills.

He raised demons, of course – this facility above all others would always distinguish Aleister Crowley from the rest of the *rentier* class. No fewer than one hundred and fifteen spirits and their servitors entered Boleskine House, with startling consequences. A workman employed to renovate the villa unaccountably attacked Crowley and had to be locked in the cellar. His lodgekeeper, who had claimed to be a teetotaller, went on a three-day binge and tried to kill his wife and children: an incident which may have had as much to do with the whisky on the doorstep as with the spirits and their servitors, if anybody had thought the matter through. Crowley absently scribbled some incantation on the Foyers butcher's bill, and the poor man promptly chopped through his own femoral artery and died. He took 'Laura' the army widow to Boleskine, but she soon fled back to London. His housekeeper unsurprisingly handed in her notice. Local people began to resort to the old hill paths, rather than use the main road which ran directly past the front gate of Boleskine House.

Like most such lairds, he was not there for long. Boredom was always an enemy on the south bank of Loch Ness. Crowley staved it

off temporarily with some innocent pranks. Using his old pseudonym of 'Aleister Macgregor' he wrote to the vice-busting Vigilance Society in London complaining that an epidemic of prostitution was raging in Foyers, causing 'a nuisance which every day seems to me to grow more intolerable'. Crowley would claim that the Vigilance Society despatched some hapless agent from London to Foyers; it seems more likely that the society's secretary simply made some inquiries before replying to 'Aleister Macgregor' that there was no conspicuous evidence of prostitution in Foyers. 'Conspicuous by its absence, you fools,' responded Aleister Macgregor.

Such practical jokes could while away an hour, but they were insufficient to keep Crowley in the Highlands. He drifted south, to the antics of the Golden Dawn, and when they were exhausted, to Paris and to Mexico.

His epic journey of 1900 to 1901 was the first of a series of similar adventures which exhausted Aleister Crowley's legacy, consumed his small fortune, and left him later in life as penniless as he was without friends. But while they lasted, they were formidable experiences. He sailed for New York in June 1900.

For the bare details of the circumnavigation of the globe which followed his disembarkation in New York early in July, we are almost entirely dependent upon Crowley's autobiography. That is not necessarily a bad thing, however frustrating it may be to the biographer. To be sure, Aleister Crowley lied incorrigibly and exaggerated habitually, but mostly about matters of finesse, performance, motivation; the components of character and legend. Rarely can he be caught out on base detail, or in his relation of affairs which do not threaten his own reputation. So if Aleister Crowley tells us that he commanded a vulnerable army widow to give a friend of his £100 for the good of *her* own karma, we must

immediately be suspicious. If he tells us that W.B. Yeats disliked him because Yeats recognised and was jealous of a superior poet, we must instantly go in search of other sources. But if he casually relates that it was on or about 6 July 1900 that he arrived in New York, and that an intolerable heatwave was raging at the time, we may as well take his word for it, as that of anybody else.

So, it was on or about 6 July 1900 that he arrived, for the first time, in New York. He related: 'I crawled, panting, through the roasting streets and consumed ice water, iced watermelon, ice cream and iced coffee.' If this, he thought, is New York, what must Mexico be like? He left after a couple of days, travelling south by train to the border with some trepidation, only to discover with relief that a Mexican July could be, and was, more comfortable than midsummer by the Hudson.

The Mexico City hotel service was bad, though, and the food and drink unpleasantly foreign. But he slowly came to enjoy the ambience of life; the pre-industrial leisurely poverty, the easy-going attitude towards casual sex, the happy-go-lucky view of material possessions. He rented rooms and settled in to a daily enjoyment of all these things, while working up his spiritual repertoire into magical dances and the attainment of invisibility – 'I reached a point when my physical reflection in a mirror became faint and flickering', and he found himself able to walk in the public street wearing a golden crown and a scarlet robe 'without attracting attention'.

In common with almost everybody else, he disliked and avoided Mexico City's 'constipated and drunken' English colony (Aleister himself at this time hardly touched alcohol), but found suitable English-speaking company in the capital's hive of American gamblers and confidence tricksters. And always, from the roof of his rented house, he could see the twin snow-capped peaks of Ixtaccihuatl and Popocatepetl, forty miles away – thanks to the clear dry air of Mexico City before the internal-combustion engine – rising respectively to 16,000 and 16,500 feet, and tempting him as surely as any girl.

Oscar Eckenstein joined him in Mexico before the end of 1900,

and together they ascended both mountains. They camped for a couple of weeks at 14,000 feet up Ixtaccihuatl, and when they finally came down, fit and exhilarated and typically claiming a clutch of new world records (again, not unreasonably: not many European or North American climbers had attempted the Mexican mountains), they were presented with what was supposed to be deflating news.

On 22 January 1901, Queen Victoria had died at Osborne House on the Isle of Wight. The *jefe* of the parish of Amecamema who gave Crowley and Eckenstein these sorrowful tidings 'assumed an air of sympathetic melancholy' and broached the subject only gently, by degrees. He was not aware that he was dealing with two iconoclasts. Aleister and Oscar 'broke into shouts of joy and an impromptu war dance'.

Not many Englishmen, scattered across the huge diaspora of the Empire, reacted in such a way to the news of the demise of the Great White Queen. But some did, men and women who, like Crowley, considered that their country and its culture had stultified during her long regime. Aleister would explain:

> While she lived it would be impossible to take a single step in any direction. She was a huge and heavy fog; we could not see, we could not breathe . . . Smug, sleek, superficial, servile, and snobbish, sentimental shopkeeping had spread everywhere . . . It is hard to say why Queen Victoria should have seemed the symbol of this extraordinary state of suspended animation. Yet there was something in her physical appearance and her moral character which pointed to her as the perfect image of this inhibiting idea . . . England had become a hausfrau's idea of Heaven, and the Empire an eternal Earl's Court exhibition.

Twenty years later Lytton Strachey's collection of monographs *Eminent Victorians* would represent most perfectly this reaction against Victoriana. Before that, in 1914, Rupert Brooke's generation of

young men would march happily into a world war in the belief that fire and blood alone could purge the mouldering Western civilisation:

> To turn, as swimmers into cleanness leaping,
> Glad from a world grown old and cold and weary.

Aleister Crowley was immune to such sentiments in 1914 because he had experienced them much earlier; had already turned away; had already leapt from the soiled old values into his own variety of cleanness. His response to Victoria's death was not entirely idiosyncratic, but it was exceptional and sincerely felt. It was also extremely personal. Perhaps because she reminded him of his mother, he had from a very young age disliked the Queen-Empress, and once as a child had announced that he intended to lead the forces of Patagonia against her. It is also difficult not to spot some lingering influence from his egalitarian Plymouth Brethren upbringing: had not his father taught him to view 'peer and peasant as equals'? We are all worms in the eyes of the Lord.

Crowley and Eckenstein separated in Mexico, having vowed to undertake a major Himalayan expedition. Aleister moved north across the border again, this time up the west coast to San Francisco: 'A glorified El Paso, a madhouse of frenzied money-making and frenzied pleasure-seeking.' In May 1901 he took ship from there to Honolulu, continuing to Japan, Shanghai and Ceylon – where he was reunited with the benificiary of 'Laura's' troublesome £100, Allan Bennett. Bennett, 'the noblest and gentlest soul that I have ever known', had become a Buddhist. Aleister lost no time in soaking up his friend's new philosophies and in taking lessons in yoga. He immersed himself so thoroughly in these studies that he decided at one point to cancel the attempt on Chogo Ri, or K2, or Mount Godwin-Austen, which he had agreed with Eckenstein, and wrote to the latter announcing this decision. Bennett decided, however, that he should not let Oscar down, and a cable was sent reversing the message of the first letter.

So he travelled north through India early in the winter of 1901–02, and in March he met in Delhi with Eckenstein and his

team. There was another Cambridge man, Guy Knowles, a thirty-three-year-old Swiss named Jacot Guillarmod, and two Austrians, H. Pfannl ('reputed the best rock-climber in Austria') and V. Wesseley.

Eckenstein and Crowley had formulated a written (written, that is, by Aleister) contract for the expedition. Its purpose was to 'climb a mountain higher than any previously ascended by man'. To this end, according to Crowley's version of the agreement, he personally had donated £1,000 towards the expedition, which entitled him to become second-in-command to Eckenstein's leader. Many years later, however, Guy Knowles told Crowley's executor John Symonds that Aleister had handed over not a penny: he, Knowles, had borne the financial burden. This version of events accords perfectly with Crowley's attitude towards his and other people's finances.

They had decided upon K2 because, at 8,611 metres, or 28,250 feet, it was the second-highest mountain in the world, and because Eckenstein had been a member of the 1892 expedition led by Sir William Martin Conway which had surveyed the region and named the mountain after the great explorer, geologist and surveyor of the area, Henry Haversham Godwin-Austen.

The Eckenstein–Crowley assault was the first serious attempt to conquer this peak. K2 was considered to be almost unscalable; more difficult, if anything, than Everest. Given those obstacles – and the uncomfortable fact of Crowley's undisguised contempt for all of his colleagues but Eckenstein, and the deputy leader's insistence on taking all his poetry books halfway up the hill – the expedition did well. They left Srinigar on Monday, 28 April 1902. Two months later, on Sunday, 29 June, they were almost at 20,000 feet, and Crowley – marching where no man had ever previously set foot – was suffering from snow-blindness, but consoling himself with the thought that he was higher on earth than any other poet had ever been – and writing 'better' verse than Percy Bysshe Shelley had ever achieved in those European molehills, the Alps!

There is debate about the final nature of their achievement, however. Eckenstein would claim that on Thursday, 10 July, an

advance party of Wesseley and Guillarmod attained 22,000 feet, or 6,705 metres, after which they all descended the mountain with a new world-altitude record (and with Aleister Crowley now claiming yet another world's first to put on top of his highest-ever-poet and best-poetry-written-at-altitude markers: he had gone down with malaria, and claimed to be the first person ever to suffer from that ailment at 20,000 feet).

But they are credited in the climbing histories with reaching only 6,600 metres, or 21,653 feet.

If Eckenstein's claim is correct, then so is that of Crowley's executor John Symonds, who insists that the 22,000-feet mark is, 'two hundred feet higher than the highest point reached seven years later by the Duke of Abruzzi, whose expedition to K2 is considered, erroneously, to be the first attempt ever made on this mountain.'

The difficulty is that climbing historians who do *not* assume the Duke of Abruzzi's 1909 expedition to have been the first attempt on K2, who happily credit Eckenstein and Crowley with that feat, also clearly state that Abruzzi's team reached 6,666 metres, or 21,870 feet, 66 metres and 217 feet higher than Wesseley and Guillarmod's official height of 6,600 metres. What is more, the Duke's party attained 7,500 metres on the neighbouring peak of Chogolisa, which remained the world-altitude record until it was bettered on Everest in 1922.

The importance of the detail is that if Eckenstein and Crowley were correct in their claim, then their 1902 achievement would not have been improved upon for fully 36 years, when in 1938 an American reached 7,925 metres on K2.

Even if – as is possible, if not provable – they were incorrect, their party reached just 6,600 metres, and was bettered seven years later by the Italians, it was a formidable feat. They set a new altitude record; they got higher up the most difficult peak in the Himalayas than anybody until the enormously well-resourced Duke of Abruzzi came along in 1909; and neither Crowley nor Eckenstein nor the Duke would live to see the mountain finally conquered. Not until June 1954, a year after the conquest of Everest, did two Italian climbers manage to set foot on the peak of K2. Those two men, Lino

Lacedelli and Achille Compagnoni, walked for more than three-quarters of their 8,600-metre journey in the obscured footsteps of Aleister Crowley.

On Saturday, 4 October 1902, Aleister took ship from Bombay, reaching 'ghastly' Aden five days later and Cairo on Thursday, 9 October. He stayed in Egypt for almost a month, preferring the loose life at Shepheards Hotel to the Pyramids, which he managed completely to ignore – 'I wasn't going to have forty centuries look down on me! Confound their impudence!'

He had sustained a correspondence with his old college friend Gerald Kelly, who had opened a studio in Paris, where Aleister arrived at the end of 1902.

He discovered instantly that little, sickly Gerald had placed himself at the centre of a great Bohemian city in one of its purple patches. Here, as Arnold Bennett would discover twelve months later when he watched the city welcome the English King Edward VII, was *style* . . .

> Even the churches wore tiaras of fire. Lighted gas . . . ran in quivering lines along the borders of all the massive edifices in which France administers education, justice, comedies and music-dramas to the citizens of its metropolis. And as one travelled gradually from the east to the west by way of the principal boulevards, the blaze became prodigal, vast, overpowering . . .

5

Up and Up in Paris, Strathpeffer and the Himalayas

He was a fake . . . but not entirely a fake.

– W. Somerset Maugham

During Aleister's long absence, Gerald Kelly had made a new friend – one whom, unlike his old university chum, he would keep until that new friend predeceased him in 1965.

He was a twenty-six-year-old writer, who had also been brought up by a clergyman (in his case an uncle who became his adoptive father), named William Somerset Maugham. Maugham's major novels were still ahead of him in 1902 – he had published only one, *Liza of Lambeth*, in 1897. But he had a reputation as an up-and-coming playwright, he was shy but personable, he shared some of Kelly's sexual preferences, and both young Englishmen, battling for an artistic reputation in the cultural capital of Europe, were captivated by Paris.

Gerald Kelly's life revolved around his studio in the rue Campagne Première and a celebrated Montparnasse restaurant named Le Chat Blanc. Let us turn once more to Arnold Bennett for a brief description of each:

Bennett informed his diary in June 1904:

> I went down to Kelly's studio, a very large one, and he
> showed me a lot of his work which interested me very
> much. He made some good remarks about the present
> condition of painting. He said painters were afraid of
> making mistakes, afraid of being vulgar, and that they
> never used their eyes in search of material. They all
> painted the same things. He said some artist had said
> to him: 'We paint like governesses.' I certainly
> thought Kelly was doing good and original work, both
> in landscape and portraiture.

There, then, a sketch of Crowley's Parisian host, from the most
respected English novelist of the 1910s. Next, Le Chat Blanc . . .
Bennett continued:

> Afterwards, he took me to dine at the Chat Blanc.
> Stanlaws, the 'creator' of the 'Stanlaws girl' was there,
> a terrible American, and also a girl I had previously
> seen at Kelly's. The girl and Stanlaws and the man
> who was the girl's host threw bread at each other, and
> sang American songs very loudly. It was terrible at
> times. I could not stand such manners and customs
> for long. It is these things that spoil Montparnasse.
> We finished up at the Café de Versailles.

If the second and third sentences of that last paragraph sound
unnervingly familiar, it is because Le Chat Blanc was, of course, a
prototype of the kind of Left Bank eating, drinking, flirting and
singing parlour which was so to entice Hemingway, Fitzgerald,
Miller and company a couple of decades later. It was no more than
a narrow upstairs room hard by the Gare Montparnasse, with three
tables arranged in a horseshoe shape, all of which were permanently
reserved for British and American artists. The 'Stanlaws' referred to
by Bennett was another friend of Kelly's, a supposedly American

artist named Penrhyn Stanlaws who made a lot of money from selling daring sketches of young women – the 'Stanlaws girls'. In fact, his name was Stanley Adamson and he had started adult life as a stable boy in Dundee. More than one young Briton reinvented his past in Paris.

The artists were served by a 'motherly' waitress in a black dress and white cap named Marie. The *patron*'s method of calling time after a long day and night of arguing and bun-throwing was to stack the chairs on top of one another. Here the expatriates gathered: 'A sort of international clique,' Aleister Crowley would write, 'of writers, painters, sculptors, students and their friends.'

Kelly introduced Crowley to Le Chat Blanc, and there Crowley himself met the sculptor Auguste Rodin, the intellectual essayist Marcel Schwob and the young English writer W. Somerset Maugham. Despite himself, Crowley was impressed by the milieu – and he would remain impressed. Writing the place up in a short story titled 'Snowdrops from a Curate's Garden', he renamed it Au Chien Rouge, and painted the place as a temple of intellectual rigour:

> In such a circle humbug could not live. Men of high intellectual distinction, passing through Paris, were constant visitors at the Chien Rouge. As guests they were treated with high honour; but woe to the best of them if some chance word let fall led D. or L. to suspect that he had a weak spot somewhere. When this happened, nothing could save him: he was rent and cast to the carrion beasts for prey.

There is a large discrepancy here between Aleister's impression of the restaurant and that of Arnold Bennett. Some of it was to do with temperament, some with taste and some with age. Some of it is also to do with a distaste or acceptance of posing and falseness. The two men did meet – in Marcel Schwob's apartment.

According to Crowley, who described Bennett as:

very ill at ease to find himself in Paris in polite society
. . . everything was alike a source of innocent wonder.
He was very much pleased by the generous amount of
respect which he received on all hands simply for
being a novelist. His speech and his appearance
attracted no insult from literary circles in Paris.

Aleister's reference to Arnold's accent and dress allude to the
man's middle-class Staffordshire background. It indicates that while
Paris may not have noticed such things, Crowley did. Bennett
himself would record his own version of that and a later meeting in
his memoirs of *Paris Nights*, where he carefully disguised Crowley as
'The Mahatma' . . .

The Mahatma said that he had arrived that evening
direct from the Himalayas, and that he had been made
or ordained a 'khan' in the East. Without any preface
he began to talk supernaturally. As he had known
Aubrey Beardsley, I referred to the rumour that
Beardsley had several times been seen abroad in
London after his alleged death.

'That's nothing,' he said quickly. 'I know a man
who saw and spoke to Oscar Wilde in the Pyrenees at
the very time Oscar was in prison in England.

'Who was that man?' I inquired.

He paused. 'Myself,' he said in a low tone.

This entirely reliable report is the record of one man desperately
attempting to impress another. Crowley had not come that evening
directly from the Himalayas. He had never known Aubrey Beardsley,
merely had an affair with a friend of Beardsley's, an episode which
he clearly saw advantage in elaborating for the ears of bohemian
Paris. There can have been no reason for his slipping instantly into
mystical incantation in the company of the staid, prosaic Bennett,
other than to astonish the older, more successful man. To round off
so brief an encounter with unverifiable boasts about having

experienced an ethereal rendezvous with his old hero Wilde, shows a rare ambition.

But in this way did the twenty-seven-year-old Crowley leave his mark. He was simply amazing. The likes of Arnold Bennett may have seen through his pretensions, and even found them mildly irritating, but they could not ignore the man.

Nobody could ignore the man: he made sure of it. He disdained the young Maugham (he attempted in truth to disdain almost everybody, including Gerald Kelly, whose painting he claimed to excoriate: 'He would use paint the colour of Thames mud for the highlight on the cheek of a blonde.'). William Somerset, according to Crowley, was the object of many cruel practical jokes over the crème de menthe and *oeufs sur le plat* at Le Chat Blanc. 'Maugham claimed to have ambitions to become a man of letters and his incapacity was so obvious that I am afraid we were cruel enough to make him the butt of our wit . . . [he] suffered terribly under the lash of universal contempt'. Butt of the Crowley wit or not, in his turn, Maugham was fascinated by Gerald Kelly's newly arrived friend.

The novelist would reflect much later:

> He was a fake . . . but not entirely a fake . . . the odd thing was that he had actually done some of the things he boasted of. As a mountaineer, he had made an ascent of K2 in the Hindu Kush, the second highest mountain in India, and he made it without the elaborate equipment, the cylinders of oxygen and so forth, which render the endeavours of the mountaineers of the present day more likely to succeed. He did not reach the top, but got nearer to it than anyone had done before.

It was perhaps inevitable that Maugham should have found in Aleister Crowley a fictional lead. Crowley, masked as 'Oliver Haddo', features in Maugham's second novel, *The Magician*, which was published in 1908. It is an eminently forgettable book – indeed, Maugham himself would ashamedly plead with a later readership to forget it. But it gives us a vivid view of the young Aleister in Paris:

> 'Marie,' cried Haddo upon entering that renowned Montparnasse eaterie 'the Chien Noir' . . . 'Marie, disembarrass me of this coat of frieze. Hang my sombrero upon a convenient peg . . . I grieve to see, O most excellent Warren, that the ripe juice of the *apéritif* has glazed your sparkling eye.'

To cut *The Magician* short: Oliver Haddo, a tall, fleshy man wearing extravagant clothes and given to bragging in flowery phrases, is a self-advertised magician with a house in Scotland named 'Skene'. When a young woman spurns his advances, Haddo seduces her with the help of spells, and sacrifices her horribly to an experiment which involves the growth of homunculi in test tubes. Maugham may have intended some brutal metaphor – his elder brother's wife was a good friend of Gerald Kelly's sister Rose, and by 1908 Rose Kelly's marriage to Aleister Crowley was, as we shall see, a deeply unhappy union. But the role of fiction in embellishing the character of Aleister Crowley can hardly be overstated. The man might, as Arnold Bennett dutifully recorded, have behaved oddly – but *homunculi!* Maugham meant it, though. Many years later, in December 1955, he would tell Christopher Isherwood that, 'He hadn't known that many really evil men. The only two he could think of offhand were Aleister Crowley and Norman Douglas . . .' Maugham did not elaborate, except to add that Douglas (an itinerant writer who would himself hardly feature on most people's list of demons of the twentieth century) 'commanded devotion even from the little boys to whom he behaved so meanly.'

Crowley claimed to hate *The Magician*. In truth, it thrilled him to be caricatured and fictionalised between so many different covers. What was his life but a great drama, and what were all these books but an open recognition of that fact? A drama misunderstood, to be sure, and caricatured and even reviled – but was that not the fate of genius down through the ages? His comment to Maugham when they met in London immediately after the publication of *The Magician* – 'I almost wish that you were an important writer' – has usually been interpreted as a disgusted put-down. It was in fact

probably no more than the truth, for in 1908 W.S. Maugham was not yet a particularly important writer, and an important writer might have attracted some genuine attention to his leading men.

And why, if he was so annoyed by *The Magician*, would Aleister Crowley have drawn the eyes of a wide public to his own role in the book by writing an – albeit pseudonymous – critique of the novel in *Vanity Fair*? 'The author, bless my soul!' he proudly expostulated in print . . .

> No other than my old and valued friend, William Somerset Maugham, my nice young doctor [Maugham had been a medical student] whom I remembered so well from the dear old days of the Chat Blanc. So he had written a book – who would have believed it!

He then detailed a series of publications from which he claimed Maugham had lifted wholesale sections of *The Magician* – publications which Crowley himself had told their mutual friend Gerald Kelly to buy, back in the salad days of the Order of the Golden Dawn. According to Crowley, when Maugham and he next met, Maugham meekly pointed out that the *Vanity Fair* piece had managed to miss some of his plagiarisms. 'The editor made me cut the article,' replied Aleister.

Before he left Paris Crowley had one more curious encounter. It was truly bizarre, if not actually historic in significance, and we have only his word for it. But the time and the place both fit.

In March 1903 the fifty-year-old General Sir Hector Macdonald KCB DSO ADC had been called back to London from Ceylon, where he was Governor and Commander-in-Chief-of Troops. Hector Macdonald had been born in Dingwall, just to the north of Crowley's Loch Ness-side home, and this, combined with his presence in the Ceylon which Aleister had visited a year earlier, had led Crowley to keep an interested eye on the Highlander's career.

In London, Macdonald was confronted at separate meetings by the Commander-in-Chief of the British Army, Earl Frederick Sleigh 'Bobs'

Roberts, and by King Edward VII, with allegations that Macdonald had committed a homosexual act in Ceylon. Edward followed his meeting by declaring that a court martial would be convened back in the colony. On 20 March Sir Hector travelled to Paris, intending to take a ship from Marseilles to resume his command and await trial. No publicity had yet been afforded this affair.

On 24 March 1903, according to Aleister Crowley:

> I dropped into the Hotel Regina . . . to lunch. At the next table, also alone, was Sir Hector Macdonald. He recognised me and invited me to join him. He seemed unnaturally relieved; but his conversation showed that he was suffering acute mental distress. He told me that he was on his way to the East. Of course I avoided admitting that I knew his object, which was to defend himself against charges of sexual irregularity brought against him in Ceylon.

On the morning of the next day, Wednesday, 25 March 1903, the Paris edition of the *New York Herald* featured the full details of Hector Macdonald's plight across two columns of its front page. Having bought the newspaper, General Macdonald returned to his room in the Hotel Regina and shot himself dead. If Crowley's story is true, and it must be repeated that the date and the environment both ring true, then he was almost certainly the last Englishman to talk to the living subject of one of the great Edwardian scandals. As a footnote, he learned from Gerald Kelly (who perhaps received his gossip from W.S. Maugham's brother at the Embassy) that the dead General's pockets had been found to be stuffed with pornographic photographs – *which he had bought that very morning*! 'The psychology is appallingly obscure,' mused Aleister . . .

Shortly after Macdonald's suicide Crowley left Paris for London, where he met Oscar Eckenstein and the two men shared a sleeper north to Inverness and a summer's fishing and climbing around Boleskine – where Aleister discovered that word of his magical hobby had so distressed the locals that by 1903 few of them would

go near the house, preferring to travel to Inverness by way of a long, high detour. He took up meditation and he fiddled with his writing, but after Eckenstein's departure boredom set in again. He would relieve it in the most extraordinary manner.

On Monday, 13 July, Aleister travelled south to Edinburgh to engage a woman servant (no local being available), stock up on wine, and meet Gerald Kelly off the London train.

Kelly was on his way to Strathpeffer, a douce Victorian spa town just to the north-west of Inverness, which was set in the Highland landscape rather like an Indian hill station in the Himalayan foothills. Kelly's mother Blanche and his sister Rose were already taking the waters at Strathpeffer, and awaiting a suitable solution to a family difficulty. Rose was, at the age of twenty-seven, a widow. She had been married when young to an older man, a Major Skerrett, who had fairly quickly predeceased his young bride. The Kelly family was in 1903 planning another wedding for Rose, this time with a man named Howell who was travelling from America for the nuptials.

Rose herself had complicated matters by conducting an affair with a married man, by attracting the attentions – she was a fine-looking woman – of divers elderly bachelors and widowers, and by extracting £40 from her mother under the false pretence that she needed an abortion. (The £40 – which ninety-five years later would be the equivalent of £2,000, giving an indication of the cost of private illegal abortions in the Edwardian period – was spent on 'dinners and dresses'.) What with one thing and another, Mrs Blanche Kelly was anxious for Howell to arrive and take this troublesome daughter off her hands. In the meantime, Strathpeffer was surely as safe a place as any.

Early in August, Gerald Kelly arrived at the spa with his friend from Boleskine, an athletic, impressive figure, extravagantly spoken and dressed from head to toe in full Highland fig.

On Tuesday, 11 August, Aleister and Rose fell into conversation over luncheon, and she told him the full extent of her predicament. His reply, for which we have only his authority, was: 'Don't upset yourself about such a trifle. All you have to do is to marry me. I will go back to Boleskine and you need never hear of me again – unless I can be of further assistance to you.' This solution would, he explained, neatly get her family off her back, as she would be answerable not to the Rev Frederick Festus and Mrs Blanche Kelly but to her husband, Aleister. And he, Aleister, would happily allow her to carry on her affair with the married man.

Subsequent events indicate that there may have been a little more romance involved in the arrangement than Crowley would later admit. But the upshot is quite undeniable. It is in black and white at the General Register Office in Edinburgh. Early on the morning of Wednesday, 12 August – the Glorious Twelfth, the start of the grouse season – 1903, Aleister Crowley and Rose Skerrett, née Kelly, left Strathpeffer and hastened a couple of miles down the road to the sheriff's office at Dingwall. There they discovered the office to be shut, so Aleister roused a solicitor, who informed him that the sheriff's attention was, in Scottish law, quite unnecessary. If they met at the solicitor's office at 8 a.m. he, Alexander Ross, would take care of the proceedings.

And so Aleister and Rose were married at Ross's office in Tulloch Street, Dingwall, shortly after 8 a.m. that morning, witnessed by Ross and by his clerk Andrew Robertson MacLeod. They took the married surname Macgregor: he was wed as 'Aleister Crowley Macgregor, Landed Proprietor (Bachelor)', and she as 'Rose Skerrett Macgregor (Widow)'.

At that point little Gerald Kelly burst into the room and, upon learning that the knot was tied, threw a futile punch at Crowley. The party adjourned: Aleister back to Boleskine and Rose to Strathpeffer, where one of her unlucky suitors, an elderly solicitor, attempted desperately to persuade everybody that the proceedings could be nullified. Crowley was summoned back to Strathpeffer, where it was agreed to do the decent thing and return to a Dingwall 'seething with scandal' to have the marriage officially confirmed by

the local sheriff. On Monday, 17 August, Sheriff-Substitute Alex Dewar of Ross, Cromarty and Sutherland issued his warrant, and the marriage was complete. Rose and Aleister, somewhat at a loss for honeymoon arrangements, went to the station and bought tickets to the end of the line. This took them, giggling like naughty children after a successful prank, to 'some place on the west coast of Scotland, the name of which I have entirely forgotten', which was probably the large Station Hotel at Kyle of Lochalsh. There they drank a lot of champagne and made love.

If there was, on Aleister's part, no initial feeling for his bride, it quickly grew. Before long, he would confess to realising that he was married to 'one of the most beautiful and fascinating women in the world'. They left the west coast of Scotland not to go their separate ways, she to her married lover and he back to the tedium of Boleskine, but to empark upon a lengthy transoceanic odyssey. It would in time grow cold and sour, but for a while Aleister Crowley Macgregor knew undreamed-of bliss.

He wrote to make his peace with Gerald Kelly ('I thought at the time you were only bitter because you felt yourself wrong') and to inform his mother of his newly wedded state ('The Rev F.F. Kelly, the bride's father, preached such a beautiful sermon over the open grave'), and the happy couple set off for Paris, Marseilles, Cairo and Ceylon. By the time they reached Asia, Rose was pregnant, and they turned round to head back to Europe . . . via Egypt, and an epiphany.

To suggest, as one ardent disciple has done, that it is impossible for anybody to write about Aleister Crowley who does not understand and sympathise with his magic, is to speak a grain of truth. The difficulty facing most agnostics, however, is that all of those who have taken that injunction literally, all of the hagiographers from Crowley himself down to his self-proclaimed offspring, have produced biographical works which do more to obscure than to

explain the man. That is certainly as Aleister would have wished it, but it need not be the last dreamy word.

One of the difficulties faced by a sympathetic but curious and sceptical biographer of Aleister Crowley is that he was a proven liar and charlatan. He lied about many things – often just to make life interesting – and he embellished almost everything else, usually for the same reason. Nor did his fictions end with the distortion of mundane reality. Indeed, as we have seen, mundane reality – the dates of events, the timetable of expeditions, the lunches with acquaintances – was often recorded with bland punctiliousness. It was the important things that got pumped up. According to many of his contemporaries and mystical colleagues, he lied about his religion. He boasted of supernatural acts which others, such as Gerald Kelly, would later disclaim as 'pure invention'. Where, then, does this leave the biographer who begins by accepting one man's 'pure invention' as his own gospel truth?

We cannot say how much of Aleister Crowley's magick was the genuine ecstasy of an imaginative, visionary mind, and how much of it was so much guff, laid on *pour épater le bourgeoisie,* or in a well-intentioned attempt to impress such bourgeois as Arnold Bennett. We may believe, for example, like Bennett, that he did not have a conversation with the *alter ego* of Oscar Wilde in the Pyrenees during Wilde's incarceration in Reading Jail. We may have difficulty in crediting that the Foyers butcher cut through an artery because Aleister had absently scribbled on a bill; and we might not be able to picture one hundred and fifteen playful demons frolicking about the living-room of Boleskine House. If we are sceptical about such things, we are not alone – we are, indeed, in the well-qualified company of such colleagues and friends of Crowley as W.B. Yeats, Oscar Eckenstein and Gerald Kelly. But this subject was a fierce imagination locked inside a rampant egotist. Who is to say what he believed? Who is to say what he *saw*? Who is to say what he *knew*? Who, in the end, is to say that Aleister Crowley did not learn to harness remote and unexplored corners of the human brain, and put them paranormally to work? An atheist is certainly not debarred from writing accurately about the lives of men who make

such claims; he is – in common with all adepts who did not know the subject – simply unable to substantiate the claims. Best merely to report, and leave beliefs to the committed and messages to Western Union.

In the spring of 1904 he had the experience that, he would advertise, changed his life. The fact that his life did not in fact take much of a discernible deviation in the following years – it continued along as eccentric a course as ever – is by the by. He considered that a vision in Cairo crystallised his beliefs and his purpose.

At a series of invocations, undertaken with Rose, he received from the Angel Aiwass, on behalf of the Secret Chiefs, between Friday, 8 April, and Sunday, 10 April 1904, his *Liber Legis*, or *The Book of the Law* of the new epoch of mankind. A new millennial religion was born; the *Book* was to be its Bible, its Koran; and Aleister Crowley was to be its prophet, its saint, even in time its godhead.

It is, in comparison with most of the other texts of world religions, a short book. It establishes a simple law, the Law of Thelema. *Thelema* is the Greek for 'Will', and the Law of Thelema insists – famously, thanks to Crowley, although perhaps not yet so famously as 'Love thy neighbour' – 'Do what thou wilt shall be the whole of the law.'

> Love is the law, love under will.
> There is no law beyond Do what thou wilt.

This was, the cynical may suggest, an extremely convenient set of maxims for a self-indulgent twenty-eight-year-old Edwardian man who was not given to restricting his pleasures. It was followed by a series of future predictions of the Old Mother Shipton variety. The present 'outcrop of dictatorships . . . prevalence of infantile cults . . . popularity of the cinema, the wireless, the football pools . . . war, the atrocities which occur daily . . .' would be cured by the Law of Thelema – 'the only way to preserve individual liberty and to assure the future of the race.' The verses which followed included a vague prediction of world war (which has been taken since by many of Aleister's followers as proof of his powers, although it must be said

that he was not alone among educated westerners in 1904 in anticipating – even *expecting* – some global bloodbath to drain the tension from post-Victorian international affairs); and one or two lines which would return to haunt Aleister Crowley, lines about a special perfume which required blood, and 'The best blood is of the moon, monthly: then the fresh blood of a child . . .'

He and Rose packed. The handwritten text of *The Book of the Law* was apparently thrown carelessly into a trunk, and they returned to Paris. There the couple met with Arnold Bennett, and – for Bennett kept a journal – we once again have a window throwing everyday light onto the increasingly unusual life of Aleister Crowley; a view which reminds us that he still did commonplace things like going out to eat . . .

Bennett told his diary of Friday, 22 April 1904:

> In response to a telegram, I went to lunch with Aleister Crowley and his wife (Kelly's sister) to-day at Paillards. He had been made a 'Khan' in the East, and was wearing a heavily jewelled red waistcoat, and the largest ring I ever saw on a human hand. I rather liked him. He said some brain specialist had told him that what made a great brain was not the number of facts or ideas known, but the number of facts or ideas co-ordinated and co-related. I said: 'Of course.'

That 'I rather liked him', from the careful Bennett, was as glowing a compliment as Aleister would ever receive. Bennett's host was not so gracious. 'His [Bennett's] accent and dialect,' reported Crowley of that same luncheon, 'made his English delightfully difficult.'

The Crowley-MacGregors returned once more to Boleskine, where Rose gave birth to a baby girl, whom her father christened Nuit Ma

Ahathoor Hecate Sappho Jezebel Lilith. To avoid mother and daughter having to winter in the Highlands, they departed in October for St Moritz. There, in the January of 1905, Aleister met a man named Clifford Bax, who later left an account of their acquaintanceship which illustrates better than most Crowley's attractions, and strength of personality, and limitless ego. Bax wrote:

> A powerful man with black magnetic eyes, walked up to me. He wore a velvet coat with ermine lapels, a coloured waistcoat, silk knee breeches, and black silk stockings. He smoked a colossal meerschaum . . .
>
> Every evening we played chess together and to play chess with a man is to realise the voltage of his intellect. A strong and imaginative mind directed the pieces that opposed me. Moreover, he was an expert skater, an expert mountaineer; and in conversation he exhibited a wide knowledge of literature, of occultism, and of Oriental peoples.
>
> I am certain, too, that with a part of his personality he did believe in his Messianic mission. On the eve of my return to England, after we had played the last of our chess games, he exhorted me to devote myself to the study and practice of magic. I understood that he would instruct me. 'Most good of you,' I stammered, 'but really, you know – perhaps I am not quite ready. I must read a little more first.'
>
> 'Reading,' he answered, 'is for infants. Men must experiment. Seize what the gods have offered. Reject me, and you will become indistinguishable from all these idiots around us.' He paused, and then asked abruptly, 'What is the date?' 'January 23rd,' I answered. 'What is the year, according to the Christian calendar?' 'Nineteen hundred and five.'
>
> 'Exactly,' said Crowley, 'and in a thousand years from this moment, the world will be sitting in the sunset of Crowleyanity.'

Only a man raised in the certainties of such as the Plymouth Brethren could have sustained such a faith in the power and longevity of organised religion.

Aleister and Rose repairing in the following spring of 1905 to Scotland – where they were joined by Aleister's Swiss climbing colleague from the K2 expedition, Jacot Guillarmod. These were still happy days for Aleister Crowley. Marriage and fatherhood unaccountably suited him; his bank account had not yet haemorrhaged; he was full of writing, climbing and a modest kind of achievement. The pranks which were played on the unfortunate Guillarmod indicate that our extrovert was a lively, cheerful, companionable man.

Jacot expressed a lively interest in hunting, and was anxious to return to Lausanne with the head of some Highland vertebrate to hang on his wall. Aleister managed to convince the Swiss that northern Scotland was home to a feral sheep, a wild, untameable beast, rarely seen, which was known as the Haggis. Guillarmod swallowed the tale, and Crowley arranged for his friendly local ghillie Hugh Gillies to burst into the billiard room two mornings later exclaiming: 'There's a Haggis on the hill, my lord!'

He then led Guillarmod, elephant gun in hand, through the artificial trout lake in the grounds to 'throw the Haggis off our scent', up a rain-drenched hill, to where a local man's prize ram was eating a strategically laid supply of oats. Jacot blew the hind quarters off the beast, and carried his trophy proudly home.

More significantly, he also took back with him to Lausanne plans to attempt with Crowley immediately an assault upon Kangchenjunga, the third-highest mountain in the world.

For his own reasons, Oscar Eckenstein did not go on the 1905 Kangchenjunga expedition, which may be as good a reason as any for its ending in catastrophe. For in the absence of Eckenstein, who else could the sainted Aleister respect? Without him, the party met on the last day of July 1905, in Darjeeling. Guillarmod had brought with him two Swiss Army officers with Alpine experience, Alexis Pache and Charles Reymond. Crowley himself added to the expedition, which it had been agreed he should lead, an Italian hotel

manager named Alcesti C. Rigo de Righi. Alcesti had never before attempted a single mountain. He was carried along on the grounds that he spoke Hindustani and Tibetan, and because his experience of the catering trade would be useful in ordering provisions.

In climbing Kangchenjunga Aleister Crowley was travelling closer to the homes of his Secret Chiefs than ever before. He could have half expected to stumble upon their hearths. To the people of Sikkim and Nepal *Kang-chen-zod-nga* ('the five great treasuries of the snow'), although not so high as Everest or K2, was the abode of the gods who bestowed prosperity and benevolence upon them. For this reason nobody who, since the first conquest in 1955, half a century after Crowley's attempt, has reached the mountain's 8,585-metre (28,150 feet) summit, has stood on the actual top of the hill. All successful assaults have honoured a promise made by the first conqueror, Sir Charles Evans, later President of the Alpine Club, to the Maharaja of Sikkim in 1955, to stop just short of the peak.

Aleister Crowley and his team got nowhere near to hurting local feelings. Crowley's behaviour alone took care of that: it was, from start to finish, abominable. Within days of setting out on Tuesday, 8 August, he had fallen out with Guillarmod over his habit of trekking on ahead without leaving markers, and – much worse – for his insistent, sadistic beating of the porters. By the time they reached 21,000 feet a coolie had died and there were effectively two leaders of the expedition: Guillarmod, whom everybody else followed, and Crowley, who was going his own way. 'It was nothing more,' Aleister would unconvincingly attest, 'than the resentment of a foreigner at being led by an Englishman.'

The crisis came on the evening of Friday, 1 September. The assault on the summit had effectively been abandoned at 21,000 feet, and a party of Guillarmod, de Righi and Pache decided to make their way down for a relatively comfortable night from Camp V to Camp III. The three Europeans and three coolies were on a rope, when an ill-shod coolie slipped on the ice and fell. He took with him the two other coolies and Alexis Pache. Guillarmod and the inexperienced de Righi thought at first that they might hold their four colleagues when, in Guillarmod's words, 'Immediately the cord

became stretched, the snow slipped away quickly from under our feet, thus causing an avalanche which soon took on enormous proportions.'

De Righi was knocked senseless. The half-stunned Guillarmod revived him, and the two began to dig for the other four, shouting for help all along. Hearing their cries, Charles Reymond quickly appeared from Camp V, and joined in the futile excavation.

Aleister Crowley, who was also still up at Camp V, had heard the cries for help along with Reymond. But he did nothing. His later explanation was that he had advised Guillarmod not to make the descent, and that once Guillarmod had rejected his advice the Swiss had also abrogated any claim on his person; and that although Reymond – who had 'not yet taken off his boots' – had indeed left Camp V to help, Reymond did not return to tell Aleister of the disaster and request his help. So Crowley turned over and went to sleep.

The others, digging for their comrades' bodies in the cold early light of the following morning, saw him making his descent from above. But he did not see them, although he claimed to have heard ghostly voices around the region of Camp IV. He carried on down, and that was the last that any of the only mountaineering expedition ever to be led by Aleister Crowley saw of their leader until Darjeeling. He had fallen out with them, ignored their peril, and then deserted them on the side of the third-highest mountain in the world. 'Had he ever been a member of the Alpine Club,' commented the pioneering British skier Arnold Lunn over forty years later, 'he would certainly have been expelled once the facts about his callous attitude after the accident became known.' According to Guillarmod it had been 'Crowley's last villainy'. It had been inexcusable behaviour, and it set a certain tone for the remainder of his life. What there had been of joyous, generous innocence in Aleister Crowley may have died on the evening of Friday, 1 September 1905, in the shadow of the home of the Secret Chiefs.

6

Publisher and Entrepreneur

Dust we are, and to dust we will return

– Aleister Crowley

Why had he behaved as he did on Kangchenjunga? Because it was in his character. Under immense stress, in danger at a great altitude, with no Eckenstein figure to control or comfort him, with civilisation far away, the unrefined Aleister Crowley bubbled to the surface. He revealed himself as a spoiled and weak little boy, who ran from rather than confronted unpleasantness – as his mother's child, in fact. Nothing could have been more unpalatable. He hated to recognise that fact himself, and wasted no time once back in northern India in preparing newspaper articles which blamed Guillarmod and De Righi for the accident – articles which the Swiss and the Italian rebutted with fury and conviction. In the end, nobody, not even Aleister, can have believed his own self-serving version of the tragedy. To any ordinary person, the mirror would have been an unappealing sight for months after 1 September 1905. And Crowley was himself not so lost to honour as to believe that he had nothing to answer for. But . . . was he not a prophet . . . or a saint? Was there no immunity from ordinary mores for the holy, for

the founding figure of a new millennial religion? There, and there alone, lay some consolation.

It was his birthday on Thursday, 12 October 1905. He spent it in Calcutta alone – if we exempt the probable company of an occasional *nautchee* girl. From the age of thirty onwards he became impossible to live with, unless the cohabitee was in love with his body, his spirit, or his mind. Luckily, a few people were. For the rest, they might – like Arnold Bennett – still quite like Aleister Crowley in small doses, but extended exposure to his ego and what were increasingly perceived as his divine pretensions proved indigestible. At about the same time he began to lose his hair, his money and his charm, and of the three, the last was the most costly loss.

Some ominous watershed had been reached. 'After five years of folly and weakness,' he wrote to Gerald Kelly, 'miscalled politeness, tact, discretion, care for the feeling of others, I am weary of it.'

His personal melancholy he characteristically rationalised as the fault of momentous global forces . . . 'I say today: to hell with Christianity, Rationalism, Buddhism, all the lumber of the centuries . . . I want blasphemy, murder, rape, revolution, anything, bad or good, but strong.' A letter of complaint to an assistant comm-issioner who was slow in processing some paperwork was signed 'Saint E.A. Crowley'. His wife and child joined him in the east for a journey through Burma into China, and he realised that along with everything else, he had fallen out of love with them: 'I was no longer influenced by love for them, no longer interested in protecting them as I had been.'

He left them behind in April 1906 in Tonkin, at the mouth of the Fleuve Rouge, the Red River, in what is now northern Vietnam and was then French Indo-China, having received word that his old friend and ally from the Golden Dawn, Elaine Simpson, was in Shanghai. He rushed to the side of Sister *Donorum Dei Dispensatio Fidelis*, anxious to partake of some of her gifts of god. But Elaine was married, and refused. So he travelled alone back to England, disembarking at Liverpool on Saturday, 2 June 1906. There he received the news that his daughter had died, before reaching the age of two years, of typhoid in Rangoon. Typically, and

disgracefully, he instantly blamed the grief-stricken mother. Rose was, he insisted, a helpless alcoholic whose drunken negligence with the baby's feeding bottle had allowed entry to the typhoid germ. In such a manner was Aleister Crowley made instantly free of two persons who had recently become an encumbrance: one by a death which he could not have helped; and the other through a simple projection of guilt and blame. After fewer than three years of marriage he considered himself to be thoroughly absolved: a free party once again.

He duly recorded the next two years, 1907 and 1908, to be 'years of fulfilment'. He certainly prepared and published a lot of material. He compiled a Cabbalistic dictionary titled *Liber 777*, which was published in 1909 and achieved a certain renown. (It was selected in August 1912 by eighteen-year-old Gerald Brenan, who would later become famous as a travel writer and authority on pre-Civil War Spain, as one of his precious handful of essential books when Brenan ran away from home and set off to walk to the Pamirs, 'among the tents of the Kirghizi'. The usefulness of *Liber 777* to this young tiro was never tested: Brenan turned back at Yugoslavia.)

He published his *Collected Works*, and offered a prize of £100 (almost £5,000 in the 1990s) for the best essay on his writing. It was won by the only entrant, Captain John Federick Charles Fuller of the 1st Oxfordshire Light Infantry, then currently stationed at Lucknow. Fuller completed a book-length adoration of Aleister titled *The Star in the West*, which could hardly fail to scoop the award:

> Crowley is more than a new-born Dionysius, he is more than a Blake, a Rabelais, or a Heine; for he stands before us as some Apollo, hovering 'twixt the misty blue of the heavens, and the more serious purple of the vast waters of the deep.
>
> It has taken 100,000,000 years to produce Aleister Crowley. The world has indeed laboured, and has brought forth a man . . . Crowleyanity has led us through more marvels than Dante ever bore witness to . . .

Captain Fuller never did see his £100 purse; the Crowley funds were already too tight. But he did see *The Star in the West* in print. It was reviewed in 1907 by, among others, Aleister's old Golden Dawn adversary Florence Farr Emery. 'It is a hydra-headed monster, this London Opinion,' wrote the actress in the *New Age* magazine:

> But we should not be at all surprised to see an almost unparalleled event, namely, every one of those hydra heads moving with a single purpose, and that the denunciation of Mr Aleister Crowley and all his works.
>
> Now this would be a remarkable achievement for a young gentleman who only left Cambridge quite a few years ago. It requires a certain amount of serious purpose to stir Public Opinion into active opposition, and the only question is, has Mr Crowley a serious purpose?

His critics were often as heavy-handed as his acolytes. Predictably enough, Aleister and Captain (later Major-General Fuller) shortly fell out, and Fuller progressed to new heroes – most notably the Chancellor of the German Reich. John Frederick Fuller was one of only two Englishmen who travelled to Germany in 1939 to help celebrate the fiftieth birthday of Adolf Hitler. (The other was Baron Brocket of Brocket Hall.)

They were insignificant setbacks. 'Looking back on the year,' he told his diary of 1907, 'it seems one continued ecstasy . . . I am able to do automatic writing at will . . . At last I've got to a stage where desire has utterly failed. I want nothing.'

And Aleister Crowley found other disciples, of course. In 1908 he travelled to Spain with a Cambridge graduate named Victor Neuberg, a short, gnomish figure with a nervous disposition and unfeasibly large lips who was also 'an agnostic, vegetarian, a mystic, a Tolstoyan, and several other things all at once'. Neuberg was an enthusiast for Esperanto who could speak hardly a word of the

language, and he rarely washed. But he was a disciple, and a biddable lover.

They travelled down through France and into Spain, walking from one wretched hamlet to the other until they reached Gibraltar and crossed over to Tangiers. There Aleister shaved the impish Neuberg's head, leaving two tufts of hair on either forehead so that Victor, with his pixie face, resembled some grotesque caricature of the god Pan, and Aleister could achieve his unique consummation of sex and magick, of sexual magick:

> Pan! Pan! Io Pan! – before whom I lie prostrate with
> my robes careless and freeflung . . . his teeth fasten in
> my flesh – a terrible heave flings our bodies into mid-
> air with the athletic passion that unites us with the
> utmost God . . . and the life of my strange lover boils
> within my bowels.

Refreshed from his lengthy holiday, Aleister decided in 1909 to publish a magazine. *The Equinox* was an enormously ambitious venture. The size of a small book, it cost almost £400 to produce, and its cover price – five shillings a copy (£12 ninety years on), with fifty bound subscription copies at a guinea a throw (£50), were never – even if all 1,050 copies were sold – going to retrieve the capital after retailers had taken their percentages. But its function was not to make money. Its purpose was to announce the New Crowleyan Age.

Aleister's first editions proclaimed:

> With the publication of this review begins a
> completely new adventure in the history of mankind.
> Whatever knowledge may previously have been
> imputed to man, it has always been fenced in with
> conditions and restrictions. The time has come to
> speak plainly, and so far as may be in the language of
> the multitude.

The Brothers of the A.'.A.'., the new order which Aleister would use to replace not only the Golden Dawn of bitter memory, but also Christianity, announced themselves 'without miracle or mystery. It is easy for every charlatan to perform wonders, to bewilder and even to deceive not only fools but all persons'.

There followed a number of articles, including a short story from Frank Harris and, from the editor, 'the best poem of its kind that I had so far written'. This was 'The Wizard Way':

> Over the untrodden road,
> Through the giant glades of yew
> Where its ray fell light as dew
> Lighting up the shimmering veil
> Maiden pure and aery frail . . .

And so on, for another 250 lines. W.B. Yeats, who was busily preparing the contents of *The Green Helmet* ('Why should I blame her that she filled my days With misery, or that she would of late Have taught to ignorant men most violent ways . . .'), must have squirmed with envy.

Curiously, it would be *The Equinox*, that almost unmarketable collection of strange prose, bad verse and mystical theory, which landed Aleister Crowley once more in the dock. The magazine occupied much of his attention as 1909 turned into 1910. He had time, at the end of 1909, to formalise his divorce from Rose after the poor woman had firstly taken a cure, and then relapsed and run up a grocer's bill for one hundred and fifty bottles of whisky in five months. On Wednesday, 24 November, Decree of Divorce was pronounced: 'At the instance of Mrs Rose Edith Kelly or Skerrett or Crowley, at present residing at the Vicarage, Camberwell, London, against her husband Alister [*sic*] Macgregor Crowley formerly called Edward Alexander Crowley of Boleskine, Foyers, Inverness-shire, and at present residing at 21 Warwick Road, Earls Court, London.' The 'corrected entry' was signed at Dingwall on 30 November by the same Registrar, Alex Dewar, who had issued the official sheriff's marriage warrant six years earlier.

Crowley's attention then skipped from the sheriff at Dingwall to the Court of Appeal in London. In one of the oddest publishing cases of that or any other time, *The Equinox* was prosecuted, not for obscenity, or for sedition, or for libel, but for breach of supernatural copyright. The second issue of the magazine, which was published in September 1909, had contained a long account by Aleister of the rites of the Hermetic Order of the Golden Dawn. It is unlikely that many people furrowed through 'The Temple of Solomon the King', and of those that did, few can have realised that its gnomic text – 'That which is below is like that which is above, and that which is above is like that which is below, for the performance of the miracles of the *one substance*' – contained the most precious secrets of Samuel Liddell Macgregor Mathers' occult company.

One person did spot the guilty secret, of course, and that person was Macgregor Mathers himself. Noting with alarm that the article was scheduled for continuation in numbers III and IV of the magazine, Mathers – who by 1910 was known as the Comte Liddell Macgregor – applied to a judge in chambers, Mr Justice Buckmill, for an injunction preventing further publication of *The Equinox*. To the astonishment of all concerned, Buckmill granted an interim injunction. Crowley assumed, probably correctly, that this was because the judge was a freemason and therefore both respectful of the hidden rights of secret rites and sympathetic to the claims of clandestine societies.

He appealed, and this bizarre case was pled before three peers of the realm at the Court of Appeal on Monday, 21 March 1910. They opposed each other, Samuel Liddell Macgregor Mathers, the Comte Liddell Macgregor, and his susceptible protégé Aleister Crowley, Laird of Boleskine and Abertarff, across the well of the court. It must have seemed occasionally like a duel between wizards who had condescended, for the nonce, to employ the secular arbitration system: Mathers, a striking figure with long white hair brushed back from his head, and the theatrical, balding Crowley staring with bulging eyes at the unfolding drama.

Crowley won. Acting on behalf of Macgregor Mathers, Sir

Frederick Lawrence argued that Aleister had violated his oath of secrecy by disclosing the Order's Rosicrucian rituals. 'What harm would be done by publication?' inquired Lord Justice Farwell.

'Irreparable harm,' replied Lawrence, 'for the cat would be out of the bag.'

'But so much of the cat,' offered Lord Justice Vaughan Williams, 'came out of the bag in September.'

'It seems to me,' said Farwell, 'that it is a dead cat.'

'Perhaps,' continued Sir Frederick tortuously, 'there is a second cat in the bag.'

The three law lords, Farwell, Fletcher Moulton and Vaughan Williams, were handed a copy of the second number of *The Equinox*. The offending article, it was explained to them, was being serialised. 'Is it a romance?' inquired Lord Justice Williams, kicking off one of the judicial exchanges which dignifies the British legal system:

> Lord Justice Moulton: Anyone who knows anything about these societies knows that the ritual of most of them has been published.
>
> Vaughan Williams: I have not observed any indication that you are, either of you, Masons. [Laughter]
>
> Frederick Lawrence: I don't propose to give your Lordship any, either. The society is in no way a Masonic society . . . the defendant is publishing the article as an act of revenge for having been expelled.
>
> Vaughan Williams: I see the plaintiff says he is the 'earthly chief' of the order, and subject to the guidance of the 'Spiritual Order'. [Laughter]
>
> Farwell: What is the 'Spiritual Order'?
>
> Lawrence: I cannot go into it, my lord. It is clear the spiritual head would not be answerable for costs. [Laughter]

And following that genial discussion – whose disrespectful levity

had Macgregor visibly displeased – of most serious matters, the two other law lords agreed with Lord Justice Moulton that:

> the plaintiff knew Mr Crowley was the editor in November last, and that he would have had no difficulty then in bringing his action in respect of breach and threatened breach.
>
> As a matter of a fact, he let it go on till just before the third number had been issued, and then came and asked the court, before he had established any right, but merely on the possibility of having some right, which had been infringed, to give him the very serious remedy of an interim injunction to prevent publication . . . he had not shown such promptitude in asserting his rights at a time when they could be effectively asserted as to justify the granting of an injunction now.

In other words, the Comte had dawdled too long. The Court of Appeal found in favour of Aleister Crowley and the right to publish, and even awarded him costs. It was the last time that the British courts would smile upon the Laird of Boleskine and Abertarff.

This strange case naturally excited the British press. SECRETS OF A MYSTIC SOCIETY, enthused the *Daily Express*, ROSICRUCIAN RITUAL TO BE REVEALED. There was also one small notice which would have a considerable resonance in the future. The magazine *John Bull*, which had been established in 1906 by the extraordinary journalist, millionaire financier and Liberal Member of Parliament Horatio Bottomley, featured in its edition of 2 April 1910 an odd little open letter. To Aleister Crowley, Esq., Editor of *The Equinox*, it read:

> Congratulations on the result of your appeal. It is rather nice to have lawsuits about Rosicrucian mysteries in the prosaic twentieth century. Incidentally, there is also a fine advertisement for your periodical. Meanwhile, I wish you would teach me to

He again came under notice in November 1910 when he held a series of meetings at the Caxton Hall to witness the performance of the 'Rites of Eleusis' etc. It was alleged at the time that he was addicted to sodomitical practices. Observation was kept by the Police at these meetings, but although the proceedings were of a blasphemous character, no open act of indecency was witnessed.

How disappointing. The press also ankled across to Westminster in the hope of finding something more titillating than a new-age devotion, and they also felt let down. 'Harmless eccentricity,' explained one typically deflated – but nonetheless fair-minded – report, 'is the chief quality in the "Rites of Eleusis", the first of which was performed in the Caxton Hall last night.' He went on:

One is told that Mr Aleister Crowley, who presides over these rites, has invented a new religion, and that his idea is to plant Eastern transcendentalism in English soil under the guise of ceremonial magic. But if one may judge by the first act of the Rite of Saturn, Mr Crowley's sole claim to originality is the belief that what would merely be yawned at in the light becomes impressive in the semi-darkness. And perhaps that error has been made before.

An atmosphere heavily charged with incense, some cheap stage effects, an infinity of poor reciting of good poetry and some violin playing and dancing are the ingredients of the rite. There is nothing to give offence to the most sensitive. The Mother of Heaven, who plays the fiddle with considerable technical skill, but no inspiration, is probably not intended to represent any figure in other religions. Some of the poetry, such as passages of Swinburne, is mildly erotic, but rendered in a sing-song voice, with little expression, was void of passion.

> Positively the only relief in a dreary performance
> was perfomed by a neophyte falling from his stool,
> which caused mild hilarity among a bored and
> uncomfortable audience, most of whom were perched
> on small wooden stools a foot from the floor. Mr
> Crowley says that the end and aim of his rites is
> ecstasy. Somebody ought to tell him that ecstasy of
> any kind is impossible when your foot has gone to
> sleep.

It is possible to picture that happening, as through a glass darkly. A respectable, Edwardian middle-class audience (leavened by a sprinkling of suspicious police officers and sceptical journalists) squats in evening-dress upon tiny bamboo stools, drawn to the Caxton Hall by their period's insecurities and credulousness, ready and willing to receive enlightenment, to grasp the key to the eternal mysteries. Once securely in place, their five guineas entrance fee paid (an incredible £260 in the currency of the late 1990s – although that five guineas did cover all seven rites), they heard Aleister reciting Swinburne . . .

> And Pan by noon and Bacchus by night,
> Fleeter of foot than the fleet-foot kid,
> Follows with dancing and fills with delight
> The Maenad and the Bassarid . . .

while Leila Waddell played competent violin and Neuberg undulated across the stage, avoiding the methylated-spirit fire whose fumes were only partly suppressed by the burning incense, and which cast a faint blue glow on the proceedings. Not knowing when or whether to applaud, laugh or cry, they sit out the night in excruciating discomfort. 'Death!' Aleister has told them. 'There is no God! There is nothing behind the veil but a pinch of dust!' And the police officers leave, wondering if that statement warrants a charge of blasphemy.

One publication was not satisfied with simple cynicism. *The*

Looking Glass, a paper anxiously seeking scandal, became aware – along with much of the rest of chattering London – of Aleister Crowley's unsavoury personal habits and seditious, blasphemous opinions. By 1910, he had made a lot of enemies among people who had never met him. When the Eleusinian Rites had run their course in December 1910, Aleister took a holiday. In its issue of Saturday, 17 December, *The Looking Glass* sent him on his way with a vicious couple of sentences:

> We understand that Mr Aleister Crowley has left London for Russia. This should do much to mitigate the rigour of the St Petersburg winter. We have to congratulate ourselves on having temporarily extinguished one of the most blasphemous and cold-blooded villains of modern times. But why were Scotland Yard about to let him depart in peace?

They followed this strange piece of provocation – how was Scotland Yard supposed to *stop* a British citizen with a clean bill of legal health from taking a foreign holiday? – with an item of yellow press exposition so perfect of its kind that it merits reproduction almost in its entirety. It is instructive in its essentially accurate, if partial, account of the hermetic activities of Aleister and his disciples on stage in London in 1910. It is illuminating in its depiction both of Aleister's own extraordinary view of himself as the St Peter of a new order, and of his oddly naïve manner of broadcasting his faith – through a kind of metaphysical question-and-answer session: 'Does God exist?' 'No. Next . . .' It is informative about the carnival-quackery of Crowley's 'magickal' feats at the time – producing fire from the floor, for instance, by opening in a darkened room a trapdoor with a flame beneath. It is entertaining in its proof that the journalism of false pretences and subterfuge, the reportage of I-made-my-excuses-and-left, was far from being an invention of the second half of the twentieth century. It is curiously deceitful because *The Looking Glass* based its supposed 'exposé' of a secret ritual upon a public performance at Caxton Hall – a

performance which, far from being anxious to conceal, Aleister
Crowley was eager to publicise. It is important because *The Looking
Glass*, more than any other publication, set rolling the reputation
which was henceforth to haunt Crowley up to and beyond the grave.
AN AMAZING SECT, the paper announced:

> We propose under the above heading to place on
> record an astounding experience which we have had
> lately in connection with a sect styled the Equinox,
> which has been formed under the auspices of one
> Aleister Crowley . . . the meeting or seance which we
> are about to describe, and to which after great trouble
> and expense we gained admittance under an assumed
> name, was held in private at Caxton Hall.
>
> We had previously heard a great many rumours
> about the practices of this sect, but we were
> determined not to rely on hearsay evidence, and after
> a great deal of manoeuvring we managed to secure a
> card of admission, signed by the great Crowley
> himself [this was an easily purchased five-guinea
> ticket – R.H.]. We arrived at Caxton Hall at a few
> minutes before eight in the evening – as the doors
> were to be closed at eight precisely – and after
> depositing our hat and coat with an attendant were
> conducted by our guide to the door, at which stood a
> rather dirty looking person attired in a sort of
> imitation Eastern robe [the unfortunate Victor
> Neuberg, one supposes], with a drawn sword in his
> hand, who, after inspecting our cards, admitted us to
> a dimly lighted room heavy with incense.
>
> Across the room low stools were placed in rows,
> and when we arrived a good many of these were
> already occupied by various men and women, for the
> most part in evening dress. We noticed that the
> majority of these appeared to be couples – male and
> female. At the extreme end of the room was a heavy

curtain, and in front of this sat a huddled-up figure in draperies, beating a kind of monotonous tom-tom. When all the elect [i.e., the paying customers] had been admitted the doors were shut, and the light, which had always been exceedingly dim, was completely exhausted except for a slight flicker on the 'altar' [the methylated-spirit fire]. Then after a while more ghostly figures appeared on the stage, and a person in a red cloak [the Laird of Boleskine and Abertarff], supported on each side by a blue-chinned gentleman in some sort of Turkish bath costume, commenced to read some gibberish, to which the attendants made responses at intervals. Our guide informed us that this was known as the 'banishing rite of the pentagram'.

More Turkish bath attendants then appeared, and executed a kind of Morris dance round the stage. Then the gentleman in the red cloak, supported by brothers Aquarius and Capricornus – the aforesaid blue-chinned gentlemen – made fervent appeals to the Mother of Heaven to hear them, and after a little while a not unprepossessing lady [Leila Waddell] appeared, informed them that she was the Mother of Heaven, and asked if she could do anything for them.

They beg her to summon the Master, as they wish to learn from him if there is any God, or if they are free to believe as they please. The Mother of Heaven thereupon takes up the violin and plays not unskilfully for about ten minutes, during which time the room is again plunged into complete darkness. The playing is succeeded by a loud hammering, in which all the robed figures on the stage join and after a din sufficient to wake the Seven Sleepers the lights are turned up a little and a figure appears from the recess and asks what they want.

They beseech him to let them know if there really is

a God, as, if not, they will amuse themselves without any fear of the consequences. 'The Master' promises to give the matter his best attention, and, after producing a flame from the floor by the simple means of opening a trapdoor, he retires with the Mother of Heaven for 'meditation', during which time darkness again supervenes.

After a considerable interval he returns, flings aside a curtain on the stage, and declares that there is no God. He then exhorts his followers to do as they like and make the most of life. 'There is no God, no hereafter, no punishment, and no reward. Dust we are, and to dust we will return.' This is his doctrine, paraphrased. Following this there is another period of darkness, during which 'The Master' recites – very effectively, be it admitted – Swinburne's *Garden of Proserpine*. After this there is more meditation, followed by an imitation Dervish dance by one of the company [Neuberg once more], who finally falls to the ground, whether in exhaustion or frenzy we are unable to say.

There is also at intervals a species of Bacchic revel by the entire company on the stage, in which an apparently very young girl, who is known as the 'Daughter of the Gods', takes part . . .

In such a way was Aleister Crowley's open-stage production of his new religion conveyed to the households of suburbia as a secretive, private ritual, hidden from all but the most cunning journalist. In such a way were bourgeois eyes widened and shocked ladies of the Home Counties filled with a fluttering fascination. *The Looking Glass* concluded:

Remember the doctrine which we have endeavoured to faintly outline – remember the periods of complete darkness – remember the dances and the heavily

scented atmosphere, the avowed object of which is to produce what Crowley calls 'ecstasy' – and then say if it is fitting and right that young girls and married women should be allowed to attend such performances under the guise of the cult of a new religion.

New religion indeed! It is as old as the hills. The doctrines of unbridled lust and licence, based on the assumption that there is no God and no hereafter, have been preached from time immemorial, sometimes by hedonists and fanatics pure and simple, sometimes by charlatans whose one thought is to fill their money bags by encouraging others to gratify their depraved tastes.

In the near future we shall have much to say about this man Crowley – his history and antecedents – and those of several members of the sect . . .

The Looking Glass was as good as its word. Unfortunately, it chose to include among the 'members of the sect' that respectable chemist who had first introduced Aleister to the wonders of the Golden Dawn. 'By their friends ye shall know them,' insisted *The Looking Glass*, and among Aleister's friends were 'the rascal sham Buddhist monk Allan Bennett; the other a person of the name George Cecil Jones'.

Bennett, levitating in Ceylon, was neither of mind nor means to complain. George Cecil Jones, however, had the reputation of a consultancy in Great Tower Street to protect. He sued *The Looking Glass* for libel. Crowley would have nothing to do with the case – 'If you touch pitch you will be defiled' – but Jones insisted upon pursuit.

The action for damages was heard by Mr Justice Scrutton and a jury at the Kings Bench Division in April 1911. As was and would be common to British publishing trials, both the magazine and its printers were brought to account. The defence had therefore two counsels: Mr Rowlands for the unfortunate printers Love & Malcolmson, and Mr Schiller for the publishing company. George

Cecil Jones's prosecuting counsel was a Mr Simmons. The editor of *The Looking Glass*, a deeply unsavoury character named West de Wend Fenton (whose magazine was deeply in debt and not long for this earth, and who was prosecuted again two years later for sending indecent material through the post) attended the trial in person.

Once more it turned into a legal circus. This most curious of actions boiled down to the simple fact that the jury was asked to decide whether or not George Cecil Jones's friendship with Aleister Crowley was fair material for published abuse. As such, it centred on the one figure – Crowley – who had no direct part in the proceedings, and who refused to be called as a witness. After an initial round in which the defendants pleaded fair comment, and Jones attested that he had become 'acquainted' with Crowley in 1898 and had never since known or seen anything wrong with him, the star witness was called.

It was Samuel Liddell Macgregor Mathers. The Comte was called by the defence to bolster their case that Aleister Crowley was a nasty person, and therefore anybody who associated with him deserved anything that they got.

Macgregor Mathers' spell in the witness box was worth a dozen Rites of Eleusis. It may have been one of the great cross-examinations of the first half of the twentieth century. After informing the court that Aleister Crowley had been expelled from 'the Rosicrucian Order' for circulating libel against himself, Macgregor, and for working against the interests of the Order, Macgregor was questioned by Jones's counsel, Simmons. It was Simmons's intention to discredit this strange-looking witness by proving him to be as mad as a hatter. 'Is your original name,' queried Simmons, 'not Samuel Liddell Mathers?'

'Undoubtedly,' returned Mathers.

'Did you subsequently assume the name of Macgregor?'

'The name Mathers,' explained the witness, 'dates from 1603. At the time the name of Macgregor was forbidden on pain of death, and there is no single person of the name Macgregor at the present day who has not had another name in the interval.'

Simmons found this (faulty) lesson in Scottish history difficult to

take. 'Your name was Macgregor in 1603?' [Laughter, which did not disconcert Mathers.]

'Yes, if you like to put it in that way.'

'You have called yourself Count Macgregor of Glenstrae?'

'Oh, yes.'

'And Cagliostro?'

'No.'

'Have you ever suggested that you had any connection with King James IV of Scotland?'

'Every Scotsman who dates from an ancient family must have had some connection with King James IV, as well as with the other kings.'

'Have you ever asserted,' pressed Simmons, 'that King James IV of Scotland never died?'

'That is a matter of common tradition. The old tradition of that nature in Scotland forms the basis of one of Allan Cunningham's novels.'

'Do you assert that James IV of Scotland is in existence today?'

'I refuse,' intoned Mathers, 'to answer your question.'

'And that' – Simmons got to the point – 'his existence today is embodied in yourself?'

'Certainly not. You are confusing me with Crowley's aliases.'

'Do you believe that the Count de St Germain is living?'

Mathers replied that such traditions existed in the St Germain family. 'Then,' pounced Simmons, 'we have two people who are supposed to be dead, and who are not dead?'

'I am not responsible,' pronounced Mathers, 'for traditions.'

Entering into the spirit of the debate, Justice Scrutton then interjected: 'The Flying Dutchman is a third, if you want to pursue this subject.' [Laughter.]

'And the Wandering Jew,' added an inspired Mathers. Simmons turned from this cul-de-sac. If he could not confirm the witness's delusionary pathology, he could paint him as an aged wastrel.

'Have you any occupation?'

'This is as you like to take it. For a man of no occupation I am probably the most industrious man living.' [Laughter, which must

have disturbed Simmons. The court had seen in Mathers no dangerous lunatic, but a harmless and entertaining eccentric.]

Mathers then refused to tell the court how many members subscribed to the Golden Dawn: 'A great many, more than two hundred with whom I am actually in touch.' He confirmed the existence of Secret Chiefs, but as for their names: 'I am sworn not to give them.' He attested that he had the power of expulsion from the Order, and had expelled 'as many as fifteen at one time'.

'This trial,' said Mr Justice Scrutton as the Comte prepared to leave the witness box, 'is getting very much like the trial in *Alice In Wonderland*.'

The defence then produced a city merchant named William Migge who had coughed up five guineas for all seven of the Rites of Eleusis, and had been so profoundly disenchanted that he had asked – unsuccessfully – for his money back.

'Was one of the characters,' asked defence counsel Schiller, anxious to establish the unseemly involvement in Crowley's activities of women and children, 'taken by a lady called "The Mother of Heaven"?'

'Yes.'

'And another taken by a small girl called "The Daughter of Heaven"?'

'I don't recollect that. There was so much incense I couldn't see much.'

William Migge then told Jones's counsel Simmons that he had been induced by a lady clairvoyante to attend the performances, and had expected for his money to get some clairvoyant manifestations, which were not forthcoming. He had not seen, nor had expected to see, 'improprieties'.

Dr Edward Berridge, otherwise known as *Frater Resurgam*, testified as a member of the Golden Dawn that he had 'heard rumours about Crowley, which I do not want to state specifically, as there are ladies in the court'.

'Any ladies remaining here,' sighed Justice Scrutton, 'are probably beyond scruples of that sort.'

As regards Aleister Crowley, summarised the judge: 'It has been

shown that he wrote, published, and advertised literature of a most disgusting character and conduct.' The judge asked the jury to consider three questions:

'Were the words and statements complained of defamatory of the plaintiff?' (Who was, lest we forget, not Aleister Crowley himself, but his acquaintance George Cecil Jones.)

'If yes, were the statements of fact substantially true; and if yes, were the comments founded on those statements of fact, fair?'

The jury answered all three questions in the affirmative, and found for the defendants, *The Looking Glass* and its printers. George Cecil Jones had been found liable, in a court of law, to be open to libel because he knew a man named Aleister Crowley.

Jones's, and some of Crowley's, friends were furious with Aleister for refusing to prosecute himself, and then for refusing to take the witness-box on Jones's behalf and prove to the jury what a fine upstanding fellow he really was. 'Through your own folly,' wrote John Frederick Fuller, 'you now find yourself at St Helena [i.e., ostracised] . . . I am extremely sorry that Jones should be the sufferer for your want of pluck.' Crowley was naturally unrepentant. The words 'sorry', and 'I may have been wrong', not to say 'I let you down', would always be as foreign to him as Friuli. His stated reasons for failing to support Jones in a trial which revolved around the character of Crowley were that it was pointless to sue a bankrupt scandal sheet like *The Looking Glass* – and that his own Secret Chiefs had advised him in no uncertain terms against going to court. Men who had on other occasions protested their belief in the existence of those Secret Chiefs, men like Fuller and Jones themselves, chose not to believe him. In its own, less lethal way, *The Looking Glass* court case was another Kangchenjunga. Hearing the sound of guns and the cries of his friends in distress, Crowley had decided that their trouble was not his trouble, and had walked away, alone, down the other side of the mountain.

Aleister was unperturbed by this sacrifice of friendship, not least because he did not, and had not for many years, wanted friends. Friendship implied a two-way traffic in regard and devotion. Aleister was concerned chiefly with the receipt rather than despatch

of those emotions. He wanted not critical friends, but undemanding devotees and lovers. He hied himself off to France and Switzerland with a new lady friend, an associate of Isadora Duncan named Mary d'Este Sturges, who replaced Rose Kelly and Leila Waddell as the female object of desire and magical – which is to say, as always with Aleister, the combined sexual and hermetic – partner. It was the beginning of a frantic affair, fuelled by drugs and drink and passion – 'This lady,' Crowley would write of Sturges, 'a magnificent specimen of mingled Irish and Italian blood, possessed a most powerful personality and a terrific magnetism which instantly attracted my own.'

While Rose was committed to an asylum in that autumn of 1911, her former husband caroused around Europe. Secure in a certain notoriety, he played upon his reputation like a harp. A newly erected memorial to Oscar Wilde in the Père Lachaise cemetery in Paris was causing some civic unrest, because the sculptor Jacob Epstein had depicted a naked man's genitalia. The authorities having covered the statue with a tarpaulin, Crowley determined to liberate both the figure and the good name of Art. He surreptitiously attached a length of wire to the tarpaulin, had a friend hide some distance away holding the other end of the wire, and – having pamphletted Paris announcing a grand display in the name of artistic liberty by the 'Irish poet' Aleister Crowley at midday on Sunday, 5 November 1911 – he turned up at the cemetery and a yank of his friend's hand disrobed Epstein's statue. Even this, it should be noted, was intended as a magical trick, a crude sleight of hand and deception of the eye – the accomplice out of sight pulls on an invisible cable and lo! when the Great Crowley commands, the tarpaulin comes tumbling down! This was not magick. This was a party trick which would have embarrassed the Magic Circle, let alone the Hermetic Order of the Golden Dawn.

But hardly anybody was present to gasp. There was disappointingly little official outrage, absolutely no official resistance and a satisfactory amount of press coverage. There was also a marvellous sequel. The Parisian authorities later compromised by attaching a bronze butterfly to the Epstein statue's

penis. Crowley returned, removed the butterfly, took it to London and, having learned that Jacob Epstein was one evening in the Café Royal, donned full evening dress and marched into that august establishment with the butterfly hanging over his pubic region like a sporran. 'It was a glorious evening.'

The activities of his next few months and years were plentiful and coloured – most coloured, of course, in his own account – without differing overly from what had already passed, and without shedding too much extra light upon his character. He continued, perhaps anachronistically by now, although he was due a further £4,000 (£200,000 in the 1990s) when his mother died, to lead the life of a moneyed extrovert. He travelled with Mary d'Este Sturges to Italy, smoking hashish and drinking alcohol all the way. He took a female dancing troupe headed by Leila Waddell and titled the Ragged Ragtime Girls to Paris and to Moscow. He issued in 1913 the tenth and the last edition of *The Equinox*. He made the agreeable – and absolutely crucial – discovery that opium was an excellent analgesic for bronchitis. He lived like a poetic travelling showman, an intellectual carnival hand, a hearty will o' the wisp – exasperating, romantic, overbearing, attractive, totally self-centred, sexually omniverous, devoted throughout all to the religious credo which would certainly not grip the world, but which absolutely inspired Aleister Crowley: do as thou wilt, shall be the whole of the law.

On 4 August 1914 – while Aleister Crowley was, in fact, in Switzerland – Great Britain declared war on Germany, and thereby entered the Great War, which would become known during Aleister's lifetime as the First World War. Some men younger than Aleister, who was then in his thirty-ninth year, marched willingly, even cheerfully, towards those guns – as we have noticed, 'as into cleanness leaping'. Most of Aleister's middle-aged contemporaries and compatriots applauded the necessary slaughter. Aleister Crowley did neither. He saw no reason to offer his own sacrificial blood, nor to encourage others to spill theirs. He had found his own escape from the stifling normalities of post-Victorian Britain. He was not one of the herd; he had no straitjacket to break; no

mouldering blood to cleanse. Besides, was this not just another example of a *Christian* war: a conflict engendered in, if not exactly by, the mistaken faith which he was sworn to usurp?

Shortly before his thirty-ninth bithday he boarded the SS *Lusitania* and made off to spend the war years – in circumstances of the most furious controversy, and with results which would affect the rest of his life far more severely than any Gilbert and Sullivan London court case – in the United States of America.

7

The Renegade Englishman

A low villain and a bad egg generally

– H. Christopher Watts

Some of Aleister Crowley's friends – most notably his executor and biographer John Symonds – would claim that, when the First World War broke out, he made 'every attempt to persuade the government to employ him'. Crowley's own explanation of this persuasion revolved around one highly coloured, and at least partly fictionalised, account of a dinner with an old aristocratic acquaintance who had a job in the censor's office. After listing most of Aleister's unique qualities, the friend supposedly told him – in a monologue too faithfully Crowleyan to be true – that those very qualities disqualified him. 'You cannot serve your country.'

Naturally, Aleister himself went one step further. Following a war which he subsequently spent in exile, devoting himself to propagandising not for Great Britain but for its enemy, Germany, he would claim that he *had* actually been working for British intelligence as a fifth columnist and subversive element in the midst of Germany's American friends.

It was an implausible claim, but not entirely impossible, and one

can easily spot the inspiration for this typically self-serving and extravagant deceit. It is that many of his acquaintances and former friends were doing just that. W. Somerset Maugham worked during the First World War at the Intelligence Department of the Foreign Office (thereby receiving the inspiration for his Ashenden stories). Gerald Kelly worked for the duration of the conflict in naval intelligence. It was perfectly commonplace for educated men past the fighting age to offer their services in this way. Possibly Aleister did try – although what we know of his character suggests otherwise, and what evidence survives shows no sign of his application, and indeed rather suggests that no such approach was made. If he offered himself and was rejected, his subsequent activities are entirely explicable within the bounds of Crowleyan logic. And if, as seems likely, he simply went off to the States and adopted the most untypical and unreasonable stance for an Englishman abroad between 1914 and 1918, then that, too, is absolutely characteristic.

On 20 July 1915 the British ambassador to Washington, Sir Cecil Arthur Spring-Rice, wrote to the foreign secretary Sir Edward Grey on the vexed subject of Aleister Crowley. (The achievements of both of these diplomats is deserving of a parenthetical footnote. Spring-Rice's career had taken him to Cairo and to St Petersburg coincidentally at times when Crowley himself had visited those cities, and – less relevantly – he would achieve great renown as the author of the patriotic hymn 'I Vow to Thee My Country'. Grey, who had been Foreign Secretary since 1905, was of course the source of that apocryphal declaration in 1914 that 'the lights are going out all over Europe' [apocryphal because Grey could never remember having spoken those words]. Both men were extremely anxious to gain the support of the USA for Britain in the First World War, and when that practical support was finally forthcoming, both of them were credited with having achieved it.)

Spring-Rice's communication to Grey contained a copy of a long article from the *New York Times* of 13 July 1915. His letter read:

> I have the honour to report that I have received from
> an anonymous correspondent in New York a copy of
> the enclosed article with a warning to 'keep an eye on
> the people named in the clipping'. The only one of
> whom I know anything is Aleister Crowley, whose
> peculiarly venomous anti-British articles in the
> German *Fatherland*, of New York, are ascribed to
> 'Aleister Crowley, the great English poet'. Both he and
> Frank Harris are active supporters of the German
> propaganda and much is made of them both on
> account of their English nationality and the gift of
> invective which both possess and use freely against
> their country.

Copies of these documents were forwarded upon their receipt early in August to the head of the Whitehall Press Bureau, Sir Edward Cook. A couple of memos were subsequently attached to them. One, apparently from a Foreign Office civil servant, read: 'I don't think these followers in the footsteps of Sir R. Casement are likely to do much real harm. Irish, anti-English fanatics are hardly worth watching, though it is interesting to know of them.'

The other, seemingly by Cook, added shortly: 'I know nothing of Crowley. Harris is a great scoundrel.' Nothing in these private responses, it should be noted, indicates that Aleister Crowley had one year earlier petitioned Whitehall for gainful patriotic employment.

What had Aleister been up to? His activities were two-pronged. As the reference to Roger Casement – who was then in Berlin propagandising for Irish nationalism, and who would the following year be arrested at Tralee as he landed from a German submarine, and later hanged for treason – indicates, the 'great English poet' Aleister Crowley had fallen back on his supposed Celtic roots and was proclaiming Irish independence in New York. He was also working, along with his buddy Frank Harris, directly with pro-German groups.

In his own words, early in 1915 he was sitting on the top deck of

an omnibus proceeding up Fifth Avenue when an Irishman tapped him on the shoulder and asked if he was interested in a 'square deal for Germany and Austria'. Aleister replied 'that I was', and was then escorted to the office of the weekly paper *The Fatherland*, which was edited by a man with 'bulging eyes and the kind of mouth which seems to have been an unfortunate afterthought' named George Sylvester Viereck. Viereck was a German-American of some repute, who was already famous for his promotion of Teutonic virtues and values in the USA – he had written a book, much criticised, titled *Der Kampf um deutsche Kultur in Amerika* [The Struggle of German Culture in America] 'It dawned upon my dull mind,' Aleister would explain, 'that here were the headquarters of the German propaganda'.

The difficulty now faced by Aleister, in his version penned after the war had ended with the defeat of Germany and he wished to return unmolested to England, was how to infiltrate this group by convincing Viereck of his genuinely anti-British convictions – 'personally I was so terribly English!' He claimed then to have had an inspiration. He seized upon the device of calling up his mythical Irish ancestry, presenting himself as a Roger Casement-type Irish nationalist of the my-enemy's-enemy-is-my-friend variety, and demonstrating this through a Hibernian protest at the Statue of Liberty. He would then be free to 'wreck the German propaganda' by controlling much of it himself, and making it so outrageous that no American could possibly take it seriously.

That version of events is nonsense. If it were true, then Crowley not only deceived the British ambassador, the Foreign Office and Viereck himself, he also deceived so astute an American pro-German propagandist as the brilliant journalist and editor H.L. Mencken. Aleister remained in the company of pro-German activists for almost the whole of the four-year duration of the First World War. He could not possibly have endured this supposed double life if he did not enjoy their company. He had no reason to stay with them other than the personal satisfaction which came from being with like minds – he was certainly not being employed, or even encouraged, by British intelligence to do so.

In fact, Mencken – who was nobody's mug – became, and remained, so convinced of Crowley's wild sincerity and belief in the Kaiser's cause (a belief which Mencken held passionately) that the two men corresponded then and after the war, and met most amicably in London in 1922. Nor did Aleister publicly invoke the Irish connections of his surname firstly in New York in 1915 – he had done so four years earlier, in Paris in 1911, when the flysheets announced that 'le poète Irlandais' would lead a demonstration at Oscar Wilde's memorial in the Père Lachaise cemetery. The truth, of course, is that Aleister did not believe in much at all. Not in the Irish cause, nor in the German cause, nor in the British cause. But he was thoroughly cheesed off with bourgeois British moralities and their censorships and courts of law, and if an opportunity arose to cause them some mischief – from a safe distance and in clubbable company, at the same time as enjoying a damned fine prank or two – why then, Aleister Crowley was your man. He was certainly dissembling when he later suggested that he had deliberately subverted German propaganda in the USA by over-egging its body-copy – if Viereck had not seen through such an obvious ruse, then the high priest of critics Mencken certainly would – but he was not entirely falsifying matters when he claimed that the whole adventure had been, to Aleister Crowley, a bit of a jape.

Let us now follow Aleister on the morning of Saturday, 3 July 1915, through the pages of the *New York Times*, which headlined its scoop, its article which would be forwarded to Sir Edward Grey in Whitehall:

IRISH REPUBLIC BORN IN NEW YORK HARBOUR, Ten Patriots at Daybreak Renounce Allegiance to England . . . Sympathy with Germany, They Say, a Matter of Expediency . . .

As dawn was slowly spreading over the city on the morning of 3 July a 30-foot launch slipped from the recreation pier at the foot of West Fiftieth Street and glided down the Hudson. On board were ten persons, silent and serious with the consciousness of what was to them a profoundly solemn and significant ceremony.

Certain details of the next paragraph are to be read as perfect, classical examples of the Crowleyan sense of humour and of the cupidity of journalists. It is safe to assume that W.B. Yeats was not contacted for confirmation . . .

> In the prow of the boat was Aleister Crowley, Irishman-poet, philosopher, explorer, a man of mystic mind – the leader of an Irish hope. Of nearly middle age and mild in manner, with the intellectual point of view coloured with cabalistic interpretation, Crowley is an unusual man, capably so to those who believe and feel in common with him. He has spent years exploring in Persia, India and Tibet, and he is the author of several volumes of translations of the early writings of those countries. He is said to be a close friend of William Butler Yates [sic], the Irish poet, and he has written several Irish poems himself.
>
> In the boat also was Miss Leilah Waddell, whose mother was an Irish refugee of the last generation and who believes herself an Irish patriot. She is a violinist and has appeared publicly on several occasions since her recent coming to America. And among those in the exotic party were one J. Dorr, an Irish editor who has published papers in both Ireland and England, and Patrick Gilroy, an Irish agitator. All of those in the launch were Irish. Most of them have come to this country since the beginning of the war.

These native-born Irish patriots – a son of Warwickshire who had never set foot in Eire, an Australian musician, and what Crowley described as 'four other debauched persons on the verge of delirium tremens' – had described themselves to the *New York Times* as members of 'the secret Revolutionary Committee of Public Safety of the Provisional Government of the Irish Republic'. The reactions to that news of Michael Collins in London and Eamon De Valera in Ireland can only be imagined.

Their launch took them to Bedlow Island, at the foot of the Statue of Liberty, at precisely 4.32 a.m., because Crowley 'had read the heavens and found that the conjunction of certain stars was auspicious for Ireland at exactly 4.32 on the morning of 3 July'.

There and then Aleister Crowley stood in the boat and pronounced an immense and – by the standards of political normality – utterly bizarre address. As first light flickered across the shadows of Manhattan, this balding thirty-nine year old preached like some dispossessed prophet from the sea to the heedless shore, his disciples hunched together at his feet in the scuppers of the craft.

'I have not asked any great human audience to listen to these words,' those extravagant tones insisted at 4.30 a.m. in the middle of Upper New York Bay. 'I had rather address them to the unconquerable ocean that surrounds the world, and to the free four winds of heaven. Facing the sunrise, I lift up my hands . . . ' and one must here assume that he did indeed lift up his hands, like the etchings of Moses imploring Jehovah in some textbook favoured by the Plymouth Brethren ' . . . and my soul herewith to this giant figure of Liberty, the ethical counterpart of the Light, Life and Love which are our spiritual heritage.' He continued:

> In this symbolism and most awful act of religion I invoke the one true God of whom the Sun Himself is but a shadow that He may strengthen me in heart and hand to uphold that freedom for the land of my sires, which I am come hither to proclaim.
>
> In this dark moment, before the father orb of our system kindles with his kiss the sea, I swear the great oath of the Revolution. I tear with my hands this token of slavery . . .

At this point Crowley ripped up what was purported to be his British passport, but which was in fact a used envelope, and threw it into the bay.

> ... This safe conduct from the enslaver of my people, and I renounce forever all allegiance to every alien tyrant. I swear to fight to the last drop of my blood to liberate the men and women of Ireland, and I call upon the free people of this country, on whose hospitable shores I stand an exile, to give me countenance and assistance in my task of breaking those bonds which they broke for themselves 138 years ago.

Then, reported the *New York Times*, 'As the bits of the torn English passport scattered over the surface of the water the Irish flag, a green field supporting a golden harp, flapped free in the breeze from a mast in the bow of the boat.' And with a cry of 'Eire go Brage!' [Ireland forever!], the delegate No. 418, Brother Aleister Crowley, read aloud for some twenty minutes a Declaration of Irish Independence.

This included a declaration of war upon England, 'the enemy of civilisation, justice, equity, freedom, and therefore of the human race.' As the launch turned and headed back up the Hudson River, with Leila Waddell playing Irish airs upon her fiddle, it passed internment ships full of German seamen at the Hoboken waterfront. The inmates cheered lustily, and the captain of a Hamburg-American line tug, which happened to be standing offshore with steam raised, turned out into the river and escorted Crowley back to the Fiftieth Street landing. The party then proceeded to Jack's Restaurant for breakfast. 'An American who is acquainted with Crowley' later explained to the *New York Times* that although the 'Irishmen' of the committee sympathised with Germany in the present war, 'this was due to anti-English feeling and not by any natural love of things Germanic.'

'Over in England there was consternation,' Aleister would later reflect. 'I cannot think what had happened to their sense of humour.'

Not quite consternation, as we have seen. But irritation, which would only increase. In August 1915 an article appeared beneath

Aleister Crowley's byline in the Chicago magazine *The Open Court*. It announced:

> In the present crisis there are more pigmies than men. Obscene dwarfs like George V [the reigning British monarch], pot-bellied bourgeois like Poincaré [the President of Britain's ally, France], could only become heroic by virtue of some Rabelaisian magic wand . . . But Wilhelm II [the Kaiser of Germany] is the genius of his people. He has the quality that Castor and Pollux had for Rome . . . he seems omniscient, omnipotent, omnipresent and beautiful, sent to save the Fatherland from savage foes. Even if he perish, he will not perish as a man. He will acquire the radiance of Milton's Satan, and go down the ages as a hero of the great lost cause of humanity.

On 30 June 1916 the *Daily Mail*'s new correspondent in Holland, Charles Tower, wrote to Ernest Maxse at the British Consulate General in Rotterdam. Tower was perturbed by a number of German propaganda efforts which were circulating in the neutral Netherlands. 'I enclose for your notice,' penned Tower, 'a long article in the *Rheinisch-Westfälische Zeitung* of June 29th.' He went on:

> It purports to be a translation of an article written by Aleister Crowley, about a visit paid by him to London. Crowley has been throughout the war one of the most notorious pro-German propagandists in the United States: a regular contributor and I think even an editor of *The Fatherland*, the precious publication started if I mistake not by Dernburg. It is inconceivable · that Crowley should have been permitted to come to London. He was I think of British nationality but may of course have become a naturalised American citizen.

The patriotic journalist continued:

> He has also had in past years a fairly odiferous moral
> reputation. I imagine that the London police have
> some record of the very dubious 'revival of the
> Eleusinian mysteries' which he organised somewhere
> near Victoria about eight or nine years ago. I was
> abroad at the time but I remember that friends of
> mine who knew all about Crowley's history wrote to
> me sundry purple descriptions of the proceedings. I
> believe that Lieutenant Wyndham Harding, Chief
> Censor's Office, APO3, Boulogne could assist the
> authorities if they are anxious to make enquiries.
>
> Yours very sincerely,
> Charles Tower
>
> PS If Harding does not know the facts I think Mr H.T.
> Sheringham the angling editor of *The Field* will know
> where enquiries should be made.

Passing necessarily over the intriguing role of the angling editor of *The Field* magazine in British wartime intelligence, it should be explained that the article in the German newspaper told of an entirely fictional journey to London by Aleister, which had first been published in *The Fatherland*. It purported to discover the English nation in a state of low morale and lower morals; ripely awaiting a German victory and the overdue dismantling of the British Empire.

The Foreign Office resignedly applied itself once more to the task of dealing with their troublesome exile. 'I have seen one or more of the Crowley articles,' noted one official to another on 11 July 1916, 'in the *Continental Times* I think. As the HO [Home Office] had a copy of 9117 [a filing code number referring to an internal inquiry about Crowley], perhaps they would also like a copy of Mr Towers's reminiscences of Crowley's savoury past.'

A mud-slinging operation was thus put haltingly under way. If

only they had known that Aleister Crowley *enjoyed* mud. 'I suggest that we ask them [the Home Office],' added another Foreign Office civil servant, 'if they can give us any details as to Crowley. Some spicey [*sic*] past history in the hands of Capt Gaunt might be used to show up this renegade to the American public. We should also like to find out if there is any truth in the story of his visit to London.'

Captain Guy Gaunt was the head of British naval intelligence in the USA. He would play a crucial and unpredictable role in subsequent events.

Seven days later the Foreign Office stepped up the chase. Thomas Wodehouse Legh, the 2nd Baron Newton, who was then a Foreign Office minister, wrote a confidential letter to the Home Office on 18 July 1916. 'Respecting a certain Mr Aleister Crowley,' said Newton:

> I am directed by Sec. Sir E. Grey [the Foreign Secretary] to transmit, herewith, for the confidential information of Mr Sec. Samuel [Herbert Louis, 1st Viscount Samuel, the Home Secretary] an extract from a private letter addressed to the Consul General at Rotterdam by Mr Charles Tower, special correspondent of the *Daily Mail* in Holland, which has been forwarded by Mr Maxse to the FO.
>
> Sir E. Grey would be glad to be placed in possession of any facts in regard to the past history of Mr Crowley which may be in the possession of the police.
>
> He would also be glad to know whether it is true that Mr Crowley recently visited this country. In regard to this latter point articles written by Mr Crowley in recent editions of the German *Continental Times* purporting to describe his visit to England have been observed.

Home Secretary Samuel acted promptly. He ordered New Scotland Yard to investigate Aleister Crowley and prepare a comprehensive report. On 26 August 1916 Detective Inspector Herbert Fitch wrote to his superintendent to record:

With reference to the attached letter from the Foreign Office, respecting an alleged visit to this country from the United States of Aleister Crowley:

I beg to report having made exhaustive enquiries in likely circles with a view to obtaining corroboration of this without success. I also had an interview with Mr H.T. Sheringham, angling editor of *The Field*, but this gentleman could throw no light on the matter.

As a result it would appear that the alleged visit by Crowley is merely a piece of bluff on his part to obtain money, and cheap notoriety.

Superintendent P. Quinn followed DI Fitch's letter with a full report of all police intelligence on the life and crimes of Aleister Crowley up to 1916. It is from that report that we learn of the police interest in the 'widow's £200' in 1900, and of the police observation of the Eleusinian Rites in 1910. And there was more. Superintendent Quinn reported:

In April 1914 information was received by Police that Crowley was committing certain acts of indecency in the presence of females, in a room occupied by him at 2 The Avenue Studios, 76 Fulham Road, where he was visited by a woman named Waddell.

Police enquiries revealed that during the time he had resided at the above address he had been holding a certain kind of service at which incense had been burnt, and various instruments played, during which time a number of both sexes were present. Although he had been seen to commit an act of indecency in his studio on one occasion, no offence on which proceedings could be taken had been committed.

On 25 February 1914 a letter was received from the Director of Prosecutions enclosing a letter from a correspondent in Paris, in which reflections were made upon the contents of a periodical called *The*

Equinox edited by Crowley. Owing, however, to the high price of the book, and that the complaint came from Paris no action was taken by the Director of Public Prosecutions, the matter being left to the discretion of the Police.

(It is interesting to note that the DPP had regarded the five shillings cover price of *The Equinox* as a kind of immunity from prosecution – presumably on the grounds that at that high cost, it would never reach and corrupt the lower orders.)

The diligent Superintendent Quinn continued:

> On 5 November 1914 a letter was received here from *The Mayfair* 174 Bond Street, W., stating that a Representative who had just returned from the United States, reported that the whole country was overrun with German agents. A. Crowley, whose name was mentioned, it was alleged was not doing very much work in New York, but was closely associated with a woman of the fortune-telling class.

On 24 January 1916 an article was submitted, written by Crowley, in *The International* entitled 'The Crime of Eidith [*sic*] Cavell'.

Nurse Edith Cavell was the holy martyr of the British cause in the early years of the First World War. A forty-nine-year-old matron, she was in charge of the Berkendael Medical Institute in Brussels when the war broke out, and the institute became a Red Cross hospital. In 1914 and 1915 she used her supposedly neutral position to help Allied soldiers to escape from behind enemy lines in Belgium. In August 1915 she was arrested by the Germans and charged with these offences. She was tried in October, freely admitted her 'guilt' – and indeed, announced her pride in the success of her activities – was condemned by a German court martial to death, and was shot by firing squad on 12 October 1915.

Aleister Crowley considered his essay 'The Crime of Eidith Cavell'

to be a masterpiece of the counter-propagandist's art. He portrayed Cavell to his American readership (most of whom were almost as outraged as were the British at the execution of a middle-aged female nurse) as a Judas who had betrayed the genial trust of the occupying German forces in Brussels – those 'great-hearted, simple-minded, trusting' people. Cavell's due desserts, in Crowley's version of events, was to descend after the firing squad to hell and be welcomed there by an array of equally evil women from history, headed by Lucrezia Borgia. Aleister was having a fine old time in the States. George Sylvester Viereck and the rest of *The Fatherland* set lapped it up.

Back in Britain, nobody quite got the joke. New Scotland Yard, in horrified receipt of 'The Crime of Eidith Cavell', visited Aleister's father's sister, his own Aunt Annie, in Croydon. Annie Crowley could shed no useful light on the whereabouts, activities or intentions of her wayward nephew.

Superintendent Quinn continued:

> Information was received from New York on 8 March 1916, that Aleister Crowley is an Irish Agitator, who has attracted a certain attention from the Press largely due to his personal extravagance. He went to New York towards the end of 1914.
>
> An article published in the *NY World* of 2 August 1914 gives a description of the performance of an alleged black mass celebrated by Crowley in London. In the same paper in December 1914 Crowley denied ever having participated in such a ceremony, and claimed to have hypnotised the newspaper man who wrote of it.
>
> Brought himself under notice in July 1915 by setting out at 4 a.m. for the Statue of Liberty which stands on an island in New York Harbour, accompanied by 'Miss Leilah Waddell, J. Dorr, an editor, Patrick Gilroy, an agitator, and others'. All of them described as members of the Secret

Revolutionary Committee of Public Safety of the Provisional Government of the Irish Republic. The object of the outing was to declare Ireland's Independence. Crowley tore up his passport, and after reading a lengthy document, renounced allegiance to the 'alien tyrant', and took an oath to fight to the last drop of blood for Irish Independence.

The avowed purpose of the Secret Revolutionary Committee is to procure the establishment of the Irish Republic after the war is over and to dissuade Irish from enlisting.

In the above information Crowley is described as a man about forty.

In view of an article written by Aleister Crowley in the *Rheinisch-Westfälische Zeitunge* purporting to describe his visit to England recently, enquiries have been made by Police to obtain corroboration, but up to the present time no trace has been found of such a visit.

What were the Home and Foreign Offices to make of this individual? More to the point, what were they to do about him and his penny-dreadful bunch of Fenian caricatures? Aleister was certainly drawing attention from the highest quarters – the Under Secretary of State at the Home Office forwarded Quinn's police report to his equivalent at the Foreign Office on 13 September 1916, on the instructions of Home Secretary Samuel and for the information of Foreign Secretary Grey.

The Foreign Office continued to bat the matter about like a hot coal. And wherever the Aleister Crowley file went, an extra memo was appended; whenever it was moved from one desk to another, some fresh official had thrown in his twopence . . .

'A very unpleasant gentleman I should imagine,' opined minister Newton in a private handwritten note on 14 September 1916. He then invoked once more that beautifully named Oddjob of the Navy's American department of black arts. 'Send a copy to Capt

Gaunt (by bag) for such use as he may be able to make of the information at any suitable opportunity. Truly the Germans are unfortunate in their selection of British subjects to further their propagandist ends!'

And what about reconsidering the villain's citizenship? 'Should not A. Crowley,' pursued Newton, 'be notified to Passport Dept, Permit Office, etc. in case he should attempt to come here or, having got here, try to leave again?'

The Report is 'Confidential', added 'MWK' on the same day. 'If it goes to Captain Gaunt (as I think it should) he must be cautioned not to give away his source of information in any way. I think we can trust his discretion. And certainly inform Passport and Permit authorities as suggested.'

Two days later Newton had an afterthought, a nudge, perhaps, to the terrible Captain Guy Gaunt. 'Unnatural practices,' offered the minister, 'and German propaganda seem to be closely allied.'

The USA entered the war on Britain's side on 6 April 1917. All of Viereck's work, and Frank Harris's work, and Crowley's work, had been in vain. Or had it? What game was Aleister Crowley really playing in New York during World War One? We now know certainly what he was *not* doing. He was not working undercover for the British Foreign Office. But what else, when all lay finally quiet on the Western Front, was he supposed to suggest? That he had *meant* it all? That he really considered Nurse Edith Cavell to be deservedly destined for the fires of hell? That the Secret Revolutionary Committee of Public Safety of the Provisional Government of the Irish Republic was an authorised, accountable, actually constituted political body? That he was a fanatic for Irish Independence and the Kaiser both?

To Aleister Crowley the most devastating conflict thus far in the history of humanity was an opportunity for another one-man show.

Grand Guignol, perhaps, but theatre nonetheless. The difficulty faced by all of those who tried to understand his behaviour between 1914 and 1917 was that they – all of them, from Viereck to Lord Edward Grey, from the Washington ambassador to the *New York Times* – took it seriously. Because he did not, because Aleister took nothing and nobody seriously other than himself and his personal destiny, he fooled them all. Like the death of Queen Victoria, the First World War delivered no shocks to the sensibility of Aleister Crowley. It was not heartlessness, but something yet more egotistical and shallow. It was that he had expected it. He was not alone in that, of course, but he was fairly isolated in his following response, which was the vapid conclusion that because civilisation's remorseless tread had carried it to such a slaughter, despite the warnings and misgivings of such as himself, the bloodshed was none of his concern. The butcher's bill should be sent to another address. For the duration, Aleister was a metaphorical vegetarian. He would do what few others felt able to do. He would treat the First World War as just another blank canvas backdrop to his personal stage. And there, upon that distant set, he would play his many parts: the Irish patriot; the German sympathiser; the British double-agent; the world-weary prophet. For a time he probably believed that one or two of those roles, or all of them, were real, were not just puppet-heroes but had flesh and blood and conviction. Such a belief would have come in useful at the end of the war, when he had to choose one characterisation, one explanation, and try to stick to it. But they were not real – of course they were not real. There was no 'real'. They had the philosophical depth of a music-hall turn; the flesh of a chimera. They were the creations of a fakir.

In July 1917 Aleister took over the editorship of another of George Sylvester Viereck's pro-German magazines, *The International*. This action indicated perhaps more than anything the hapless purity of

his motives, for with the United States fighting alongside Britain, Germany's war was lost. It was no time for a careerist to take the reigns of a Teutonic fanzine. But it was a magazine, and Aleister loved editing magazines. They offered limitless promotional space.

The International also featured strongly in the last surviving Foreign Office paper on the wartime activities of Aleister Crowley. On 3 November 1917 H. Christopher Watts, an English journalist who had worked in New York and who had supplied the British government with much American intelligence, wrote a long letter from his Plaistow home to the Foreign Office on the subject of that awful trinity: Frank Harris, George Sylvester Viereck and Aleister Crowley. The Foreign Office was at that late stage still concerned about the possibility of American Catholics being hostile to the British war effort, because of the Irish independence struggle. Watts's little profiles are wonderfully instructive. He wrote:

> Mr Harris is that Frank Harris, who was for a time editor of the *London Saturday Review.* His present position is that of a renegade Englishman. I cannot account for his exit from London, though doubtless there are reasons for that. But for some time he did hack work in New York, and was associated with one or two journalistic ventures. Then he became, last year, the editor of *Pearson's Magazine,* a monthly published in New York. His editorship began with the publication of a series of articles purporting to give certain scurrilous and unsavoury scandals in the life of the late King Edward VII, and ever since the magazine has kept up this sort of tone. Harris is not a Catholic, but he is not above using the Catholics as a lever to unload some of his spite.
>
> George Sylvester Viereck is a German. It is said, with how much truth I do not know, that he is related on the wrong side to the Imperial German family. At any rate, he was a close associate with Dr Albert and other persons in carrying out the plans of the German

propaganda. At the time when the war broke out he brought out a weekly journal called *The Fatherland*. It was an English-language paper issued entirely on behalf of Germany. As far as it went it was thorough, and backed up Germany on every point, and it made a special plea of identifying Germany with the cause of Catholicism. Since America has come into the war the name of the paper has been changed to that of *Viereck's Weekly*, but the Americanism of its editor is just dust thrown into the eyes of the American Government. Actually the paper is still keeping alive by subtle means the German propaganda. I do not think that Viereck is a Catholic; in fact I know from some of his associates that he is a lewd rascal. But he took a very cunning line: for example, he wrote a poem that was quoted largely in the Catholic papers, in which one verse begins:

The Teuton thundering through the land
Shall set God's prisoned shepherd free.

This came out at about the time when there was some talk of Germany making the restoration of the Pope's temporal power one of its war objects, and it caught hold on the imagination of the Catholic public. The idea has been exploited considerably since then.

Now Viereck has another paper, a monthly called *The International*. It is a more or less radical journal, and prints articles by English pacifists. Also it has taken an anti-British standpoint, though not after the vulgar manner of the Gaelic-American. In fact, it has always appeared to have for its aim the fuddling of American opinion on the truth about the war. Among the contributors to *The International* have been Frank Harris and a man named Aleister Crowley.

Now this Crowley is another renegade Englishman. He achieved an unsavoury notoriety in England chiefly on account of his connection with those

Eleusinian mysteries stunts at the Caxton Hall in Westminster. I think there was a scandal about it some few years back. Anyway, Crowley left this country for the country's good a few years back, and appeared in New York where he posed as a mystic and a Rosicrucian and a good many other things. He found it somewhat difficult to make a living, and took to hack work, when he could get it. Then Viereck got hold of him, and now he is doing work on behalf of the German propaganda.

Crowley was very anxious to get into touch with a man I was working with at the *New York Times*, a well-known Catholic poet and man of letters. But this man happened to be friendly with one of Crowley's former associates, a man named Everett Harre, the author of a highly sensational and salacious novel. Harre quarrelled with Crowley on account of his being a low villain and a bad egg generally, and warned my friend against him, so he refused to have anything to do with Crowley.

Some time last year Crowley sent a woman, with whom he was living, round to the [New York] *Times*, asking him if he would recommend a priest whom he [Crowley] might consult with some idea of his becoming a Catholic. My friend refused to have anything to do with the matter, and when Crowley called him up on the phone he asked to be excused from giving the name of any priest, and he left the matter at that.

Now I do not know for a fact that Crowley has become a Catholic. But I do know with some certainty that he is still working with Viereck, and that Frank Harris is also associated with whatever is going on. I think that the open German propaganda has been abandoned, and that it is carried on subtly under the guise of the future welfare of Catholicism . . .

—

Watts concluded by pointing out that the sixteen million Catholics in the USA could be susceptible to anti-Ally propaganda because of the British role in Ireland, French 'persecution' of the Roman Church, Italian state seizure of Church lands and property and the traditional Orthodox Russian rivalry with their Roman cousins, which had just recently been complicated by the arrival in Moscow of an atheist Bolshevik regime. Compared with German promises to restore the Pope's temporal power, remove the ban on the Jesuits and the fact that 'Austria is the only Catholic country left', the Allies might therefore be on shaky ground, and in targeting American Catholics, the likes of Viereck, Harris and Crowley were boxing clever.

Christopher Watts's letter raises one astonishing question. Did Aleister Crowley, the prophet, saint and future godhead of a new global religious philosophy which aimed to replace Christianity, attempt in 1916 to convert to Roman Catholicism?

Of course not. Watts's friend at the *New York Times* had either been fed a line or had gotten the wrong end of the stick (most likely the former). Rational explanations are not always valid or available when the subject under consideration is the deeds of Aleister Crowley. But if one is to be found for that peculiar set of visits, representations and telephone calls, it is this: Aleister wanted ritual advice. In 1913 he had become interested in the *Ordo Templi Orientis* [Order of the Oriental Templars], or OTO. This was then an eleven-year-old body of men who claimed to have inherited the secret rites of the Knights Templar, which included such extravagant masonic rituals as kissing each other's bottoms and engaging in buggery – the kind of thing which was hardly calculated to appeal to respectable devotees of the Ancient and Accepted Scottish Rite of Masonry, but which was meat and drink to Aleister Crowley.

Aleister considered, however, that certain things were missing from the rites of the OTO and he took the trouble of preparing a new 'central ceremony' of 'public and private celebration', which was centred upon a long lyrical invocation written (naturally) by A. Crowley, and 'corresponding to the Mass of the Roman Catholic Church'.

He worked on this ritual in New York throughout the war years

and finally published it in *The International* in March 1918. 'Human nature demands (in the case of most people),' he asserted, 'the satisfaction of the religious instinct, and, to very many, this may best be done through ceremonial means. I wished therefore to construct a ritual through which people might enter into ecstasy as they have always done under the influence of appropriate ritual.'

It would have been perfectly characteristic of Aleister Crowley to gain access to the mysteries and the logic of the Roman Catholic rites by offering himself to some unsuspecting priest as a potential convert. He would have done it without blushing, and the pretence would have appealed hugely to his sense of humour. Why he needed to find a suitable priest through a second-hand contact at the *New York Times* is not clear – but why not? Had his ruse succeeded, he could possibly have tapped the mind of a 'well-known Catholic poet and man of letters' and located some susceptible priest with that poet's reference, all with the one stone. Jackpot! He did not succeed, of course, no more than he became a Roman Catholic.

The Foreign Office received Christopher Watts's information about Crowley, Viereck and Harris in the November of 1917 with something approaching equanimity. With the USA already committed to the Allied effort and American troops already on the battlefields of Europe, the need to contain and discredit anti-Allies propaganda in the USA was no longer so pressing as before. 'This is most interesting,' appended one civil servant. 'Harris and Crowley are both very shady characters,' judged another. Nonetheless, copies of the letter were sent to the Irish Office; to George Geoffrey Gilbert Butler, the director of the British Bureau of Information in New York (who was also an alumnus of Trinity College, Cambridge, having attended that university some ten years after Crowley), 'in case all the facts in it are not already known to him [Butler]'; and to Basil Home Thomson, who was presently assistant commissioner of the Metropolitan Police, and who would shortly, in 1919, become the director of intelligence at Scotland Yard.

Basil Thomson, by then Sir Basil Thomson, occupied his new position in police intelligence when a penniless Aleister Crowley returned to Britain from the USA in the middle of December 1919.

In the previous year Viereck had sold *The International* over his head, leaving Aleister jobless. The capitulation of Germany in November 1918 had broken up his little band of agitators, leaving him without colleagues and a renewable supply of acolytes. In January 1919 he had found some consolation in the company of a new lover, Leah Hirsig, an exquisite beauty from the New York avant-garde whom Aleister greeted upon first meeting with passionate kisses, and at their second encounter by – without introduction, without ado, without a by your leave – undressing her, and then painting her as a 'lost soul'.

Rich in love, perhaps, but Aleister Crowley found himself in 1919 to be without money. He had worked through his inheritance, and was left only with his assets. These were considerable. He had the property at Boleskine, which was sold for – we can only assume – a similar sum to its buying price of a couple of thousand pounds. The value of the pound had more than halved since the outbreak of the First World War, the property market had also fallen, and in 1919 that couple of thousand pounds would have had a value of perhaps forty per cent of its 1899 quotation – some £40,000, perhaps, in the money of the late 1990s. By far his most valuable remaining asset, however, was his library. His books, which he almost certainly overestimated at a worth of £20,000 (£400,000 in 1998) were in storage in England. But whatever their value, he could not release them without paying the storers £350 (£7,000). And he did not have £350. All he had, he claimed, was 'some of my Highland costumes which had been sent for repair to a tailor just before the outbreak of hostilities and had remained safely in storage'.

Upon his return to Britain at the end of 1919, therefore, the Laird of Boleskine and Abertarff found himself reduced to the plaid on his back and the brogues he stood up in. He left the United States disillusioned and broke: 'This is no country for the poet Aleister Crowley'. And astonishingly, he was allowed unmolested back into the United Kingdom.

It was not astonishing to Aleister Crowley, of course. He considered such free passage no more than his due. But consider this: he had during his five years in the USA actively campaigned

against his native land for an Irish republican struggle which, justified or not, was illegal. In the course of this agitation he had renounced his British citizenship, supposedly torn up his passport and declared war on the British state. While Britain was at war with Germany he had written in American, Dutch and German publications in favour of the German war effort. This is an extract from one of his polemics in *The Fatherland*:

> There is only one solution to the problem of England's piracy – the Sovereignty of England must be destroyed once and for all. England herself has understood this with admirable if devilish clarity. It is for this reason that she has not only destroyed the Sovereignty of Ireland, but deliberately ravaged and depopulated it. She must be made to swallow a dose of her own medicine. England must be divided up between the Continental Powers. She must be a mere province, or better still, colony of her neighbours, France and Germany. Count Reventlow has found the word for the situation: that word is 'vampire'. Let him look therefore to tradition. It is not enough to kill a vampire in the ordinary way. Holy water must be used, and holy herbs. It must be severed limb from limb, its heart torn out, and the charred remains run through with a stake.

British citizens had been shot for less.

The response of the British Foreign and Home Offices had been to notify the Passport and Permit Offices, with the explicit intention of identifying and apprehending Aleister Crowley if he should ever again dare to set foot back on British soil. They had also notified – among a host of other influential bodies – the assistant commissioner of police Basil Thomson who, when Crowley did arrive back in London, had been knighted and made the head of intelligence at Scotland Yard. At the end of 1919 Aleister Crowley could have been presented with a charge sheet the size of his kilt.

But he walked home scot-free. So far as we are aware they did not even search his luggage, what there was of it. How did he get away with it? The answer is partly that the British state was tired of conflict, weary of courts martial and firing squads, anxious to put the war behind it; and partly that it could be more tolerant and reasonable than is generally allowed. Even when Crowley's propagandising seemed most dangerous – before the USA had entered the war, when Ireland was in open revolt, and while a deadly stalemate existed on the Western Front – those comments appended to his docket by civil servants and ministers were more genial than vicious. They were occasionally witty, often good-natured, and mystified rather than vindictive: 'Truly the Germans are unfortunate in their selection of British subjects!' . . . 'Unnatural practices and German propaganda seem to be closely allied!'

In the last resort, they did not consider him worth shooting. Many years later Aleister's executor John Symonds wrote to that head of British naval intelligence in New York who had been bombarded with Crowley material between 1915 and 1918, Captain (later Admiral Sir) Guy Gaunt.

'Re the man you mention,' Gaunt replied with reference to Aleister Crowley, going on:

> I think you describe him exactly when you refer to him as a 'small-time traitor'. As regards his activities, I think they were largely due to a frantic desire for advertisement – he was very anxious to keep his name before the public somehow or other. I knew all about him at the time and for a short time either Grey [Sir Edward, foreign secretary from 1905 until December 1916] or Balfour [Sir Arthur, foreign secretary from 1916 to 1919] was very worried about him. I went over to London and had a long talk with Basil Thompson [*sic*] at Scotland Yard and I preached 'Let him alone, I have got a complete line on him and also *The Fatherland*.'

Gerald Kelly, who was also involved with naval intelligence, was asked his opinion. He did his former friend and brother-in-law one last favour by persuading his employers that Aleister was too much of a clown to do any real harm. Kelly may also have suspected that his old college chum was mentally disturbed. He knew of the visions and of the delusions of saintliness, and behind the mischief there had been a clearly schizophrenic aspect to Crowley's wartime activities – he seemed at times truly convinced of his undercover role in the British effort, and at others equally assured of the justice of the German cause. Perhaps he would, after all, have made a useful double-agent.

But if he escaped the censure of the law, he could not evade the British press. Just days after his return to Britain a shot was fired in what was to become one of the most sensational press campaigns of the twentieth century. Horatio Bottomley's *John Bull* magazine leaped to the guns.

Bottomley was that journalist and financier who had commented so enigmatically upon Crowley's successful appeal against Samuel Macgregor Mathers' injunction ten years earlier. While all of those years in America had returned to Aleister a kind of fragile anonymity in his own country – for the Home and Foreign Offices had not made public their findings – since 1910 Horatio Bottomley's reputation had grown. In 1911 he petitioned for bankruptcy, disclosing liabilities of £233,000 (£11 million at the end of this century). He kept his country house and French villa in his wife's name, however, resigned from parliament, and set about regaining a fortune through patriotic journalism. In 1915 he was employed by the new *Sunday Pictorial* as a columnist at the astronomical rate of £100 (£4,000) per article. His popularity grew apace and he re-entered the world of business, collecting by public subscription almost £900,000 (£34 million). In 1918 he was consequently able to pay off his creditors and relieve his bankruptcy. He stood once more for parliament, this time as an independent, and won the seat of South Hackney with a huge majority.

This was the man – incompetent financially, but nonetheless enormously rich, wonderfully adept in the dark skills of populist

journalism and greatly admired by much of the population – who chose in 1920 to direct the fury of his magazine *John Bull* at the slightly pathetic forty-four-year-old figure of Aleister Crowley. In doing so, he re-established Aleister's reputation.

Bottomley must have been told through government sources of Crowley's mischief in the United States. On 10 January 1920, just three weeks after Aleister's return to Britain (a fact of which Horatio was clearly as yet unaware), *John Bull* – which had earlier pilloried Crowley's fellow degenerate Frank Harris – trumpeted: ANOTHER TRAITOR TROUNCED – Career And Condemnation Of The Notorious Aleister Crowley.

Bottomley reported in a prototypical piece of what would become known as tabloid journalism:

> Now we hear that the traitorous degenerate, Aleister Crowley, is anxious to sneak back to the land he has sought to defile. Crowley is no stranger to the columns of *John Bull*. As long ago as November 1910, we pilloried this man for his bestial posturings and his disgusting blasphemies. He was then, forsooth, the inventor of a new religion, with its pseudo-teaching supposed to be derived from the medieval alchemists, and its licentious cult in which dark rooms, impressionable women and poems recited to throbbing music played their appointed part. But, having then denounced this person, we should have been well content to leave his so-called religion to the execration and disgust of every healthy-minded man. But, as we observed in relation to Frank Harris, the war which brought out the best in human nature, also forced the scum to the top, and Aleister Crowley is of the scum.

> Like Harris, he sought satisfaction for his degraded soul in America, and, like Harris, he was heralded as 'a distinguished literary man'. O! literature, what offences are committed in thy name! He was heralded

as a poet; the fact that he won honours at Cambridge adds to his dishonour. Never forget that when these traitors and renegades emitted the venom of their poisoned natures in America the war was in its early stages – the die had been cast, the issue was in the balance.

Crowley added such power as his pen could commend to the campaign of calumny against his native land, and vied with Harris in the cruel bitterness of his invective. Easily getting in touch with one George Silvester Viereck, a German-American and one of Dernberg's agents, and the owner of such notorious German journals as *The Fatherland* and the *International Monthly*, Crowley found a ready market for his prostituted talents . . .

Now we ask, in all seriousness, can such a dirty renegade be permitted to return to the country he has spurned and insulted? We await an assurance from the Home Office or the Foreign Office that steps are being taken to arrest the renegade or prevent his infamous feet ever again polluting our shores . . . We warn the Government of the danger they run. Both Harris and Crowley pose as patriotic Irishmen. They are dangerous firebrands; we pay them the compliment of declaring that their presence here or in Ireland would involve perilous consequences. It is the duty of the Government, in the national interest and for the sake of that splendid patriotism which these creatures have denied, to take immediate and effective action against them.

'I must admit that I was rather disgusted,' Aleister would reflect, 'when my own solicitors sent me half a page of ravings about myself and asked the explanation of my crimes.' He did not consider taking action, however, supposedly on the grounds that, 'I did not think that anybody took his *John Bull* . . . seriously.' The likelihood is, of

course, that even if Horatio Bottomley had libelled Crowley – which is doubtful – no English jury would in 1920 have found in favour of the latter against the former.

Bottomley would in due course, to Aleister's great delight, reach a sticky end. Shortly afterwards he quarrelled with a business associate, who then issued a defamatory pamphlet. Bottomley sued for criminal libel. His action failed, and in the course of the proceedings revelations were made of Bottomley's business practices which resulted in the Lord Chancellor's Court of Chancery appointing a receiver to examine his enterprises. In March 1922 he was charged with twenty-four counts of fraud, and in May of that year Horatio Bottomley was found guilty on twenty-three of those counts. He was sentenced to seven years in prison (he served four), and expelled from the House of Commons.

John Bull magazine staggered on for a year or two more, and would return again to the profitable subject of Aleister Crowley before Bottomley's death as a broken man at the age of seventy-three in 1933. But what had begun as little more than a spat between two different colours of English rogue, ultimately achieved something slightly more substantial. It set the tone of the public reputation of 'the wickedest man in the world'.

8

Addicted, Assaulted and Abroad

*They don't understand my point of view. They misquote my
words, after hearing them every time we have met. They
misinterpret four words of one syllable, 'Do what thou wilt'.
Finally realising their lack of comprehension, they assume at
once that I must be one of the filthiest scoundrels unhanged.*

– Aleister Crowley

Aleister Crowley had long suffered from a variety of minor ailments.
He had been asthmatic since boyhood and was increasingly
dyspnoeic. In 1920 he took these complaints to a Harley Street
doctor. The physician prescribed him heroin.

That was not, even in 1920, so unusual. Heroin (diacetyl-
morphine) had first been synthesised from morphine just five
decades earlier. It had been available over the counter of chemists
ever since. 'Poor little man,' wrote a friend of his family to the
sixteen-year-old Winston Churchill at Harrow School in 1891, when
the future prime minister was suffering from a toothache, 'have you
tried the heroin I sent you . . .'

In 1898 it was widely marketed by the German pharmaceutical
company Bayer as a powder or as a syrup. Heroin was claimed

initially as a wonder drug, possessing all of the analgesic properties of opium, laudanum or morphine, but without their addictive properties. It was, indeed, prescribed as a cure for opium or morphine addiction. It was also announced to be particularly effective in the curing of coughs. It would, said a New York advertisement of the time, 'suit the palate of the most exacting adult or the most capricious child'. By the end of the First World War the drug's addictive properties were widely recognised, but it was still commonplace. In 1920, the same year that Aleister Crowley was given his treatment, the author of *Peter Pan*, J.M. Barrie, was prescribed heroin for sciatica. When his doctor baulked at Barrie's demand for a repeated and increased dosage the writer pleaded that it gave him 'such a blissful sensation'.

Heroin was not outlawed, and subsequently made available only on prescription, in Great Britain until the Dangerous Drugs Act of 1922. By that time the fact of millions of addicts in western Europe and the USA had become impossible to ignore. And by that time Aleister Crowley – however much he may deny it – had become one of those millions of addicts. He would remain hooked on prescription heroin for the rest of his life.

Crowley's attitude toward drugs had always been characteristically idiosyncratic. Essentially, he believed that addiction was no more than a state of mind to be conquered. His earliest experiments with drugs had encouraged him in this delusion. Hashish – which he had by 1920 used recreationally and ritually for two decades – is not physically addictive. The opium pipes which he had enjoyed during journeys to the East were, compared with a refined and concentrated opiate such as heroin, comparatively benign. The pages of *The Equinox* had been littered with essays and fiction and verse, written by Aleister and others, on the subject of such drugs. 'Silence and darkness are weaving a web,' explained Crowley's own 'The Opium-Smoker' in the second issue of the magazine:

> *Broidered with nothing at uttermost ebb:*
> *Cover, oh cover the shaming of Seb!*

Fling the wide veil, O Nuit, on the shame!
Shame from the Knowledge and unto the Name
Hide it, O hide it, in flowers of flame!
Now in the balance of infinite things
Stirs not a feather; the universe swings
Poised on the stealth of ineffable wings.

Cocaine, which he – in common with much of his class in the first and last decades of the twentieth century – freely enjoyed, is also a comparatively mild narcotic. It was easy for a young man of Crowley's strength and physique to take any and all of those drugs for several days on end, and come away with nothing worse than a hangover.

In a curious self-deception which would long outlive Aleister Crowley, much of the rest of society also insisted upon grouping all of those diverse substances together, either as dangerous and instantly addictive, or – when they had a profit to turn for the commercial pharmaceutical companies – as gentle medicines, as harmless as aspirin when taken on the instructions of a doctor. Combine those two sets of attitude, those two social phenomena; combine the ignorance of his society with the stubborn egotism of Aleister Crowley, and there emerged the perfect candidate for addiction. Simply put: if the Bayer company and Harley Street physicians did not realise or advertise the danger, Crowley himself – convinced of his own deific powers of control – stood not a chance. Heroin relieved his asthma. It also – as *Peter Pan*'s author testified – made him feel wonderful, particularly when combined with cocaine. In a novel titled *Diary of a Drug Fiend*, which was written in 1922, just two years after he was first prescribed heroin, Aleister has left us convincing accounts of his first experience of each of those two narcotics.

Of cocaine, he wrote:

> We have drunk alcohol since the beginning of time;
> and it is in our racial consciousness that although 'a
> hair of the dog' will put one right after a spree, it won't

do to choke oneself with hair. But with cocaine, all this caution is utterly abrogated. Nobody would be really much the worse for a night with the drug, provided that he had the sense to spend the next day in a Turkish bath, and build up with food and a double allowance of sleep. But cocaine insists upon one's living upon one's capital, and assures one that the fund is inexhaustible.

As I said, it is a local anaesthetic. It deadens any feeling which might arouse what physiologists call inhibition. One becomes absolutely reckless. One is bounding with health and bubbling with high spirits. It is a blind excitement of so sublime a character that it is impossible to worry about anything. And yet, this excitement is singularly calm and profound. There is nothing of the suggestion of coarseness which we associate with ordinary drunkenness. The very idea of coarseness or commonness is abolished. It is like the vision of Peter in the Acts of the Apostles in which he was told, 'There is nothing common or unclean.'

As Blake said, 'Everything that lives is holy.' Every act is a sacrament. Incidents which in the ordinary way would check one or annoy one, become merely material for joyous laughter. It is just as when you drop a tiny lump of sugar into champagne, it bubbles afresh.

Saint Aleister Crowley was in the habit, as we have seen, of dignifying and justifying most physically pleasurable experiences by enlisting them into the sacrament of his religion. Powerful, pure, newly synthesised heroin from Harley Street was heaven-sent for such a function:

We found ourselves looking into each other's eyes with no less ardour than before; but somehow it was a different kind of ardour. It was as if we had been

released from the necessity of existence in the ordinary sense of the word. We were both wondering who we were and what we were and what was going to happen; and, at the same time, we had a positive certainty that nothing could possibly happen.

It was a most extraordinary feeling. It was of a kind quite unimaginable by any ordinary mind. I will go a bit further than that. I don't believe the greatest artist in the world could invent what we felt, and if he could he couldn't describe it. I'm trying to describe it myself, and feel that I'm not making out very well. Come to think of it, the English language has its limitations . . .

There followed several paragraphs of stoned waffle. From the age of forty-five onwards, Aleister Crowley wrote hardly a word uninfluenced by opiates. This resulted in an already loquacious, flowery writer becoming positively pleonastic. When he turned to dictation rather than handwriting, after a few grains of the prescription his style – never pithy – metamorphosed into a tropical garden of verbiage. He was already a compulsively prolix author; with the help of strong narcotics his output became uncontrollable. 'The world had stopped suddenly still,' he concluded of that first sniff of heroin.

We were alone in the night and the silence of things. We belonged to eternity in some indefinable way; and that infinite silence blossoms inscrutably into embrace.

The heroin had begun to take hold . . . We felt ourselves crowned with colossal calm. We were masters; we had budded from nothingness into existence! . . . Our happiness was so huge that we could not bear it; and we slid imperceptibly into conceding that the ineffable mysteries must be expressed by means of sacramental action.

———

'Sacramental action' in this context meant making love. Heroin would in his later middle age render Aleister Crowley almost impotent, but in the early days of his addiction even that most sexually constipating of drugs could not suppress his powerful libido. It must indeed have seemed the very answer, in the troubled year of 1920, to all of life's petty slings and arrows.

Although he would not for a long time accept the unyielding physical nature of his heroin addiction, preferring to regard it as entirely a psychological difficulty, and therefore capable of suppression, it did not take long for Aleister Crowley to notice, and begin to struggle with, his habit. 'You children,' he would make a fictional idealisation of himself pronounce to two younger junkies in 1922, 'are the flower of the new generation. You have got to fear nothing. You have got to conquer everything. You have got to learn to make use of drugs as your ancestors learnt to make use of lightning. You have got to stop at the word of command, and go on at the word of command according to circumstances.'

Occasionally, very occasionally in the first few years of his addiction, Crowley would force himself to obey his own strictures. He might do without heroin or some equivalent opiate for a day and a night, before relapsing once more into the narcotic embrace. These short-lived experiments with voluntary denial convinced him at the time that he was right – and he was at least partly right, for a component of narcotic addiction is psychological. But they were ultimately as inadequate as was his thesis, and as his middle years progressed he contented himself with the steady, controlled use of heroin which he would sustain until his death in 1947.

This addiction did not proscribe his activities in the way that it would certainly have restricted (and does restrict) the heroin addicts of a later age. In Britain, as one who who was rightly regarded as a victim, a patient who had been prescribed the narcotic by a doctor before it was outlawed, he qualified for a permanent weekly prescription. On the continents of Europe and Africa, many other countries – particularly those on the shores of the Mediterranean – had not yet got round to outlawing heroin or criminalising its use. And even when they did follow the examples of Britain and the USA

and made such drugs as heroin and cocaine illegal, in Italy, Tunisia, and even in France it was frequently a half-hearted gesture, one which the authorities made little effort to enforce. Before the outbreak of the Second World War in 1939 – by which time he was safely back in Britain, and never more than a day's first-class post away from his doctor's prescription – Aleister or anybody else would have little trouble in obtaining, from the street or from a pharmacist, heroin or some equivalent opiate.

In the February of 1920, therefore, he was able to plan an 'ark of refuge' from the 'Aeon of the Dying God'. This was to be a 'community on the principles of *The Book of the Law* . . . an archetype of a new society.' It would be an Abbey of Thelema. And this prototypical hippie commune would be established, for reasons of cost, climate, and freedom from media or governmental interference, in southern Europe.

Leah Hirsig had been pregnant when she returned with Crowley to Britain at the end of 1919. On the crossing they met an unemployed French governess and single mother named Ninette Shumway. Ninette was promptly engaged into the Crowley family service. In February Leah gave birth to a girl, Ann Lea, or Poupee. Mother and baby daughter remained in northern France while, in March, Ninette travelled with Aleister through southern Europe in search of a suitable site for an abbey. He occasionally grew tired of explaining to various women the anachronism of monogamy.

Ninette and Aleister found the satisfaction of an act of sexual magic in a Neapolitan hotel room, and some days later they discovered their perfect site on the north coast of Sicily, on a promontory overlooking the town of Cefalù. Aleister had consulted the I Ching for guidance, and had taken the additional precautionary step of letting it be known in Cefalù that he required a villa. He was suitably delighted when, on 2 April 1920, both

actions bore fruit (although he naturally gave more credit to the first of them). An Italian arrived at their hotel after breakfast and escorted Ninette and Aleister to the outskirts of Cefalù.

Fictionally and non-fictionally, Aleister described the site of the villa in glowing terms. In *Diary of a Drug Fiend*:

> The cliffs towered above us. They were torn into huge pinnacles and gullies; but above the terrific precipices we could see the remains of successive civilisations; Greek temples, Roman walls, Saracen cisterns, Norman gateways, and houses of all periods were perishing slowly on the gaunt, parched crags.
>
> It was very hard work for Lou and myself to climb the hill in the wretched condition of our health. We had to sit down repeatedly on the huge boulders which lined the paths that wound among the well-tilled fields dotted with gnarled grey olives.
>
> The air of the place was a sublime intoxication . . . We had to take several goes of heroin on the way.

And in his autohagiography, he depicted:

> A villa that might have been made to order. It fulfilled all my conditions; from possessing a well of delicious water to a vast studio opening northwards. The gods took no chances. They meant me to live there and guarded against any possible perversity on my part by planting two tall Persian nuts close to the house . . . I struck a bargain on the spot.

It was not in fact so impressive a building. It was a one-storeyed pantiled house with five rooms. Later visitors would complain about the lack of sanitation, and Aleister himself was not so enamoured of the place that he refrained from planning to build a second, idealised Abbey of Thelema on the hilltop at Cefalù. A plan which was never realised because it would have cost quite a lot of money (an estimated

£5,000, which eighty-five years later would have been £125,000) and in 1920 Aleister Crowley was extremely short of money.

But it would suffice. Sicily was cheap, comfortable and comparatively tolerant. There was a regular railway service between Cefalù and the shops and streets and port of Palermo. Leah was sent for, and the lease on the villa was signed jointly by Sir Alastor de Kerval, Knight of the Sacred Lance, and the Contessa Lea Harcourt, Virgin Priestess of the Sea Grail.

If Aleister had hoped that by retiring to a distant feudal island off the toe of the Italian peninsula he would consequently be free from the attentions of the British press, he was proved sadly wrong. He was there for only three years, but in that time the Abbey of Thelema would gain a notoriety which long outlived its Abbot. Ironically, his blatantly treasonable activities in the centre of a large and friendly English-speaking city had failed to make him much of a name in Britain, but his private life on a remote Sicilian hillside would cement his popular reputation for the remainder of the twentieth century.

In retrospect, it is not surprising that Crowley's 'archetype of a new society' arrived at a scandalous end. The founder himself was hardly in the best of condition. He was treating his breathing difficulties with a measured diet of opium, cocaine, ether, morphine, heroin, hashish, wine and brandy. Most of his fellow travellers, men and women who came and stayed for varying lengths of time, shared these sacraments. At his best he was still, in his late-forties, a lively, active man. He invented a new sport in the courtyard: the game of Thelema:

> So called because of the variety of strokes. It is a sort of Fives played with an association football, but there are no side walls, only a low wall at the back over which, if the ball goes, it is out of play, as also if it strikes outside the vertical lines painted on the wall or below a ledge about a foot from the ground. The ball may be struck with any part of the body so long as it is struck clean, and the game is bewilderingly fast to watch.

But he was also an insomniac, was frequently arrested by asthma, and was also – unsurprisingly, considering the contents of his bedside cabinet – delusionary and assaulted by hallucinations. He was also chronically broke. In order to subsidise life at the Abbey he travelled to London in 1922 and signed a contract with the publishing house William Collins to deliver a novel – *Diary of a Drug Fiend* – for the pitifully small advance payment of £60; a mere £1,500 in the currency of the late 1990s. To a man who had been writing and publishing for over twenty years, it was a tiny advance. Horatio Bottomley had received three times as much for a single weekly newspaper article. But £60 was better than nothing in Sicily in 1922, and Aleister had no option other than to scoop it up and dash off the required number of words.

He dictated the novel in four weeks to Leah Hirsig in a rented London room, handed over the manuscript, and promptly pocketed a second cheque – this time for £120 – as payment of advanced royalties on his proposed autobiography. He could return to Sicily with cash in hand and some sort of a future. All would surely now be well. The communards, the adepts, the disciples – those wraiths who, in place of friends, lovers or equals, passed insubstantially around the adult life of Aleister Crowley on their way to greater or lesser tragedies – could get on with their rituals, their indulgences, their petty squabbles and minor sacrifices in peace and security.

Diary of a Drug Fiend was published by Collins in November 1922. It is a slight fantasy about two young people who become addicted to heroin and cocaine and who seek assistance from an older man, King Lamus, a master adept who runs a happy communal abbey in southern Europe. It contains those graphic descriptions of cocaine and heroin highs, and equally tortuous portraits of withdrawal. It is littered with mischievous digs at Crowley's acquaintances; with condemnations of the new Dangerous Drugs Act (the 'great

philanthropist' Jabez Platt, sponsor of the 'Diabolical Dope Act', turns out to be a drugs profiteer); and with propaganda for the Law of Thelema, which will cure not only drug addiction but also all of society's other ills. Crowley's characterisations were cardboard; his plotting facile, disconnected and irrelevant; his philosophy thin. The book's single quality lies in the anarchic individualism of its Crowley substitute, King Lamus. When the tale has died on its feet and the objective reader has slumbered in their chair, Lamus is just capable of raising a flicker of intelligent interest with such a comment as this, on the new narcotics legislation:

> I'm afraid I do honestly think that most of the troubles spring directly from the unnatural conditions set up by the attempt to regulate the business. And, in any case, the state of mind brought about by them is so harmful indirectly to the sense of moral responsibility that I am not really sure whether it would not be wiser in the long run to do away with the Blue laws and the Lizzie laws altogether. Legislative interference with the habits of the people produces the sneak, the spy, the fanatic and the artful dodger . . . An appetite should be satisfied in the simplest and easiest way. Once you begin to worry about the right and wrong of it, you disturb the mind unnaturally . . .

Immediately after publication, the *Sunday Express* bayed for the book's suppression. 'At the baser and more bestial horrors of the book it is impossible to hint,' promised the newspaper's reviewer. Collins, doubtless surprised and a little grateful for the publicity, refused to withdraw the novel. So the *Sunday Express* did a little more homework, and on the following Sunday, 26 November 1922, they returned to the attack.

ALEISTER CROWLEY'S ORGIES IN SICILY, bellowed the headline.

WOMAN'S ACCOUNT OF HIS LAST VISIT TO LONDON . . . THE BEAST 666 BLACK RECORD OF ALEISTER CROWLEY . . . PREYING ON THE DEBASED . . . HIS ABBEY: PROFLIGACY AND VICE IN SICILY. . .

'The man Aleister Crowley,' slavered the *Sunday Express*, 'is the organiser for pagan orgies. He engaged in pro-German propaganda during the war. He published obscene attacks on the King. He made dramatic renunciations of his British birthright. He proclaimed himself "King of Ireland". He stole money from a woman. He now conducts an "Abbey" in Sicily . . .'

There followed a lengthy précis of Aleister's life and times, culminating in the journey to Cefalù, where 'he was head of a community of kindred spirits established at the Villa Santa Barbara, renamed by them "Ad Spiritum Sanctum". Free sexual intercourse seems to have been one of their tenets.'

Most of the *Sunday Express*'s generalised slanders were probably within the law. One sentence, however, was clearly actionable. Aleister Crowley had never even been charged with 'stealing money from a woman', let alone found guilty. Somebody had leaked that police report, with its reference to the contentious widow's £200, and omitted to warn the *Express* that not all the information in a confidential wartime document was necessarily correct. Crowley could have sued and, given an even playing field, probably won his case. But, lounging in the Sicilian sun, he opted instead to write a letter to the proprietor of the *Sunday Express*, Lord Beaverbrook, pleading for fair play. He would later regret – and attempt to compensate for – his restraint.

For in requesting leniency he was whistling in the wind. Three months later the *Sunday Express* renewed its assault. NEW SINISTER REVELATIONS told of the death of 'a brilliant young English university man, a writer,' at the Abbey of Thelema. 'His young wife,' continued the newspaper . . .

> A beautiful girl prominent in London artistic circles, arrived in London two days ago in a state of collapse. She is unable to do more than give a hint of the horrors from which she has escaped. She said, however, to a *Sunday Express* representative yesterday that the story of Aleister Crowley's sexual debauches and drug orgies as published in this

newspaper far understates the real horror of life in the 'abbey' at Cefalù, where he keeps his women and practises black magic.

This young girl, whose name and that of her husband the *Sunday Express* withholds in deference to the parents' sorrow, said that Crowley offered her husband a secretarial position last autumn when in London. The Beast is possessed of a persuasive smile and suave manners. The young couple had no idea of the true character of the place to which he was inviting them. As the offer seemed to mean travel and congenial work the young husband – a boy of twenty-two – accepted it. Once they were in Sicily, however, they found they had been trapped in an inferno, a maelstrom of filth and obscenity. Crowley's purpose was to corrupt them both to his own ends.

In short, the *Express*'s horror story went on to describe how the 'beautiful girl' was 'forced' to cook for nine people before she finally took to the hills to escape Crowley's 'bestialities', and how the 'boy husband' caught gastroenteritis and in her absence, tended only by the sinister Abbot of Thelema, quickly died. The article concluded with a tantalising portrait of home life at Cefalù:

> Children under ten, whom the Beast keeps at his 'abbey', are made to witness sexual debauches unbelievably revolting. Filthy incense is burned and cakes made of goats' blood and honey are consumed in the window-less room where the Beast conducts his rites. The rest of the time he lies in a room hung with obscene pictures collected all over the world, saturating himself with drugs.

What happened at Cefalù?

Frederick Charles Loveday was an Oxford undergraduate who, in the hunt for bohemian cache, abandoned his given christian names

and called himself Raoul. In 1922, shortly before his graduation with a first in history, Raoul Loveday married a twice-divorced artists' model named Betty May. That summer Raoul and Betty decamped to London. There Raoul heard that a man whose writing he had admired, Aleister Crowley, was in the city preparing a book. He visited Crowley, the two men took ether and other drugs, and Loveday became entranced. In November Raoul and Betty – the latter a reluctant traveller, for she hated Aleister's influence on her new husband, and was extremely wary of narcotic drugs – followed him to Cefalù.

The Abbey was not always an attractive place. Dogs and children roamed raggedly about its yard. The paraphernalia of alcoholic, narcotic and other rites littered the floors and shelves. There were gaudy cabalistic designs and rough lewd portraits on the flaking walls. Nobody swept up; there was no running water; no flushing toilet. The food was poor, for nobody enjoyed cooking. Four-and-a-half decades later some of the communes and squats of the younger generation which purported to respect the memory of Aleister Crowley would achieve just such a grubby apotheosis in crumbling stone buildings beneath the Mediterranan sun, and they are probably the modern world's closest point of reference to the Abbey of Thelema in 1922. But then, back then, even a bohemian graduate and an artists' model had never seen anything like it.

Betty hated the place, and Raoul – who did not – grew ill. The local doctor was called in and diagnosed an infection of the liver and spleen. Betty Loveday would later claim that this infection was passed to her husband following the messy sacrifice of a cat. Aleister and Betty had a noisy falling out. She left of her own volition, saying that she was returning to England, but had a change of heart. Doctor Maggio had by now diagnosed acute enteritis in Raoul. She turned back from the town of Cefalù on Friday, 16 February 1923.

In her version, which history and experience each favour, on that afternoon Betty Loveday returned alone to the villa. In Crowley's apocrypha they were together, having gone once more to summon the doctor. It hardly matters. Either one or both of them arrived back to find Raoul Loveday dead.

Crowley was not unmoved – Betty Loveday herself reported that he wept uncontrollably, before burying Raoul in the cemetery at Cefalù – and in the succeeding weeks he went down with a fever and lay bedridden for almost a month. She herself was devastated. In a condition bordering on hysteria she entrained immediately for London, where the *Sunday Express* found her ready to tell all and embellish upon most. Indeed, all but the original trinity of Crowley, Leah Hirsig and Ninette Shumway instantly deserted Cefalù following the interment of Raoul Loveday. The strange experiment was almost done.

Aleister Crowley was responsible for Loveday's death only insofar as he was responsible for running an unhygienic household, and for initially misdiagnosing the young man's complaint as a passing fever. The latter cannot be held too strongly against him: a qualified doctor was, after all, three times called up from Cefalù, and he failed to recognise the severity of Loveday's condition until it was too late. And even if Raoul did pick up his infection from some ghastly ritual (which is unlikely, if only because it was probably quite unnecessary to try too hard to catch gastroenteritis at the Abbey of Thelema), nobody had *told* him to eat the black pudding made from goat's blood described in the *Sunday Express*.

The British press was, of course, not prepared to give Crowley the benefit of any doubt. Aleister's activities and opinions – freely undertaken and expressed – had modelled him into a perfect Aunt Sally. He would never understand this phenomenon. Even while engaged in the most preposterous of ventures, and professing one of the strangest belief systems known to twentieth-century humanity, Crowley was always ready to slip back into his abandoned persona as a middle-aged, public-school and Cambridge man appalled by the irresponsibility of the modern press. He could lay off the drugs and goats, slip on a tweed jacket and sound like a disgruntled ratepayer on a War Office pension. It seemed always to him quite outrageous that the public prints should choose to make a monster, where he himself saw only a brilliantly iconoclastic author, who happened to have been chosen to relay some eternal truths about the future of humanity. If only they would *listen*.

John Bull magazine, with its founding editor languishing in jail and its own future bleak, grasped the new Aleister Crowley story like a lifeline. Under the headline THE KING OF DEPRAVITY, on Saturday, 10 March 1923, *John Bull* congratulated itself on its percipience.

Bottomley's organ gloated:

> It is over twelve years ago since *John Bull* first exposed the corrupting infamies of that arch-traitor, debauchee and drug-fiend, Aleister Crowley, whose unspeakable malpractices are said to have driven his former wife and at least one other of his victims mad, while they have already ruined the lives of numerous cultured and refined women and young men, one of whom – a brilliant young writer and University man – has just died under mysterious circumstances at Crowley's so-called 'Abbey' of Thelema in Cefalù, Sicily . . .

Following the standard reprise of Aleister's unorthodox career, *John Bull* felt itself obliged to offer an explanation of just how he kept on getting away with it, before recounting its own lurid and somewhat partial version of Raoul Loveday's sorry demise.

The magazine suggested with perhaps a hint of envy:

> Some of Crowley's assets, besides an uncanny influence over and unholy attraction for women, are a very persuasive tongue, a glib and deceptive hypocrisy, and – on occasion – a most ingratiating manner.
>
> Many highly intelligent women – and even men – have been convinced that the Master Therion (as Crowley calls himself) is a Saint, to discover too late a devil possessed of indubitable occult powers. It is these mysterious powers which, used as they are, make Crowley one of the most dangerous men alive.
>
> It was therefore an easy matter for the Beast to lure

this young and unsuspecting married couple to Cefalù. Once in the rock-bound Abbey of Thelema, however, they quickly found that they had been trapped by an obscene and filthy devil in human form. They resisted the monster and his drug-maddened women with all the strength they could when they found that Crowley's purpose in luring them into the close confinement and terrifying 'discipline' of his infamous Abbey was to corrupt them both to his own vile ends.

Suddenly the husband became mysteriously ill, leaving the girl-wife alone to fight the Beast. She bravely defied him, and said that Crowley turned her out that night. Within twenty-four hours of his seizure the young husband died. The doctor from Cefalù, who was called, diagnosed the mysterious and fatal malady as acute enteritis, we're told, but 'was puzzled at the case and at certain peculiarities in the nature of the attack' which quickly ended in death.

Two weeks later *John Bull* returned to the theme, and in so doing coined the first of its immortal Crowleyan headlines. Under the banner THE WICKEDEST MAN IN THE WORLD – a title which would stick to Crowley like a burr – readers were advised that 'in this article we reveal startling facts regarding the corruption of children in Aleister Crowley's "cesspool of vice" in Cefalù, and describe some of the blasphemous and bestial ceremonies – or orgies – which have taken place in the so-called "Abbey of Thelema", for which he is now seeking new recruits.' The article continued:

The more the activities of this degenerate Englishman are investigated, the more incredible becomes the tale of his villainies. It is understood that the Italian Government are resolved to put an end to Crowley's career of vice, and in this effort they will have the sympathy of decent-thinking people in every land.

> Our past exposures of Crowley have been, to say
> the least of them, highly sensational, but they are as
> nothing compared to these we have yet to make
> concerning the amazing record of this degenerate
> poet and occultist, traitor, drug fiend, and Master of
> Black Magic ...

John Bull had, of course, cottoned on to the presence at Cefalù of
Hirsig's and Shumway's children. These innocents existed in Sicily,
the magazine reported, 'half-starved and already have been taught
by "the Beast" to indulge in the vilest practices, while they are made
to witness sexual debaucheries that are too disgusting to describe.'

Bottomley's magazine then presented its readership with a
vibrant précis of the form of ritual worship at the Abbey of Thelema.
The exact details were naturally unavailable – or if available, simply
too horrible for transmission in a family publication – but a rough
sketch would suffice. They had to do 'with the violation of a naked
woman in front of the "altar", and her subsequent slaying and
"sacrifice" of a goat, which is made to play a principal part in these
disgusting Dionysian rites.' The article went on:

> The woman, who acts as the 'Virgin Goddess' or
> priestess in this vile ceremony, is first given an
> aphrodisiacal drug, such as hashish (known in the
> East as Vhang) or another similar drug distilled from
> Indian hemp, known in scientific circles as
> *Anhalonium Lewine.*

'This renders the debauchee,' explained *John Bull* in a beautifully
ambiguous sentence whose last three words reflect a strange
integrity upon the journalist, 'capable of participating in practices
which no normal person could conceive of, much less describe.'

Crowley's British reputation was, after 1923, guaranteed. But in
normal times and circumstances the squawks and vapourings of the
London yellow press might have had little or no effect upon the life
in Italy of an affected party. It was Crowley's ill luck that the *Sunday*

Express and *John Bull* articles appeared in 1923. For at the end of 1922, following the 'march on Rome' of his Fascist colleagues, Benito Mussolini had come to power.

Aleister's reported activities concerned Mussolini's regime in more ways than one, without being serious grounds for expulsion. It was naturally embarrassing to harbour within one's frontiers a foreign national so controversial that his own press denounced him – but in the absence of representations from the embassy, Mussolini had no grounds for thinking that the British government thought less of him for that. It unarguably offended against the purity of Fascist philosophy to see a man in late middle age doing unmentionable things to women and goats in Sicilian villages – but the women, if not the goats, were not of Italian origin; they seemed to be there of their own free will; despite the tone of the British press reports it seemed that no crime had been committed (even *John Bull* had been obliged to admit that the post-mortem had diagnosed the cause of Raoul Loveday's death as naturally caused enteritis); and Italians were more inclined than were the British to dismiss with a worldly shrug such verifiable eccentricities as engaged the time of the occupants of the Abbey of Thelema.

Some of the above may have disturbed the Italian Fascists, but none of them would on their own have outlawed Aleister. What really did for him was Mussolini's young crusade against secret and quasi-mystical societies. The same systemised repression, which would assault and almost destroy the Italian Mafia, in 1922 and 1923 flexed its muscles on the occult. Grand Masters of various hermetic groups were banished, abroad or – in the case of the Master of the Grand Orient of Italy – to internal exile in the Lipari Islands.

In the face of this assault on large, established and Italian groups, Aleister Crowley and his little band of foreign neophytes in Sicily

had no chance. Why, even their home press was calling for their persecution. In April 1923 Aleister received a summons to the police station at Cefalù. There he was presented with an order from the Italian Minister of the Interior expelling him, but not his associates, from the country. He asked for, and was granted, a week in which to make good his departure.

John Bull magazine was in raptures. Its issue of 16 May 1923 coined yet another memorable headline. Under the words: THE MAN WE'D LIKE TO HANG, *John Bull* sustained its attack: 'The infamous Aleister Crowley, who has been expelled from Italy, proposes to return to this country. He is not wanted here. We do not want a man of his record on British soil. Apart from anything else, he is a beast whose disloyalty is only exceeded by his impudence.'

Having thus proposed the creation of a stateless citizen out of a man with no criminal record in Britain, the USA or Italy, *John Bull* went on to gloat:

> The Italian police, who have been kept informed of our revelations concerning Aleister Crowley, the debased and blasphemous person who both preaches and practises corruption, have taken the appropriate action. They have ordered him peremptorily to leave their country within seven days, never to return.
>
> So far, so good. It is at least a tribute to public decency that this man should be bundled unceremoniously out of his Abbey at Cefalù, where he practised his horrible rites and perverted his victims. But clearly what is required is concerted international police action. Otherwise Crowley will simply transfer his malevolent activities elsewhere; and continue to find fresh followers.

There, then, in a few short weeks, was created the legend of Aleister Crowley, the Beast, the Man We Would Like To Hang, the Wickedest Man in the World. It was a dizzying experience. The most immediate effect of all of this deranged publicity was not, of

course, to set the police of Europe at his heels: they had no real grounds to do so. Nor was he banned from Britain. But the publishers Collins, after suffering silently all of the bad publicity which had been directed like a firehose upon *Diary of a Drug Fiend*, decided that enough was enough. They would write off the £125 advance on Aleister's autobiography and refuse to publish it. This was more of a blow than it might have seemed. Fired up on self-righteousness and narcotics and the need to justify his slandered activities, Aleister had actually managed to dictate most of his 'Autohagiography'. It was enormous: some half-a-million words. More than that, the book represented his apologia, his opportunity to explain himself and his career to the curious world. It was also – not negligibly – easily the most accomplished piece of writing that he had achieved. Freed from the pretensions of verse or the demands of fiction, both of which were well beyond his abilities, he proved to be a masterly and witty exponent of practical non-fiction. The book which could, in the 1920s, have made for him some kind of a literary reputation, was temporarily lost to the world.

He left Cefalù for Tunisia in May 1923, leaving Leah Hirsig and Ninette Shumway behind to keep the Abbey warm for his return. He was forty-seven years old, addicted to heroin, a failed writer in all eyes but his own, and effectively penniless. His name was made: he was infamous to a startling degree. All that was left was a long decline.

9

The Long Descent

*In England, Crowley the gentleman bohemian is a much
contested personality. One group consider him as a
revolutionary philosopher, another as a foolish artist.*

– Berliner Tageblatt

The long last years of Aleister Crowley were not devoid of
controversy. It was just that, after his astonishing deeds in the
Himalayas, in New York and in Sicily, almost *anything* else would
have been anticlimax. And that is how it proved.

After three months in Tunis in the company of a new disciple,
another Cambridge graduate named Norman Mudd, Aleister
realised that he was not going to be allowed back to Sicily. He flirted
with the idea of re-forming the Abbey, perhaps on the island of
Zembra off the Tunisian coast. But it was not to be. Suffering
regularly from heroin withdrawal – the severity of which finally
convinced him of his physical addiction, and therefore that the
psychological cure he had proselytised in *Diary of a Drug Fiend* was
falacious – he travelled north to Paris, where he nursed an
increasingly poisonous hatred of the *Express* group of newspapers.
Beaverbrook, he wrote to all and sundry – his old acquaintance

Arnold Bennett included – had been solely responsible for the demolition of his dreams.

There followed a crippled, directionless lurch around Europe and North Africa. His acolytes scattered to the winds – by 1924 Ninette Shumway was the only disciple left at Cefalù; she shortly left, and disappeared from this narrative. Leah Hirsig and Norman Mudd passed on to Paris, where the former was finally reduced to prostitution, only for Crowley to leave once more to winter in Tunis. Hirsig would eventually recover some sort of a life as a schoolteacher back in the USA, having renounced all of Crowley's teachings, before her death in 1951. Norman Mudd drowned himself in 1934.

Aleister Crowley moved on to Germany, and then back to North Africa with the eternal appeal of its easy market in opiates. He was rarely short of prospective followers.

In 1925 he received from the University of Oxford a letter from an undergraduate named Thomas Driberg. 'I have for a long time,' wrote the future Labour MP and member of the House of Lords, 'been interested not only in drugs and the possibility of using them moderately and beneficially, but also generally in the development of latent spiritual powers and questions of occultism.'

Such promising material did not often, these stricken days, present itself. Aleister cultivated the young Driberg, and after further amicable correspondence, the two lunched in London. 'It was often hard to tell if he were serious or joking,' Driberg would claim, 'as when, soon after this, he told me that he had decided to nominate me as his successor as World Teacher.'

Aleister, of course, said that to all the boys. Driberg shortly had a more respectable (and remunerative) career to consider. After Crowley's death – by which time Tom was an MP – he turned up anxiously at the apartment of Aleister's executor and demanded the return of all his correspondence.

By 1929 Aleister Crowley was more or less comfortably settled in Paris. That traditional haven, however, was soon to be closed. An inspector from the *Préfecture de police* called, clearly in search of evidence of drug abuse. After a wary but not unpleasant conversation, which was lightened by some misapplied suspicion

about the true nature of Aleister's coffee percolator, the inspector left, and his visit was followed by a notice informing Aleister that he must leave France within twenty-four hours. Slowly but surely, his reputation was catching up on an elderly gentleman.

Six years had passed since the *Sunday Express* and *John Bull* had elevated Crowley into a demon incarnate; six years during which he had done, written or said absolutely nothing of note. His public persona was therefore dormant; his name still rang clamorous bells, but not every journalist was quite sure *why*. The news of his expulsion from Paris, therefore, excited a curious international media response.

In the United States, the *New York Times* reported on 17 April that:

> An expulsion order from France, becoming effective tomorrow, has been issued by the French police against Alastair [*sic*] Crowley, an Englishman, who was well known in New York during the early years of the war. Crowley, who regularly used on his visiting cards the title of Knight, asserts that he is the foremost authority on black magic, which he says he studied in Mexico, China and Africa.
>
> While in America he wrote articles for German papers, but declared he was a member of the British counter-espionage service. Various charges have been made against him and he has already been expelled from Italy.

In England, the *Eastern Evening News* of Norwich gave over a column to the most fantastic second-hand interpretation of Aleister's recent career:

> The *Paris Midi*, a somewhat sensational evening paper, publishes an article concerning a certain supposed English nobleman, whose name does not appear in Debrett.

Pending further inquiries, the story is given under the strictest reserves. According to the *Paris Midi*, the Englishman in question, who is stated to have a Paris address, is threatened with expulsion from the country on the ground that he has been acting as a secret-service agent for Germany. The paper describes him as a celebrated citizen and a great traveller. At present he is lying ill in Paris . . .

The paper alleges that he admits having acted for Germany in the United States during the war, but in complete agreement with the Naval Intelligence Service, and that he succeeded in counteracting by his influence the formidable German organisation which was acting there. He represented himself to the Germans, and in particular to Count von Bernsdorff, the ambassador, as an Irish revolutionary, and in order that this might be believed, published articles against Britain in *Das Vaterland* suggesting, among other things, that Great Britain ought to become a German colony and that Britain was doing her best to obtain the maximum profit from the war at the expense of France.

From New Zealand, the *Auckland Star* told its readership that:

An Englishman, against whom there are accusations of having practised black magic and of offences against decency, has been ordered to quit Paris. He is Edward Alexander Crowley, and caused some stir in London years ago. Born in Leamington 53 years ago and educated at Malvern and Trinity College, Cambridge, his profession was that of a poet and a writer on Buddhism. He had, he said, published books for over 30 years, and lived by authorship and on invested money. A strange wandering life he led. He travelled through China on foot, and almost

succeeded in ascending the Himalayas, and was received at Tibet by the sacred lamas.

The Star had, peculiarly, gained access through a stranger or an agency to Aleister himself. It continued with his own partial version of those wartime years.

> I had no difficulty in ingratiating myself with the New York Irishmen for my name, which was that of many of them, served as a passport. I discussed with Bernsdorff, the German Ambassador, the possibility of an Irish revolution, and to further this idea I wrote violent articles in the German paper in New York, *Das Vaterland*, and suggested that England should become a German colony.
>
> But I did these things in order to win the confidence of the Germans. The object I had in view was to make the German submarines sink American ships, and so compel America to enter the war. I was well in with the chief of the American Naval Intelligence Service, and I have sent him a telegram, begging him to send me a letter, which I shall forward to the French government.

Aleister told his interviewer that he knew of no grounds for his deportation from Paris, where he had lived for seven years:

> I have led a peaceable life, writing during the day and playing chess at my club in the evenings. I was notified on 9 March that I would have to leave. When the police came here they were muted by a coffee mill, and asked whether it was a machine for cocaine.
>
> My case can be likened to Dreyfus. The French authorities have been obliged to give reasons for the action they have taken against me, and I recall they have given none. The British Embassy has left my case

severely and has absolutely refused to help me. There
was a suggestion that those who helped me might be
expelled. I am insisting on an open inquiry. . .

And a short, plaintive missive arrived at the London offices of the
Tribune magazine in mid-April, from the Hotel Métropole in
Brussels. 'Permit me to make the following corrections on
important matters,' it read.

> 1. I was not expelled from France. It was merely a
> question of *refus de séjour*.
> 2. The police treated me with the utmost politeness
> and consideration . . .
> Yours faithfully,
> Sir Aleister Crowley.

'The wickedest man in the world' was winding his way home, a
latter-day Dreyfus, eager as ever to spin away his misdeeds, to a
nation which had half forgotten. Those that met him in that spring
of 1929 were inclined to regard him as a kind of anachronistic freak-
show; a bogeyman grown old; a stranded vestige of the wicked '90s.
A *Daily Sketch* reporter wrote:

> One of the most interesting and talked-of men in
> Europe, is now visiting London after a long absence.
> He is Aleister Crowley, famed for his knowledge and
> reputed practice of black magic, who was asked to
> leave France two months ago.
> Crowley has an amazing appearance, and eyes
> which, when you first look into them, are literally
> terrifying. I hate to imagine what they must be like
> when he is not in a benevolent mood.
> He has been branded in many countries, and
> showed me, with some amusement, a newspaper
> cutting concerning himself, and headed 'The Human
> Beast'.

> But stories about him have been exaggerated to a ridiculous extent. Actually he is a very brilliant and interesting man, who has travelled all over the world observing religious practices and philosophy. He has been in the most remote places, like the Yucatán Peninsula in Mexico, and was once a tremendous mountaineer.
>
> Crowley, who is exceptionally witty, is publishing a volume of his short stories soon, and these will probably be followed by his memoirs. The latter, dealing largely with the practice of the magic arts, are unique and enormously long.

The Sketch – whose kindly profile of the Beast was excoriated by a successor to *John Bull* titled *The Patriot* for 'wholesale advertisement to subversive persons' and 'weakening the old standards of the traditional moral code' – was correct in its final paragraph. Aleister had finally found a publisher once more.

The Mandrake Press had only just been founded by a London bookseller named Edward Goldston. In June 1929 Goldston handed Aleister Crowley an advance payment of £50 for his autohagiography. The William Hickey column of the *Daily Express* reported in July 1929:

> It is only a few months since its [The Mandrake Press's] birth was first announced in these columns – the mandrake, you may remember, is a fabulous plant which shrieks loudly if uprooted – but its proprietors have an ambitious programme still in hand. Among other works, they intend to reprint all the books by the black magician Mr Aleister Crowley. And some translations from the Gaelic, and a young author who once starved in Berlin has written a volume entitled *Starving In Berlin*.

The William Hickey column was written, in 1929, by Aleister's former Crown Prince, Tom Driberg. It paid to have friends.

On 16 August 1929 Aleister married once more. The ceremony took place in Leipzig, and the bride was a middle-aged Nicaraguan whom he had two years earlier appointed as his new Scarlet Woman. Her name was Marie Teresa Ferrari de Miramar. She was strong-willed, blousily attractive, moderately well off and devoted to her new-found semi-aristocratic English eccentric. Their wedding was attended, as was customary but nonetheless gratifying, by the British Consul, and was recorded in the pages of *The Times*. With great restraint, and with an eye on the solemnity of the occasion, that newspaper contented itself with merely jogging its readers' arms about the chequered history of the fifty-three-year-old groom. 'During the war,' it announced, 'he went to America and participated in German counter-espionage, declaring that he did this at the request of the British Naval Intelligence Department.'

What did this gregarious Latin woman see in a paunchy aging junkie who made a virtue of exploiting affection; who reeked of the ether that he took as a sleeping aid; who had few prospects? Nothing other than his indefinable fascination to women and to susceptible men. The marriage lasted effectively no more than a year. By 1930 Aleister was indulging in sacred rites with a variety of other women, and blaming his own infidelity upon Marie's drinking. Like Rose Kelly before her, she did indeed turn to alcohol and vanished from his life in a miasma of despair. He may not have been clinically mad, but he was frequently hideously bad, and he was always dangerous to know.

Two months later, in October, the Mandrake Press published Aleister's second novel. *Moonchild* was yet another untidy mesh of recycled personal history, recreations of First World War campaigns, Thelemic propaganda and other oddments of Crowleyan philosophy. It was, however, treated with dignity by the

British press, in that many of them overlooked its author's reputation and troubled to put the book out for serious review. It was more than Aleister might have expected.

Not that the reviews were all good. The *Sheffield Independent* praised 'the pen of a ready writer; the alert and spontaneous brain of the unbaiting thinker, and the action of a man who is accustomed to have thoughts translated into words and carried into deeds.'

The *Morning Post* was less impressed. 'Much of the book is frankly revolting in its details,' commented that daily in a rather more traditional response to the deeds of Aleister Crowley. 'If such abominations are performed they are hardly fit subject for a work of fiction . . . The whole atmosphere of the story is unreal and unpleasant.'

The *Times Literary Supplement* noted a 'curious novel' which 'will be found interesting more for its dabblings in medieval magic, both black and white, than for any merits it possesses as a novel.' But six hundred miles to the north, Aleister had at least one literary fan. The reviewer for the Aberdeen *Press & Journal* was impressed by 'one of the most fantastic yet attractive novels we have read . . . We are constantly reminded of the moods of Anatole France and the methods of Rabelais . . . *Moonchild* is not more fantastic than a thorough-going thriller, but it is also a satire and an allegory, full of disorder and genius.'

Early in 1930 the Mandrake Press followed *Moonchild* with the first two volumes of Aleister's *Confessions*. They slumped and so too, within months, did the Mandrake Press. But at last, it seemed, a career and a reputation as a literary figure might be forged out of the unpromising base material of the first five decades of his life. That promise – so dear to Crowley – can only have been intensified by an invitation to address the Poetry Society of Oxford University on the evening of Monday, 3 February 1930.

Aleister carefully prepared a scholarly address on Gilles de Rais, a magician of medieval France. He would never deliver it. Shortly before that fateful Monday the Roman Catholic Chaplain of Oxford University, Father Ronald Knox, wrote to the Poetry Society's secretary. We may only surmise the contents of Knox's letter. The

poor secretary wrote to Aleister to cancel the meeting, explaining: 'It has come to our knowledge that if your proposed paper is delivered, disciplinary action will be taken, involving not only myself but the rest of the committee of the Society.'

The Beast had the power yet, not only to provoke, but also to unleash the posturings of the press. The Darlington *Northern Echo* sent a reporter to Crowley's cottage in Kent. He was met by a large, bald, deeply-spoken gentleman ready to pronounce a *tour de force*. 'I challenge anyone,' Aleister intoned to the scribbling journalist, 'to show why I should not lecture at Oxford today. Full investigations will be made. If there has been a misunderstanding, the lecture will be given later. If the ban is official the lecture will be printed and sold at the street corners of Oxford. There is some underhand business behind this.'

Warming to his theme, Aleister thundered on:

> Perhaps the refusal to let me lecture has come because Gilles de Rais is said to have killed 600 children in ritual murder, and in some way this was connected with myself, since the accusation that I have not only killed but eaten children is one of the many false statements that have been circulated about me in the past.
>
> Probably the authorities are afraid that I may kill and eat 800 Oxford graduates.

Aleister smiled, and continued:

> The main point about my lecture was to show that the allegations against Gilles de Rais were unfounded, just as they were against Joan of Arc. Those were curious times, and anyone was liable to be burned as a witch on the least evidence . . . I understand that there is a Roman Catholic priest behind all this business. I have reason to believe that the ban is not official. Mr P.R. Stephenson of the Mandrake Press, my publishers, is

> going to Oxford on Monday to make investigations.
> We want all the facts, for I have spent many hours
> preparing the lecture, only to find that it has been
> cancelled at the last moment. I hope that he comes
> back safely to tell me, and is not arrested while he is in
> Oxford. It must be a surprise to some people to learn
> that I am in England at all. They cannot believe that I
> would not be hanged immediately upon landing.

The banning of Aleister Crowley from Oxford University caused national press coverage. The injunction against his lecture was, however, never lifted. The Mandrake Press instantly capitalised upon their author's retrieved celebrity by publishing the Gilles de Rais lecture as a pamphlet and by issuing, in July 1930, the first quasi-critical study of Aleister's life and times. Titled *The Legend of Aleister Crowley*, it was hastily written by the Mandrake director P.R. Stephenson, and put on sale for a reasonable 2s 6d.

This 'study of the documentary evidence relating to a campaign of personal vilification unparalleled in literary history' was, naturally, welcomed in the pages of *The Freethinker* which protested:

> Rigid moralists like the good Horatio Bottomley . . . it
> seems to us protest too much in their religious efforts
> to keep England pure and holy; and for this reason,
> differing as we do from very much that is taught and
> advocated by Aleister Crowley, we respectfully decline
> to join the howling mob of interested pietists who
> every now and then raise the wind in the Silly Season
> by shrieking with inspired vituperation at the poet
> under discussion.

The Freethinker continued in the most convincing – if wordy – defence of its subject yet mounted in the British media:

> If a fraction of the charges brought against Crowley

were true, he should be exiled from every country in the world, and, after judicious application to his reason of various Chinese tortures, he should be hanged, drawn and quartered first, broken on the wheel afterwards, and the remains sown with salt before being cast into the infernal pit; but somehow we have an instinct against accepting the unsupported assertions of the professional moralists of our popular journals, and we do not know that . . . Mr Bottomley and the lesser lights of cheap journalism have not [*sic* – *The Freethinker's* syntax ran away with itself: the second 'not' is misplaced] proved their case up to the hilt.

In these circumstances we venture publicly to record our opinion that the poet might be allowed to follow his paths in comparative peace until something definitely criminal can be proved against him, when the police, no doubt, will be quite capable of dealing with the case.

The Freethinker's final lines will have transported especial joy into the Crowley household. 'Crowley,' it asserted:

is at least as important a figure as the the late D.H. Lawrence and Mr James Joyce, both unquestionably men of genius; and when we remember the kind of things said against these artists in our cheaper prints, we hesitate to acquiesce in the Sunday newspaper verdict of Aleister Crowley . . . we ourselves differ profoundly on many points – on most points, indeed – from Crowley; we do not see why he should not have a fair share of [fair play]. This notice therefore is written solely in the interests of fair play, by one who is in no respect a follower or partisan. It is a plea for ordinary human tolerance addressed by a Freethinker to his fellow Freethinkers.

———

> Those of them who feel inclined to quarrel with this estimate of Crowley's genius might inform themselves by glancing at his latest published work, *Confessions*. This work, now in the course of publication, is, in my considered judgement, the greatest autobiography that the world has ever seen. We have not the least doubt that posterity will endorse this finding.

That was more like it! If the worthy liberals of *The Freethinker* had been fully aware of Aleister's exotic private life; if they had been appraised of the fact that while that glowing encomium was being set in type, its subject was rooting around in tireless search of somebody – male or female – with whom to enjoy his favoured sexual sacraments of buggery and the subsequent drinking of 'elixir' (the resultant mixed semen), they may not have been quite so fulsome in their praise. But they were not aware, and fulsome they were, and Aleister's belief – never entirely doused – that the world might yet come round to recognising his genius, was given fresh hope and substance.

The early 1930s were good years for Aleister Crowley. In May 1930 he travelled to Berlin to exhibit some of his paintings, and was warmly welcomed in the pages of the *Berliner Tageblatt*:

> Aleister Crowley is a painter by passion. He became one because as an Alpine climber he has seen air and light effects which previously were hardly accessible to human eyes. Crowley has ascended all the peaks of Mexico. After that he undertook two attempts to subdue the Himalayas. The last of his Himalayan expeditions took place in 1905. Crowley got up to

7,000 metres. Then a mutiny forced him to return . . .

In England, Crowley the gentleman bohemian is a much contested personality. One group consider him as a revolutionary philosopher, another as a foolish artist; that this mountaineer, chessplayer, poet-philosopher and painter is one of the most peculiar personalities is denied by nobody.

In Germany he met and befriended a nineteen-year-old artist named Hanni Jaeger. That signalled the end of Marie: his wife of nine months was finally abandoned as Aleister took off to southern Europe with Miss Jaeger. In Portugal, following several seamy and painful sessions of sexual magic, Hanni decided to return home. Aleister determined upon a dramatic stunt. He walked down to the Boca do Inferno, the Hell's Mouth outside Cintra, where the Atlantic waves crash into a spout and are funnelled dramatically into the air, and there he left a note which read: 'I cannot live without you. The other "Boca do Inferno" will get me – it will not be as hot as yours! Hjsos! Tu Li Yu!' He then returned to his hotel, packed and left for Germany. A Portuguese friend, Ferdinand Pessoa, alerted the press to the mysterious disappearance of 'the wickedest man in the world'.

The press, of course, seized upon the tale. The *Empire News* reported: A mysterious note pinned to the entrance to a cave known as Hell's Mouth, 20 miles from Lisbon, and the disappearance of a man believed to be Aleister Crowley, the notorious English mystic, who is well known in London and Paris . . . The real Aleister Crowley is known as an author and a poet, and also a kind of mystic and magician. He has been much criticised, and has been described as 'the worst man in England'.

Having established that the Portuguese police affirmed that Aleister Crowley had in fact crossed their border into Spain two

days after the discovery of the 'suicide' note, the *Empire News* was obliged to consider a terrible possibility: 'Are there two Aleister Crowleys, one genuine and one an impostor?'

There was just one. He was back in Berlin, beaming broadly and buggering Hanni Jaeger. Miss Jaeger would later continue the honourable tradition of erstwhile mistresses to Aleister Crowley by committing suicide herself – genuine suicide, that is, involving no faked notes in Portuguese beauty spots.

It was perhaps this newly favourable – or at least neutral – press coverage, coupled certainly with his chronic indigence, which led Aleister at last to try his hand in the libel courts. His first such attempt proved gratifyingly easy.

Having returned from a satisfying three years in Berlin – which had featured, amongst other indulgences, an affair with Gerald Hamilton, the model for Mr Norris in Christopher Isherwood's eponymous novel – in January 1933 Aleister was walking down Praed Street in London when he saw in a bookshop window a copy of his novel *Moonchild.* Attached to the volume was a card which read: 'Aleister Crowley's first novel *The Diary of a Drug Fiend* was withdrawn from circulation after an attack in the sensational press.'

That was not true. Collins never had withdrawn *Diary of a Drug Fiend* from circulation. They had simply refused to publish any more of the author's work. As libels go, it was a staggeringly minor assertion compared with the character assassinations which Aleister had suffered without recourse to law. But he seized upon it – perhaps because of the vulnerability of the poor bookseller – and he won his case with ease. A sympathetic judge ruled that: 'There was not the smallest ground for suggesting that any book Mr Crowley had written was indecent or improper. Mr Gray [the bookseller] wanted the public to believe that the book to which the label was attached was an indecent book.' Aleister was awarded £50 with costs.

It was that easy! He then recalled that a former acquaintance, Nina Hamnett, had featured him recently in her memoirs, *Laughing Torso.* Crowley picked up the book and read: 'He was supposed to practise Black Magic there [in Cefalù], and one day a baby was said

to have disappeared mysteriously. There was also a goat there. This all pointed to Black Magic, so people said, and the inhabitants of the village were frightened of him.'

The case of *Crowley* v *Constable & Co* Ltd [the publishers of *Laughing Torso*] *and Others* opened on 10 April 1934 at the High Court. Constable & Co were no tiny Praed Street bookseller. They assembled a formidable defence team; dug deeply into Aleister's published *oeuvre*; and quickly set about turning the trial into an examination of the morality of Aleister Crowley. Before a middle-class jury in the 1930s, there would in such a case be only one loser.

Malcolm Hilbery KC, counsel for the defence, brandished Aleister's risqué collection of verse *Clouds Without Water* before the court and asked: 'Isn't that filth?'

'You read it,' replied Crowley, 'as if it were magnificent poetry. I congratulate you.'

'Is the meaning of it filth?'

'In my opinion it is of no importance in this matter. You are reading this sonnet out of context, as you do everything.'

'You have been well known for years,' pressed Hilbery, 'as the author of all these things which I have been putting to you?'

'No. I wish I had a far wider reputation. I should like to be hailed as the greatest living poet. Truth will out.'

Had Aleister, continued Hilbery, in 1915 described the Kaiser as the genius of his people and an Angel of God sent to save the Fatherland from savage foes? 'Did you write that against your own country?'

'I did, and I am proud of it.'

'Was that part of German propaganda in America?'

'Yes. I wanted to overbalance the sanity of German propaganda, which was being very well done, by turning it into absolute nonsense.'

'That is your explanation now, after the Allied cause has succeeded?'

'Lots of people knew it at the time.'

'Does any man of distinction,' wondered Hilbery, 'necessarily have it said about him that he is the worst man in the world?'

'Not necessarily,' countered Aleister to rewarding laughter. 'He has to be very distinguished.'

Following a lengthy examination of Aleister's magical past, Malcolm Hilbery returned to his literary output. 'Is *White Stains*,' queried Hilbery, 'a book of indescribable filth?'

'This book is a serious study of the progress of a man to the abyss of madness, disease and murder.'

'You know it is an obscene book.'

'I don't know it. Until it got into your hands it never got into any improper hands at all.'

Once more the courtroom burst into laughter, and Mr Justice Swift warned that much more of the same would lead to a clearance of the building.

It got worse. Acting for Nina Hamnett, the barrister Martin O'Connor asked Aleister to deny that at Cefalù a cat was killed and its blood drunk. 'There was no cat,' protested Aleister, 'no blood, and no drinking.'

O'Connor then called to the witness box Mrs Betty May Sedgewick, the widow of Raoul Loveday. Betty attested to 'extremely improper paintings' on the walls of the abbey. 'About half-past five in the morning,' she continued, 'the household was aroused by the banging of a tom-tom and had to go out and face the sun. It was called 'adoration'. She continued:

> In the afternoon the children had to stand and put their hands up to the sun. The evening ceremony was the great thing of the day. It was called 'Going in to Pentagram'. The women sat on boxes around the circle. Mr Crowley was the head of the ceremony and wore a robe of bright colours with a cowl. A scarlet-robed woman named Leah took part in the ceremony. She was the spiritual wife of Mr Crowley.
>
> There were places in which one could get various things in the way of drugs . . . One day a cat got in and got under the table. Crowley knew it was there, and he reached down. It scratched him terribly, and he got

hold of it, and made a pass over the cat with his sword. 'You shall be sacrificed within three days,' he said.

There was great excitement in the Abbey, and preparations were made. Mr Crowley had a knife with a long handle. The cat had been put in a bag and was crying piteously. It was taken out of the bag and my husband [Raoul Loveday] held it up. He had to kill it. The cat was held over the altar, and the Scarlet Woman held a bowl to catch its blood. The knife was blunt except the top, which was very sharp. When my husband tried to cut the cat's throat, he cut his finger badly, and became frightened and let the cat fall. It dropped out of the circle, and that was very bad for magic. Crowley asked me to pick it up, but I wouldn't, and when they did finally kill the cat, the blood fell into the bowl, and my young husband had to drink a cup of that blood.

Mr Justice Swift said in his summing-up:

I have been over 40 years engaged in the administration of the law in one capacity or another. I thought that I knew every conceivable form of wickedness. I thought that everything which was wicked and bad had been produced at some time or another before me. I have learnt in this case that we can always learn something more if we have long enough. I have never heard such deadful, horrible and abominable stuff as that which has been produced by the man who describes himself as the greatest living poet.

The jury found quickly for Nina Hamnett and Constable. Aleister left the court in a black coat, lunched off *pilaf de langoustes* and a glass of milk, and quoted Kipling to all who wished to hear: 'If you can meet with triumph and disaster, and treat those two impostors just the same . . .'

There was a lighter side to the disaster. The case, which once again offered Crowley a monopoly of the nation's front pages, prompted the Marquess of Donegal to pen some reminiscences in the *Sunday Dispatch*. The Marquess mused:

> Last time I saw Crowley he was more interested in a new game he had invented than in magic. It was played with a football against the wall of a garage, the ball being both hit with the fist or kicked, as desired .

> At the same time as Crowley demonstrated his new game, he gave me a 'sex appeal' ointment. This was a noisome concoction which Crowley swore would make the man who rubbed it behind his ears irresistible to the opposite sex. I did not find it so. Thinking a bus a good place to try it out, I boarded one. The only result was that my neighbours of both sexes began sniffing heavily and quickly moved as far from me as possible.
> Eventually I gave it to a postman on the theory that if it would ward off human beings it might be efficacious against savage dogs . . . Once at a Foyle's luncheon I sat next to Miss Rose Macaulay. Crowley was to speak on 'The Philosophy Of Magick'. Such is the power of the Crowley legend that Miss Macaulay turned to me and said: 'I don't mind what he does, so long as he doesn't turn himself into a goat!'

There was a brief postcript to the Hamnett trial when Betty May Sedgewick sued Aleister for the return of five letters which had mysteriously escaped from her possession and entered his. No magick was involved: they had been stolen from Betty and delivered to Aleister by a person aware of their value in the forthcoming trial. Aleister was found guilty of receiving stolen property, bound over to keep the peace for two years, and warned that if he appeared on similar charges again he faced a prison sentence of six months.

In November he appealed against the libel-action verdict, but although Lord Justice Greer agreed that the summing-up of Mr Justice Swift was 'not as full as it ought reasonably to have been', the only possible verdict in the case was for Hamnett and Constable.

At the end of an *annus horribilis*, Aleister Crowley, who had lived off his wits, his overdrawn legacy, his name, and boundless credit for years, entered the Bankruptcy Court. Mr Bruce Park, the assistant official receiver, asked for his 'real and true name'.

'Edward Alexander Crowley.'

'By what other names have you been known?'

'Hundreds.'

'I don't want "Beast 666" or anything like that,' stressed Park, who was anxious merely to track down trading debts. 'What others have you used? Tell me some of them.'

'They are so numerous I cannot remember them all offhand. Every time I write a book I invent a new name for myself.'

'What income tax had the plaintiff returned?' wondered Mr Park.

'None. I have never had any income-tax papers.' Aleister attributed his insolvency to 'the boycotting of my works and writings in this country.'

'Is it not that the public do not want your works?'

'No, it is not. I was expecting a large sum of money from the sale of my life story, which is worth £2,000.' Aleister smiled, that winning, rakish, reckless smile which once had been so irresistible. 'The only thing lacking,' he said, 'is a publisher.'

'You had better,' advised Mr Park, 'give it to the official receiver, and see if he can sell it for you.'

His liabilities estimated at £5,000 – £160,000 in late 1990s value – following a chiding lecture about living three times over his income, Aleister's affairs were all delivered into the hands of the official receiver.

His past had caught up with him. That is the obvious and only translation of those painful hearings in 1934. He could not win a libel case if the defence had the money and the wit to raise his First World War activities and his hedonism in Cefalù. If he once appeared in court, his various creditors were alerted to his

whereabouts, and rushed to foreclose. He was now not only a heroin addict, but a bankrupt heroin addict without a publisher. He was also in his sixtieth year. It was time for the Beast to retire.

It was a dignified retirement, when all is considered. He stayed in London apartments, receiving curious visitors, dashing out occasionally to purchase oysters to cure his heroin-caused constipation, rarely venturing too far from London and his doctor's prescription.

Occasionally the outside world would remember and drag him briefly back into the limelight. When in 1937 the *Left Review* polled one hundred and twenty eminent British writers to ask which side they supported in the Spanish Civil War, Aleister was one of the hundred who voted for the Republicans against General Franco.

His fascination as a character to writers of fiction hardly faltered. One author, Anthony Powell, had the wit to beam his Crowley character, Scorpio Murtlock, right up into the 1960s in the last volume of his epic *A Dance to the Music of Time*. It was still, in the more hospitable '60s, recognisably Aleister . . .

> As ever in these cases, there was an interesting heredity. Both mother and father belonged to a small fanatical religious sect, but I won't go into that now . . . Scorpio – Leslie as he was then – already possessed remarkable gifts of a kinetic kind. As you certainly know, there has been of late years a great revival of interest in what can only be called, in many cases, the Black Arts . . .

Those who, like Powell, called to see him, discovered an old man more mischievous than threatening, more contemplative than hectoring, with a great fondness for eating curry. Allan Burnett-Rae recalled asking Crowley why:

> if, as he was the first to claim, he was a man of outstanding parts, he did not seek fame and reputation, rather than notoriety and more or less

general public distrust, in the way he had done for so long.

'What is the use of most fame?' he answered. 'I once thought of the Diplomatic Service as a career, but can you tell me now who was our representative at the Sublime Porte, say, eighty years ago?'

'Stratford de Redcliffe,' I replied instantly, having some time before read up the Crimean War . . . He looked somewhat disconcerted but quickly said: 'Oh well! You know what I mean. No one will remember in a few more years, will they?'

But they *would* recall, was his satisfied subtext, 'the wickedest man in the world'.

When the Second World War broke out in 1939 he took care not to reprise his mistakes of the First. A pamphlet called *Thumbs Up!* was published by the Crowley imprint. Its cover bore the sign of the penis with testicles, and its interior contained the rhyme:

> England, stand fast! Stand fast against the foe!
> They struck the first blow: we shall strike the last.
> Peace at the price of freedom? We say No.
> England, stand fast!

Evidence in plenty that his claim to be the greatest of twentieth-century poets must still be left on hold. But nothing, at least, to disturb the Home Office.

Following a particularly close and heavy air-raid in 1944 the sixty-nine-year-old Crowley left London – reluctantly, as it meant moving to an erratic postal distance away from his doctor's heroin prescription. But he had already suffered one minor heart attack, and did not care to wait around for German bombs to finish the business. He wound up finally in a small boarding house in suburban Hastings, the town of his miserable boyhood schooling.

There, in May 1946, the man who would be his first – bewitched – biographer, first met him. John Symonds encountered a man

of medium height, slightly bent, and clad in an old-style plus-four suit with silver buckles below the knee. In his eyes was a puzzled, pained look. He had a thin goatee beard and a moustache, and his head, in spite of tufts of hair on the sides, seemed no more than a skull . . . 'Do what thou wilt shall be the whole of the law,' he intoned in a nasal, fussy voice. 'The wickedest man in the world' looked rather exhausted.

There can be few more poignant indications of the lonely last years of Aleister Crowley than the fact that this young man, John Symonds, whom he had known for little more than a year, was appointed his executor at death.

He died in his Hastings bed on 1 December 1947. A nurse was at his side, and it was reported that he died unhappily, with tears streaming down his cheeks. His penultimate phrase on this earth, reported that nurse, was 'I am perplexed'. According to the same source, his very last words were: 'Sometimes I hate myself.'

10

To Ashes

Io Pan! Io Pan!

– Aleister Crowley

There was no room in Poets' Corner. He was cremated at Brighton on Friday, 5 December 1947. It was a raw, dank day, according to one observer, with the leaves wet and muddy on the ground. The chapel was a cold and hostile place with a few memorial plaques screwed to the walls. At 2.45 p.m. his coffin was borne inside. About a dozen people attended it, and one of these mounted the rostrum and read:

> *Thrill with lissome lust of the light,*
> *O man! My man!*
> *Come careering out of the night*
> *Of Pan! Io Pan!*
> *Io Pan! Io Pan! Come over the sea . . .*

It can never have sounded better. The reading continued for twenty minutes, after which a small woman stepped forward and threw a spray of roses onto the coffin. 'The rollers moved. The little

furnace doors opened and the coffin, slightly askew, began to push its way past the black velvet curtain covering the hole in the wall.'

Twenty-four hours after Aleister Crowley's death his doctor in London, the sixty-eight-year-old William Brown Thomson, was found dead in the bath of his Mayfair flat. It was recalled that Dr Thomson had, a year earlier, restricted Aleister's heroin prescription, and three months before the old man's death had stopped it completely. Aleister had consequently put a public curse on Dr Thomson. Scotland Yard announced, however, that both men had died from natural causes.

The newspapers hardly knew what to write. The horrors of the Second World War had, it seemed, put Aleister Crowley's misdeeds into a certain perspective. Could he really be, in a century which had bred Adolf Hitler, 'the wickedest man in the world'? They opted in the end for demystifying the Beast: 'He became a fat, olive-skinned man with heavy jowls and mean little eyes which made him look like a stockbroker when the market is bad. He was crushed to hear himself described one day as "a rather harmless old gentleman" . . .'

One Geoffrey P. Wheeler of Woodhouse Road, North Finchley, did choose to offer the press a sensible angle on the departed enigma:

> He made the fatal mistake of cultivating a flamboyant exhibitionism, which caused one famous woman writer to describe him as 'a poser who had come to believe in his own poses'.
>
> One recalls the sensational press accounts of drugs and devil worship in an 'Abbey of Theleme' at Cefalù, involving animal sacrifice, a once well-known Hollywood actress and a famous Epstein model, etc. etc.
>
> Of the real Crowley little was ever heard. I like to think he has now become filled with an inner peace he never knew in the flesh.

Index of Personalities